Modern Wildlife Painting

Modern Wildlife Painting

Nicholas Hammond

YALE UNIVERSITY PRESS
NEW HAVEN AND LONDON

Published 1998 in the United Kingdom by Pica Press (an imprint of Helm Information Ltd) and in the United States by Yale University Press.

ISBN 0-300-07458-1

Library of Congress Cataloging-in-Publication Number 98-88106.

Printed in Hong Kong.

A catalogue record for this book is available from the British Library.

The paper in this book meets the guidelines for permanence and durability of the Committee on Production Guidelines for Book Longevity of the Council on Library Resources.

10 9 8 7 6 5 4 3 2 1

CONTENTS

AUTHOR'S PREFACE

During the twentieth century interest in wildlife has grown enormously in North America and Europe. It is not surprising that this should have resulted in an increase in the numbers of artists depicting wildlife. Inevitably their work has accelerated the growth of the interest in wildlife to the extent that it has become impossible to separate cause from effect. In this book I have tried to show how public interest in wildlife and art are interwoven.

Each chapter deals with a separate theme, although these are unavoidably linked with each other. However, a disadvantage of this approach is that the work of some artists does not fit conveniently into a particular theme. For this reason some artists are not featured and no doubt some readers will be disappointed that I have not included their favourites. For that I apologise and reassure them (and the artists concerned) that omission is not intended as an expression of adverse criticism.

Of course amongst the work included are many that I admire greatly. Particular favourites tend to be those in which the artists' emotional rapport with their subjects is most clearly expressed. Their enthusiasm for their subjects has not led them to reproducing them correct in every detail of feather, fur or scale. Their emotional responses stem from their wish to share the experience of seeing an animal in a particular place and the result is as much about a sense of place and experience as it is about the animals themselves.

For many critics wildlife art is a genre to be dismissed as little more than two-dimensional model-making. But these critics may have looked no further than the sentimentalised, and extremely popular, photo-realist school of painting animals. This is a form of art that has no real connection with the experience of seeing animals in the wild. Such paintings are often created with the publication of signed reproductions in mind. While commercial success may be a legitimate motivation, it is not one that will endear the artist to the art critic, for whom popularism exempts the work from serious consideration.

Commercialism may have stultified the development of wildlife art, but the best of the genre is painted by artists who have an understanding of wildlife and the places where it is found. Lack of critical appreciation may come from the critic's lack of understanding of wildlife or its habitats. Nevertheless, historically, the greatest art to contain images of wildlife has been executed by artists such as Dürer, Brueghel, Rubens, Monet and Picasso, none of whom would ever be described as a 'wildlife artist'.

While the best wildlife art contains a truth, it may not be the suspect truth of the camera lens. If there is a truth to art, it has little to do with science and is much more likely to be found in the feelings and the observation of the artists about their subjects. And in that it has to be much more 'truthful' than either exact copying of a creature or sawing it in two and pickling it.

ACKNOWLEDGEMENTS

The initial idea for this book came on an overnight flight across the Atlantic with Graham Barker of The Wildlife Art Gallery, Lavenham, Suffolk. Graham pressed me to revisit the subject of wildlife artists in the twentieth century and by the time we arrived at Heathrow I had a first synopsis. Graham and his fellow director, Andrew Haslen, have been extremely helpful in providing me with information about artists. Andrew has also provided many of the transparencies used. Other providers of transparencies have been very cooperative and helpful and I would like to thank Ysbrand Brouwers, director of the Artists for Nature Foundation; Marie-Louise Monsouwer of Inmerc bv; Oliver Swann of the Tryon & Swann Gallery, London; Kathy Foley and Jane Weinke at the Leigh Yawkey Woodson Art Museum; Robert McCracken Peck and Carol M. Spawn of the Academy of Natural Sciences, Philadelphia; Donald T. Luce of the James Ford Bell Museum at the University of Minnesota; Ingmaris Desaix of the Gothenburg Art Museum; Sussi Wesström of the Swedish National Art Museums; Karin Meddings of the Thiel Museum, Stockholm; Julie Kasper of the American Museum of Natural History; Jennifer Churchill of the Glenbow Museum; and Lady Scott. Other publishers have also been helpful and I would particularly like to thank Myles Archibald of HarperCollins and Teresa Buswell of Houghton Mifflin. Of course, without the cooperation of the living artists in providing transparencies and artwork, this book would not have been possible. To all of them my thanks.

I have used many sources of information and the staff of several libraries have been both helpful and patient. Ian Dawson, Librarian at the RSPB, answered innumerable questions and provided information about past publications. Thanks also to staff at the National Art Library, Natural History Museum Library, Bedfordshire County Libraries, particularly the staff of the Reference Library in Bedford and of Sandy Branch Library, who processed my LASER requests.

Other sources of information and inspiration (in alphabetical order) have been Linda Bennett, formerly editor of *Natural World*; Jeffery Boswall for his advice on the history of wildlife cinematotography; Derek Bousé of University of Albion, Michigan, for information and comments on the differences between North American and European traditions of wildlife filming; Nigel Ede of Arlequin Books; Al Gilbert for drawing the work of younger American artists to my attention; Robert Gillmor, whose knowledge and insights about wildlife art make every conversation a joy; Rebecca Hakala Rowland, formerly editor of *Wildlife Art*, for supplying information on various North American artists; Rob Kret, formerly director of Leigh Yawkey Woodson Art Museum, for information about the museum and about artists exhibiting there; Bruce Pearson, President of the Society of Wildlife Artists, for information about the society and its members and for patiently allowing me to sound out some of the ideas expressed here when he might have been painting; Shari Schroeder of the Leigh Yawkey Woodson Art Museum for information about the museum's collection; Lars Svensson for information about the development of field guides, about Bruno Liljefors and for hospitality in Stockholm; Bill Thompson, editor of *Bird Watcher's Digest*; and Julie Zickefoose.

The publication of a book is team effort. I must thank all those involved in the publishing of the book. Christopher Helm signed me up and his sensitive editing of the text has improved it. Nigel Redman has been extremely encouraging and both of them have been very patient. It has been a privilege to work with the designer, Julie Reynolds, both because of her skill and her constructive suggestions.

Finally I must thank Yvonne Hammond for taking innumerable messages about the book, allowing me to discuss ideas with her and to share with her those fascinating pieces of information that did not really fit into the book.

AN INCREASING INTEREST

Remember that the most beautiful things
in the world are the most useless;
peacocks and lilies for instance.

John Ruskin[1]

Wildlife art reflects public attitudes to wildlife. Paintings over several centuries show how these attitudes have altered. The most obvious change has been the move away from the anthropocentric view that everything in the world was put there for the benefit of man. A second change has come about because of the development of photography and cinematography, which has released some wildlife artists from the constraints of trying to reproduce images faithful in every detail. Thirdly, ecological and field-based behavioural studies have created for both artists and their viewers an awareness of the scientific base of their work far removed from the sentimental anthropomorphic attitudes of the last century.

Throughout history painters have painted pictures that people wanted to buy. The medium chosen has also been determined by the purchasers. From early Christendom onwards, prelates with churches to decorate provided walls on which painters created memorable frescoes, an art form for which there is little demand in the twentieth century. The art-loving burghers of the seventeenth century Dutch Republic wished to decorate their houses with small paintings celebrating life in their emergent nation. The Establishment of imperial Britain demanded large, heroic canvases of battles won, of countries conquered and races subjugated. In the twentieth century multi-national companies commissioned modern art that would demonstrate the artistic taste of the patron without at the same time frightening customers and employees. That the market place should so encourage and determine the course of art through the centuries will no doubt satisfy the prejudices of certain political scientists and economists. Wildlife painting has been and continues to be subject to market forces, probably more than any other sphere of painting.

In most cases painters of animals have been influenced in their choice of subjects, and indeed in their approach, by what sells most easily. What better example could there be than the technically masterful Edwin Landseer (1802-1873), whose assiduous cultivation of his monarch's sentimental attitude towards animals earned him a knighthood and a fortune? He learned at a very early stage in his career that royal patronage was available to artists who could reflect Queen Victoria's attitude towards animals into pictures. Although his portraits of her dogs, parrots and pet monkeys show too much sweetness for most late twentieth century palates, he demonstrated a technical ability that few of today's wildlife artists, without the aid of a camera, could emulate, and his pen-and-ink sketches of both people and animals are superb[2]. While the sentiment in some of his paintings might often have been saccharine, he was also capable of an anthropomorphism that demonised some animals. For example, in one amazing composition he painted a group of sea eagles that appear to have gone uncharacteristically berserk in a swannery killing and maiming swans with a zest that is definitely not scientifically acceptable[3], and to achieve the strong composition he has contorted the birds' bodies in ways which suggest that his knowledge of avian anatomy was rudimentary. J. G. Millais, the bird artist son of the Pre-Raphaelite, is quoted by Ormond[4] as disputing the veracity of the scene – '... a sea eagle never touches anything in life which might offer resistance, and would just as soon think of assailing a mute swan (a bird half as big again as itself) as a hansom cab.'

Another Landseer shows the difference between nineteenth and late twentieth attitudes towards otters. Before the publication of *Tarka the Otter* otters were seen as vicious predators, competitors with man for salmon and trout, so Landseer's *The Otter Speared, Portrait of the Earl of Aberdeen's Otterhounds* (1844), with its huntsman and slavering hounds and skewered otter squirming on a spear probably provoked very little abhorrence. However, John Ruskin protested 'I would have Mr Landseer, before he gives us any more writhing otters, or yelping packs, reflect whether that which is best worthy of contemplation in a

hound be its ferocity, or in an otter its agony, or in a human being its victory, hardly achieved even with the aid of its more sagacious brutal allies, over a poor little fish-catching creature, a foot long.'[5]

Change in attitude to wildlife is clearly demonstrated by the differences between painters' depiction of big cats in the nineteenth and twentieth centuries. At a sale of art in 1994 two successive paintings showed the heads of fearsome tigers. One of these by the Victorian artist W. Spilsbury, shows an animal with bared fangs, slavering mouth and eyes so staring that they suggest a seriously overactive thyroid[6]. There is no denying that this tiger was a beast to be feared and, by implication, to be shot and turned into a rug. A hundred years later paintings by artists, most of whom have probably never seen a wild tiger, show a noble mammal that deserves our respect and protection. This respectful 'conservationist' approach may be as misleadingly anthropomorphic as the Victorian 'snarling beast' paintings because it ignores that these are dangerous animals which will kill people, and that even from the safety of an elephant's back it is impossible not to feel a *frisson* of fear when seeing one in the wild. In the collection of the National Gallery of Scotland there is a watercolour of a tiger by Joseph Crawhall (1861-1913) with blood dripping from its jaws and the severed head of its human victim lying almost unnoticed in the foreground[7].

The best wildlife paintings are not laden with judgements about the animals they depict. The big cats of the German artists, Wilhelm Kuhnert (1865-1926) and Richard Bernhardt Louis Friese (1854-1918), or the Englishman Cuthbert Edmund Swan (1870-1931), are mostly living animals with neither the vices nor the virtues of the human animal. Figurative realism is difficult to achieve without either succumbing to romanticism or being so objective as to be hyper-real to the point where a photograph might have been more effective.

There is one artist who spanned the late nineteenth and early twentieth century and who never seems to have been anthropomorphic. Bruno Liljefors (1860-1939) was born in Uppsala and was reared in rural Sweden. He was a dedicated and prolific painter with a passion for the countryside and its wildlife. He was a hunter, fascinated by the relationship between predator and prey, and seeing himself as another animal rather than a specially chosen master of nature. Few, if any, artists since Liljefors have achieved his passionate objectivity.

Today tourists to the game parks of East Africa feel that their holiday has been a success if they have seen the 'big five' (elephant, lion, rhinoceros, leopard and cheetah). Their quarry is recorded for their posterity on camera and VCR. A century earlier the tourists were armed with guns with the quarry destined to be trophies to decorate mansions in Europe or North America. In magazine stories fierce animals terrorised plucky men, who had to resort to guns to protect themselves and, incidentally, provide themselves with carcasses whose skins could become rugs, whose heads could be mounted as trophies on billiard room walls or, in the case of elephants, whose feet could be hollowed as umbrella stands.

The less fortunate, or the more cautious, who were not upholding European colonialism in Africa or Asia or taking expensive safaris, had the chance to see big game animals corralled in zoos. These late nineteenth century Europeans or North Americans were impelled by similar emotions matching, almost two millennia previously, Roman wild beast shows in the Coliseum. During the intervening period Christian churches had embraced the Old Testament doctrine whereby animal and plant life had been put on earth for the benefit of human kind.

> And God said, Let us make man in our image, after our likeness; and let them have dominion
> over the fish of the sea, and over the fowl of the air, and over the cattle, and over all the earth
> and over every creeping thing that creepeth upon the earth.[8]

In the nineteenth century the emerging theories of evolution began to undermine this comforting licence to pillage. Questions were asked about the responsibilities the human animal owed to other species with which it shared the planet. Churchmen, if not church establishment, were involved in the new philosophy. Much of the natural science of the eighteenth and early nineteenth centuries had been undertaken by priests such as Gilbert White (1720-1793) and Gregor Mendel (1822-1884), but the clergy

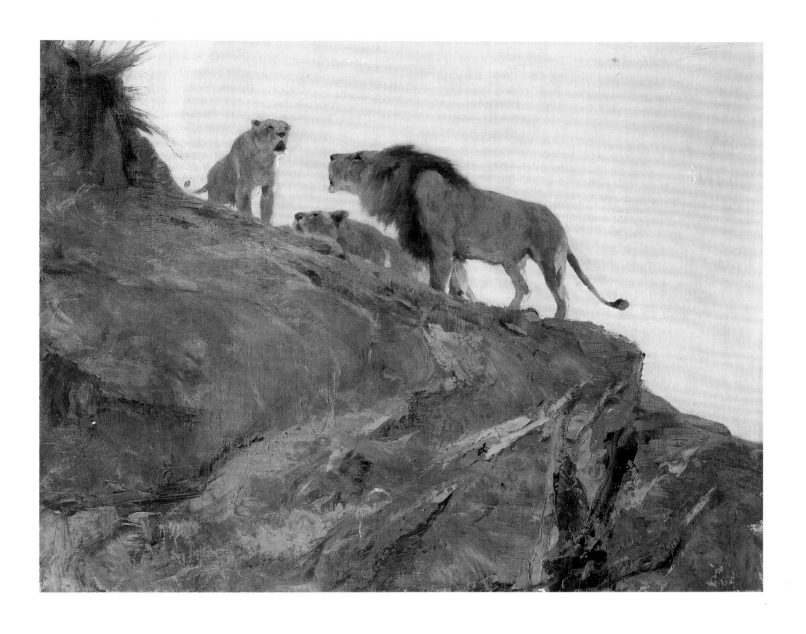

WILHELM KUHNERT (1865-1926).
The Roar of the Lion. Undated.
Oil on canvas. 420 x 500mm.
This party of roaring lions could easily have been anthropomorphic, but typically the artist has depicted the animals without judgement. In Kuhnert's work there are no heroes or villains.

were also active in the philanthropic protection movement that formed the basis of the conservation movement that grew during the course of the twentieth century.

Interest in conservation has grown as contact with animals has diminished. At the end of the nineteenth century, as Harriet Ritvo points out, animals 'figured prominently in the experience even of city dwellers. The streets were full of cabhorses and carthorses; flocks of sheep and herds of cattle were driven to market once or twice a week; many urbanites raised pigs and chickens in crowded tenements, or bred a variety of pets from pigeons to rabbits and fighting dogs.'[9] As the twentieth century has progressed most people in the Western World, even those living in rural communities, have become further removed from larger farm animals. They have disappeared from towns and, with the emergence of factory farming, they have begun to disappear from fields. At the same time people, because of the wonderful quality of photography and cinematography, are becoming more familiar, albeit vicariously, with the wildlife of both their own countryside and of the rest of the world.

That wild animals were fierce and somehow by nature antagonistic towards people was portrayed in the feature films of the first part of the century. Feature films, reflecting the written fiction of the time, showed the exploits of big game hunters, but lurking in some of them, such as *King Kong* (1933) and the Tarzan films, was the idea that this anthropocentric view of nature might not be the only one. By 1951 *Where No Vultures Fly* showed a game warden waging war against poachers, who were in turn being exploited by sinister Europeans. Its clear conservation message was confused by other considerations such as the decline of Empire and the recent world war. But despite its good intentions, the title of the film – equating vultures with poachers and therefore with something morally wrong – betrayed a misunderstanding of the natural world and the crucial ecological role of vultures as scavengers.

It was not long before the movie industry perceived the appeal that the natural world has for the viewer, and it was Walt Disney who made the breakthrough. In 1948 the 'True Life Adventure' series of feature films were launched with a strong narrative element and animals in the role of 'characters' – furry and cute, scaled and sinister. The importance of narrative was emphasised and a genre of wildlife films was created. Derek Bousé has remarked that the distribution in schools during the 1950s and 1960s of the True Lifes 'taught generations of us about the ways of nature and the behaviour of animals in the wild.'[10] He questions the effect that the blurring in these films between fact and fantasy may have had on the viewers' subsequent perception of wildlife. 'The emphasis in the True Lifes was on fun and entertainment above all else; perhaps many have come to expect this from nature and are disappointed when wild animals turn out to be shy, retiring creatures rather than amusing characters involved in fast-paced adventures. And there's not a story in sight.'[11]

BRUNO LILJEFORS (1860-1939).
Sea Eagle with Eider. Undated.
Oil on canvas. 1780 x 1310mm.
Liljefors was probably the first artist satisfactorily to depict flying birds. This large painting shows a sea eagle carrying a heavy duck.

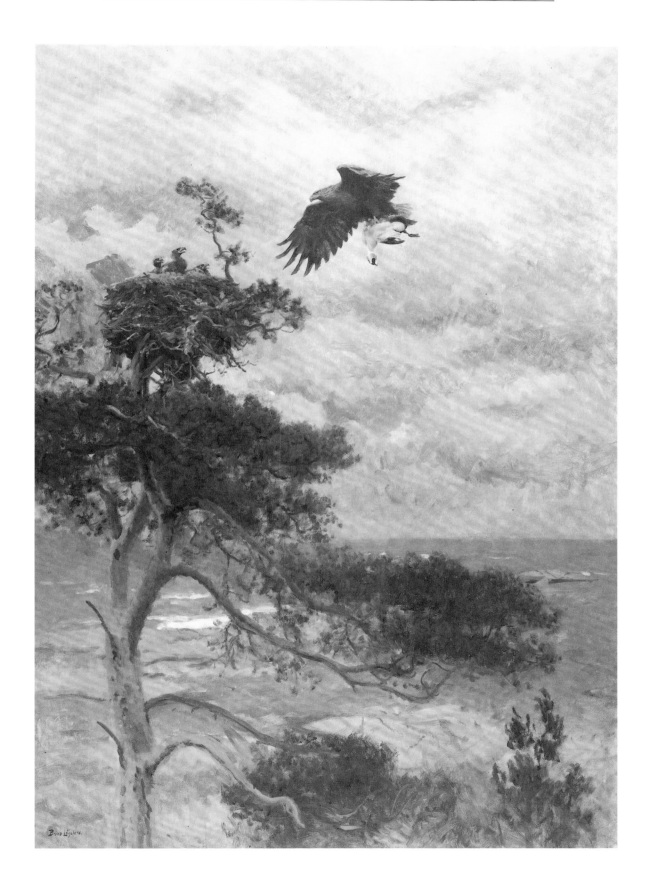

Some of the techniques used were controversial, and natural history film-makers still debate how far film-makers can go in interfering with nature for the sake of an exciting sequence. The True Lifes contained some of the most memorable movie sequences of the 1950s including the 'square-dancing scorpions', in which two scorpions locked in an embrace perform with perfection a square dance sequence. The symmetrical visual rhythm was achieved by shooting the two animals, placed on a hot plate covered in sand to make them dance. The footage was then printed first backwards then forwards over a dozen times. This meant that the sequence was as dishonest as it was inhumane, but might be justified by some on the grounds of the memorability of the sequence.

Hollywood has continued its intellectual grip on wildlife film-making. Bousé claims 'The huge and lucrative American market is so necessary to producers that it exerts a powerful influence on the final form they often take. The films tend, for example, to contain more *action* sequences, and to focus repeatedly on the same popular and "exciting" animals – *mega-fauna*, like lions, tigers, leopards, elephants, and sharks. This "colonialisation of taste" (what some would call *hegemony*) by the powerful American market also seems to mean that more Hollywood-style techniques find their way into natural history filmmaking.'[12] Bousé concludes that two distinct traditions of wildlife filming have emerged and he labels them '(if only for the purposes of schematic simplicity) the American and British models – though they are by no means geographically bound, and elements of each can be found in wildlife films from around the world.'[13] His American model tends to emphasise dramatic action, storytelling and the creation of 'animal characters' while the British tends to emphasise scientific research rather than narrative. The latter follows the dream of the French professor of natural history and motion picture pioneer, Etienne-Jules Marey, who wrote to the editor of *La Nature* in 1879 of people seeing on film 'animated zoology'. These models might be extended to modern wildlife art at least in so far as there is a recognisable strength of narrative in American painting and the Europeans tend to reflect a more scientific approach. However, Bousé has suggested that in wildlife film-making, which is now a global market-led industry, national or even continental differences are becoming blurred[14]. The art (or craft) of wildlife painting has greater opportunity for individualism, because unlike film-making it relies on the creativity of just one person. Of course, market forces, as has been observed, are far from absent and sometimes a team is involved and the artist's individuality is diminished by the involvement of publishers and printers, especially when the painter has been commissioned to paint so-called 'limited edition prints'.

Natural history filming found its mark in broadcast television, where it has made a huge contribution to creating images of nature. In the United States National Geographic Films led the way and were frequently shown on the public broadcasting service. In Great Britain, where wildlife had been covered as a subject during the early years of radio in the years between the wars, it was BBC Television which led the way, with Armand and Michaela Denis's *Animal Safari* programmes. It was, however, *Look*, presented by a wildlife artist, Peter Scott, which determined the way in which wildlife filming would go. It started in 1955 and was inevitably shown in black-and-white. Scott was a seasoned radio broadcaster. He had also made two films about geese, but his function on *Look* was as presenter and he used his skill as an artist to draw on-screen the subjects about which he was talking.

Scott was already a celebrity. His father was Captain Robert Falcon Scott, who died in Antarctica in 1911, the epitome of the British hero dying in a battle against the elements as he returned from the South Pole, and his mother was a celebrated sculptress, Kathleen Bruce. Although he was brought up in privileged surroundings that gave him introductions to influential people, he owed his success to his considerable and varied talents and his energy. His career began in the 1930s as a painter and it was then that he began to bring wildlife to the public attention. His first published pictures were 'rather simple watercolours of wild geese, reproduced in monochrome and accompanied by a bloodthirsty little article, of which I am not now very proud, describing my wildfowling adventures'[15] which appeared in *Country Life* in August 1929. While still at Cambridge he had exhibited between a dozen and twenty paintings at Bowes & Bowes bookshop, and he decided on going down from university in 1930 to become a full-time

painter. After studying at the State Academy School in Munich and the Royal Academy Schools in London, he had annual exhibitions of his paintings of wildfowl at Ackerman's Gallery in London's Bond Street from 1933 to 1939. These shows attracted the attention of high society, being opened by celebrities such as the novelists John Buchan and Hugh Walpole, and the historian G. M. Trevelyan, and attended by members of the Royal Family.

Fashionable though these London shows were, Scott's public acclaim stemmed from the mechanical prints of his paintings. Ackerman's published thirty-one limited editions in the decade before the Second World War. The Medici Society reproduced his painting, *Taking to Wing*, and sold a staggering 350,000 prints, which meant that the image of a flight of Shovelers and two Garganey was seen by large numbers of people who had never seen these birds in the wild. These prints publicised the romance and beauty of wildfowl in a hitherto unprecedented way. Although Archibald Thorburn (1860-1935) had achieved some success with production-line prints of his work, it was Scott who demonstrated that there was a large, popular market for prints of wildlife subjects. Few other artists in the United Kingdom have achieved Scott's success.

It was not only as a painter that Scott achieved fame. By the beginning of the Second World War he was a renowned dinghy sailor, having won a bronze medal for single-handed sailing in the 1936 Olympics and twice won the Prince of Wales Cup, dinghy racing's most prestigious trophy. In the Second World War he was decorated both for gallantry and for his contribution to the war effort in devising camouflage schemes for warships. On demobilisation from the Royal Naval Volunteer Reserve he began to paint ducks and geese again, took up broadcasting and in 1946 founded the Severn Wildfowl Trust (now the Wildfowl and Wetlands Trust) at Slimbridge, Gloucestershire.

It was scarcely surprising that when the BBC Natural History Unit was looking for a presenter for its first television programmes that it should have chosen Peter Scott. The acquisition of this multi-talented hero guaranteed an audience wider than just naturalists. Since the 1950s the techniques of wildlife film-making and presentation have improved a thousandfold. Presenters such as David Attenborough and David Suzuki have become household names and have introduced a huge general audience to a more realistic understanding of wildlife and its often less savoury habits.

While perceptions of wildlife have been affected by the images shown on television, these images can be grossly misleading. For example, the use of slow motion misleads and confuses viewers and the value-laden mood music which accompanies visual sequences forces the viewer into accepting the director's subjective judgements of an animal's power to evoke fear, dislike or saccharine sentimentality. The quality of the pictures may also mislead. Cameras are able to reach into places inaccessible to the human eye while lenses and lighting produce pin-sharp images that are far better than the viewer could obtain in the wild. Many viewers, especially children, are frustrated when they cannot find wild creatures as easily as the programmes lead one to suppose.

The invention of the video has also provided the wildlife artist with a useful but dangerous aid. Freeze-framing can give the artist the opportunity to check the ways in which animals move; but unless the technique is used with knowledge of the circumstances of the filming of the animal and the animal's life, the artist's lack of in-depth knowledge of the animal will produce a misleading picture. Nevertheless both moving and still photographic images can be a hugely useful source of reference; but paintings based on photographs often have a pristine quality and lack atmosphere. Used as *aides memoires* to record a moment in time the video is an invaluable tool.

Another technical development that provides both hazards and advantages has been the development of binoculars and telescopes. In the early years of the century field-glasses were crude compared with today's binoculars and, lacking detailed colour photographs, for details of plumage or fur artists had to resort to skins. High-quality binoculars with good light-gathering qualities and close focusing have been a huge help to artists, and telescopes with magnifications of up to 60 times can provide very fine detail over great distances. However, such large magnifications distort comparative sizes over distance. Parallax

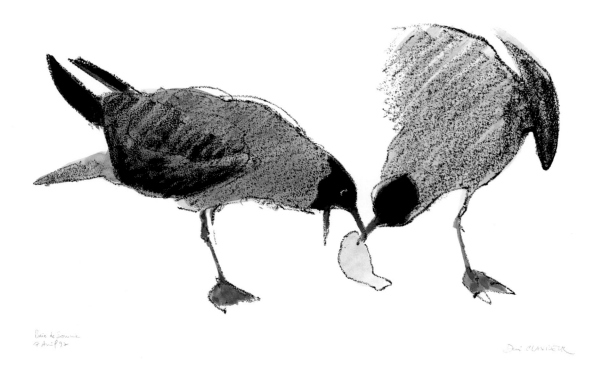

DENIS CLAVREUL (b. 1955).
Black-headed Gull. 1997.
Oil pastel and watercolour. 550 x 750mm.
Although some painters of the early twentieth
century did go into the field to sketch wildlife,
it has only been in recent years that the practice
has become much more widely practised. Clavreul
is one of the most skilled exponents of capturing
the essence of bird behaviour in the field.

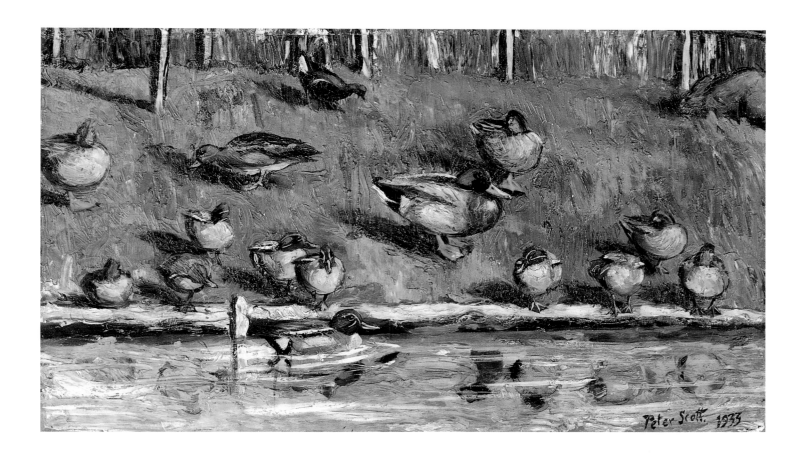

PETER SCOTT (1909-1989).
On the back landing of a pipe, Borough Fen Decoy.
1933.
Oil on board. 330 x 559mm.
Despite being in the 'pipe' of a decoy, a device designed to lead them to their deaths, these teal, mallard and wigeon loaf, sleep and rest without concern. In the background a moorhen bustles after food and a rabbit grazes.

can make some distant objects appear larger than a similarly sized object closer to the lens. If artists are not aware of this danger they can produce paintings of birds in which the relative sizes of different species are correct as seen through the telescope, but incorrect in reality. Before the 1970s and 1980s when telescopes became more widespread, artists often had difficulty in sorting out the relative size of animals, particularly when the animals were depicted in a landscape. Archibald Thorburn often got it wrong; Charles Tunnicliffe (1901-1979) usually got it right; and John Busby (b. 1928), who became fascinated with the relationship between the sizes of different species, especially those rarely seen together, almost always gets it right.

While wildlife artists in Europe tend towards the telescope and field sketching, North Americans prefer cameras. In an international gathering it is sometimes easy to sort out the Americans by their cameras with long-range lenses from the Europeans with their telescopes, tripods and sketchbooks. This is not an infallible rule and sometimes other field characters, such as the Americans' caps with earflaps or the Britons' Barbour jackets, have to be used.

Art historian Barbara Rose claims that nearly two centuries after independence from Great Britain North America was still an artistic colony of Europe. It was only after the Second World War when the United States emerged as the most powerful nation in the world that artists initiated a 'genuinely American style'[16]. Rose explains that it has been customary to discuss American art 'either as a separate entity, developed independently and divorced from the larger context of European art; or in terms derived directly from the study of European art'. Neither interpretation, she claims, places twentieth century American art in its proper perspective.[17] However, in terms of wildlife art a separate American tradition did develop in the last century and continued into the twentieth, although by the end of the century the European and American traditions of wildlife art appear to have converged.

Each of North America's two best-known nineteenth century ornithological artists were of recent European origin. The development of interest in birds in North America is described by Robert Henry Welker: '...by a happy accident, the coming of the nineteenth century coincided almost exactly with the arrivals in the United States of the man who was to be its first modern ornithologist, Alexander Wilson, and of John James Audubon, who was to be its most renowned. Towards the middle of the century, when the work of these two men had been completed, interest in birds divided and spread into various specialized phases of ornithological science, and into our finest nature literature. It also impinged upon new states and territories, new railroads, new surveys of resources – in short, it was involved in the westward movement of the young republic. Shortly it appeared in the realm of agricultural economics, and then in the gaudy domain of feminine fashion. By the end of the century, concern with birds had so broadened its base within the population that two national organizations for bird study and protection had been formed and were taking an increasing part in the new conservation movement, which reached its high point early in the twentieth century with the work of that devoted birdwatcher, Theodore Roosevelt.'[18]

Alexander Wilson was a Scottish weaver turned schoolteacher, who in the 1790s left Britain in the throes of a cruel Industrial Revolution. He published and illustrated *American Ornithology* (1808-1814). John James Audubon was born in 1785 in the south-west of the Caribbean island then known as Saint Domingue (Christopher Columbus's Hispaniola which is now Haiti and the Dominican Republic). He was christened Jean Jacques and educated in France. Although he later became an American hero, he had to go to Europe to publish his *Birds of America* and it was in the drawing-rooms of Edinburgh and London and in the *salons* of Paris that he first achieved celebrity. Audubon's watercolours, now on display at the New York Historical Society, were the basis for the large (double elephant) copper engravings initially made by William Lizars and then by Robert Havell and his son, Robert, that appeared in *The Birds of America* (1827-1838). The combination between Audubon and the Havells was fortunate. The design and painting of the plates was heavily influenced by Jacques Barraband and other contemporary French artists. Audubon, however, brought a freshness to his subjects except for those he copied from Wilson, although Audubon was a much more creative and consummate artist. Welker is specific in his definition

THOMAS BEWICK (1755-1828).
Bearded Tit. c.1800.
Wood engraving.
This Newcastle engraver has been described as the father of modern engraving and was capable of showing great subtlety of shading in his work. This delicate engraving is technically brilliant, but it betrays his lack of knowledge of the behaviour of this reedbed bird which is more usually seen in a vertical rather than a horizontal posture.

of Audubon as an artist, writing '..not merely artist as a manipulator of phrases or of pencil and paint, but artist as devotee of the creative, communicative act.'[19] Audubon was trained as an artist in the school of Jacques-Louis David, one of the leading artists of the Empire, and who, Audubon claimed, had guided his hand. His route to international renown as a painter of birds was not direct. It involved periods managing his father's estate in America and becoming a merchant in the 'frontier town' of Louisville, Kentucky, which Welker reminds us was in the early part of the nineteenth century perhaps more refined than the term suggests.[20] It was nevertheless the image of the frontiersman that Audubon emphasised when he visited Edinburgh, London and Paris in the late 1820s, having failed to find a publisher in Philadelphia or New York.

The publication of *The Birds of America* was a huge effort and would be just as remarkable today, if it were undertaken virtually single-handedly. The bald arithmetical sum of the book is 435 plates comprising 1,065 figures. Audubon generously paid tribute to the Havells, who worked on the book for twelve years, but it was he who found and painted the birds, supervised the engraving, oversaw the colouring, raised the bulk of the subscriptions and organised the financing of the project, which cost $100,000. It was heroic and for that alone Audubon deserves his status as a national hero and to be commemorated in the names of the National Audubon Society and the other Audubon societies.

The publication of *The Birds of America* was a result of international cooperation. Although the bulk of the work was Audubon's, the engravers, William Lizars and then the Havells, were British, as was William MacGillivray, the ornithologist who collaborated with the artist to produce the volumes of text that accompanied the portfolio. The work of John Gould and his team of European artists is often compared with Audubon, but although they were using the recently invented and more subtle printing process of lithography their work could not compare with Audubon. Writing in 1955, Robert Welker stated that no other Western bird art preceding Audubon can properly be compared with *The Birds of America* and suggested that it is doubtful that it has been matched since, but adding that it has been approached in Britain by John Gould and his associates and in the United States by Louis Agassiz Fuertes.[21] Perhaps readers will be able to decide from the artists whose work is presented here whether Welker is correct in his assertion that Audubon was unrivalled.

When on 20 June 1838 *The Birds of America* was completed much of the west of America had still to be settled. Many species were yet to be described. It must have been breathtakingly exciting for naturalists and artists. The artists of landscape and wildlife had much to celebrate, and animals play a large part in the landscapes of Albert Bierstadt (1830-1902), a German émigré who applied the Romantic style to painting dramatic natural scenes remote from northern Europe. However, there were exploratory forays as early as 1819 when Major Stephen H. Long led the first of three expeditions to the Rocky Mountains designed to discover more about the new continent's birds. Surveying for the Pacific coast railroad also led to surveys of birds and other animals. The first attempt to describe all the bird species of the mainland United States came as a result of this. Its chief editor, Spencer F. Bairn, assistant secretary of the Smithsonian Institution, listed 738 species of birds, compared with Wilson's 262 and Audubon's 506.

The first book devoted to the birds of an individual state was published in 1844. It was James E. DeKay's *Birds*[22] and was part of a survey of the natural features and resources of New York State. It is a very early example of an author and artist attempting to cope with the problems of field identification. J. W. Hill's illustrations are stiff and clearly the result of their being modelled on mounted specimens, but they are simple, bright schematic representations which, when used alongside DeKay's text, would have made identification simpler than any other book of that time.

Elliott Coues was a man whom Welker describes as more often irritating than ingratiating, but to whom he gives credit for a personality which 'helps relieve the general dead-levelness common to government publications'.[23] His books, *Birds of the Northwest* (1874) and *Birds of the Colorado Valley* (1878), were published by the United States Geological Survey of the territories. Government was most interested in the economic value of various species of birds and in 1885 a section of economic ornithology was established at the Department of Agriculture.

Dr Coues was to play an influential role in the development of the painting of birds in the States. Although he was no painter himself, he was the mentor of Louis Agassiz Fuertes, whom in November 1896 he introduced as a 22-year-old to the annual meeting of the American Ornithologists' Union at Cambridge, Mass. A few days later Coues wrote to his *protégé*, warning him not to let success turn his head, adding that no young man ever had a better opportunity.[24] Fuertes's biographer, Robert McCracken Peck, says 'Coues' warning was unnecessary for Fuertes' modesty and commitment to hard work were as much a part of his character as his ability to paint.'[25] The Audubon Society, through Frank M. Chapman, editor of *Bird Lore*, the Audubon Society magazine, was quick to use the work of the young Fuertes. Between 1904 until his death in 1927 he produced 70 paintings and drawings for publication in *Bird Lore*. Fuertes was to become the leading American bird painter of the first part of the twentieth century, making a name both as a scientific illustrator and a popular artist.

Scientists and popularisers were not clearly separated in the States. Coues wrote popular material, as did Frank Chapman. There were also two noteworthy women authors, Florence A. Merriam and Olive Thorn Miller, both of whom aimed much of their work at children. Fuertes, apparently commissioned as a result of his attendance at the AOU conference[26], contributed pen-and-ink drawings to Merriam's *A-Birding on a Bronco*. In a review in *The Nation*[27] Coues dismissed the text, suggesting that Merriam was revisiting ground already covered more than once by Olive Thorne Miller, but he extravagantly praised the illustrations by his *protégé* as 'better than Audubon's were to begin with'. This was one of the first instances in which a young artist was likened to the master. So widespread did this habit become during the twentieth century, especially from the keyboards of copywriters promoting galleries, that Charley Harper claimed in the 1980s that he was only American wildlife artist never to have been compared with Audubon.[28] Apart from their sharing a strong compositional sense there is indeed little other similarity between their work, as Harper specialises in witty, geometrical compositions, often based on a pun, but conveying a deeper message about wildlife and its conservation.

Towards the end of the last century and during the early years of the twentieth, conservation – or, as it was then known, protection – was championed by the popularisers. The scientists were endeavouring to make scientific and economic arguments for not destroying nature, and the philanthropists were campaigning against the wanton destruction of birds, particularly egrets and birds of paradise whose plumage was plundered to decorate ladies' hats. Protests began in the 1860s, and in the next two decades built to a crescendo. From a distance of more than 100 years it seems that it was women who most strongly championed the cause for bird protection, supported by male ornithologists and writers. The Audubon Society was founded in 1886; the Society for the Protection of Birds (later Royal Society for the Protection of Birds) in 1889 (although effectively it did not begin to function until 1892); the Deutscher Bund für Vogelschutz in Germany and Vogelsbescherming in The Netherlands in 1892.

The main protagonists of the anti-plumage movement came from the same social stratum as the women who decorated their hats and, for evening wear, their hair with feathers. Welker draws attention to the list of vice-presidents of the early Massachusetts Audubon Society. They were Charles Francis Adams, a writer who had been president of the Union Pacific Railroad, Mrs Louis Agassiz, founder and president of Redcliffe College, Mrs Julia J. Irvine, president of Wellesley, and Senator George F. Hoar. He adds: 'A goodly representation of what has been called Proper Boston – which broadly includes Proper Brookline and Proper Milton – may be discovered on the list of founders.'[29]

Similarly, the RSPB at the turn of the century recruited from *Debrett* the social and *Crockford's* the clerical register. Their council included the bishops of London and Durham, the Marquis of Granby, the Earl of Jersey, the Earl and Countess of Stanford, Viscount Wolsey, Lord Overtoun, the MPs Sir Edward Grey (later Lord Grey of Fallodon) and Sir Herbert Maxwell, Professor Cunningham, Alfred Austin the Poet Laureate, and Canons Jessop, Lyttelton and Tristram.

The newly formed conservation groups were quick to see the potential of the work of wildlife artists, and the Society for the Protection of Birds in 1898 commissioned a painting by Archibald Thorburn for

its first Christmas card. Thorburn's main market lay among the landed gentry and aristocracy, who showed an insatiable appetite for his watercolours of gamebirds and stags. That he was also working for the RSPB is a demonstration of the skilful way in which the Society managed (and continues to manage) to tread the tightrope between the shooting and the anti-blood sports lobby.

At first the prime concern of the conservationists was to end the plumage trade and much of the artwork they commissioned or were given featured the species that were its victims. The Roseate Terns portrayed by Thorburn in the RSPB's first Christmas card belonged to the group of birds in the British Isles most vulnerable to the plumage trade. J. G. Keulemans painted a monochrome oil painting of a Great White Egret in breeding plumage. It was egrets that particularly concerned the protectionists. Their hunting required the killing of breeding birds (for their decoratively plumed scapulars) which often led to the abandonment of the nestlings. The plumage trade was immensely profitable. Its centre was London, where before 1921 annual sales of bird of paradise feathers exceeded £100,000.[30] High prices were charged for the plumes, the costs of which were incurred in the hunting, preserving and transport.

The plumage trade fought hard against the protectionists, in defence of their profitable business. One firm in London built up stocks of £100,000 worth of feathers in the six months before the 1921 plumage legislation became law in the United Kingdom.[31] Hunters, too, were threatened with the loss of a profitable and relatively easy source of income. In 1905 Guy M. Bradley, an Audubon warden, was murdered by a plume hunter at Oyster Key, Florida. Presumably the resulting public revulsion must have helped to change public attitudes.

In the first few years of the century thirty-three American states and the federal government enacted anti-plume trade legislation and the Audubon movement was aided by a powerful friend in President Theodore Roosevelt, whose commitment to nature and conservation gave the movement in the States tremendous encouragement. Welker wrote '...the twentieth century was scarcely a decade old before the cause of bird protection had triumphed in its first great test.' But he was referring to the United States. Victory was slower coming to Europe. Would the victory have been achieved at all had not fashion changed during World War I?

Even before the plumage fight was settled the protectionists had begun to tackle new problems – deliberate killing of birds, illegal trapping, habitat protection and pollution, as the first globs of oil came ashore from ships sunk during World War I. As they began to engage in these battles the protectionists discovered the power of artists to help them to put their points across.

Increasing affluence led the middle classes away from urban centres into leafy suburbs where they had gardens. At their leisure they took walks, cycle rides or motor-car drives into the nearest countryside, where they sought to reclaim the paradise that had been the countryside of Gilbert White's *The Natural History of Selborne*. In his biography of White, Richard Mabey describes the book as an institution that 'has become part of that curious concoction of ideas and artefacts which are seen as somehow defining the English way of life.'[32] He adds 'It is, apocryphally, the fourth most frequently published book in the language. When English settlers emigrated to the colonies in the last century, *Selborne* was packed alongside the family Bibles and sprigs of heather. It is hard to think of another book that could have brought together so many disparate voices to pay their respects'. Coleridge, Darwin, Virginia Woolf, Constable, Edward Thomas and James Fisher are then listed among his admirers. So seeking the suburban re-creation of White's countryside Englishmen began to show the buds of an interest in nature that bloomed in the second half of the century. By then the realisation dawned (never swiftly enough) that the white heat of technology forged on the back of the Second World War was in reality destroying our environment.

Post-war interest in the British countryside had also been stimulated by books. Authors such as William Beach Thomas and H. E. Bates, whose books were illustrated with wood engravings by Charles Tunnicliffe (1901-1979) and Agnes Miller Parker (1895-1980), promoted a rural idyll. This was part of the propaganda of ruralism, created by the moving images in war-time feature films and documentaries. Town dwellers in the armed forces were introduced to the country for the first time, as were many of the evacuees from the

JOSEPH WOLF (1820-99).
Great Bustard.
Watercolour. 378 x 559mm.
Of all the artists who worked for John Gould,
Joseph Wolf was the most accomplished. This is
a watercolour on which the lithograph of Great
Bustard for *Birds of Europe* was based.

bombed cities of England. Book publishing too played a part. One of the new Penguin imprints was Puffin Books for children. Puffin Picture Books published a series of paperbacks, profusely illustrated by artists such as R. B. Talbot Kelly (1896-1971), Tunnicliffe, Eric Ennion (1900-1981) and Paxton Chadwick (1903-1961). Talbot Kelly and Chadwick also illustrated King Penguins, which were cheaply produced coloured picture books for adults. These inexpensive, expertly written and beautifully illustrated books were very popular.

In North America an interest in the great outdoors was awakening. Increasing numbers of people sought to watch and conserve wildlife. While Fuertes had done much to increase the understanding of wildlife in the early part of the century, he was to die when he was only 53, killed by a train on a railroad crossing at Unadilla, New York, as he returned from a visit to Frank Chapman. In the car with him were his wife and a collection of sketches that he had made the year before in Abyssinia. Neither his wife nor his paintings were harmed. His place as the most influential bird artist in North America would soon be taken by the young Roger Tory Peterson (1908-1996).

Thirty years after Fuertes' career began with his attendance at the American Ornithologists' Union meeting, the 17-year-old Peterson made the 400-mile journey from Jamestown, New York, to New York City. There he met Francis Lee Jaques, the great but still under-rated wildlife artist, and Fuertes himself. The great man spared the 17-year-old the time to look at his paintings and gave him a sable brush, which Peterson treasured as a keepsake but never used. He also invited the young artist to send him some work for consideration and comment, but Peterson delayed 'until they were worth his while', by which time Fuertes was dead.

There were two directions Peterson might have taken. One was to read biology at Cornell University and the other was art school. If he had been able to afford to take the first course, we might never had the Peterson System that revolutionised the presentation of field identification and consequently the interest in nature that resulted from the public's discovery that identification of animals was not as difficult as they had thought. 'Had I gone to Cornell, I would probably have become more traditional,' Peterson said in 1973[33]. 'I think my ornithology would have been better for the simple reason that some of my blind spots wouldn't exist.' However, he recognised the value of having gone to art school: 'My primary contribution – field recognition – could not have been made had I followed the traditional path as a biologist. Because of my art background I approached things visually rather than phylogenetically, hence the Peterson field guide system was born.'

Illustrated magazines have done much to popularise nature. In the United States specialised magazines such as *Field & Stream*, *Nature Magazine* and the *National Geographic*, as well as general magazines such as *Life*, *Sports Illustrated* and *Saturday Evening Post*, published the work of wildlife artists such Peterson, Don R. Eckelberry (b. 1921), Arthur Singer (1917-1990) and Guy Coheleach (b. 1933). Specialist magazines such as *Audubon* (successor to *Bird Lore*), *National Wildlife* and, in Britain, the RSPB magazine, *Birds*, all promoted the cause of wildlife painting from the 1960s to the 1980s.

Seeking opportunities to exhibit their work and provide a meeting place for fellow artists, a group of artists in Great Britain, led by Eric Ennion (1900-1981) and Robert Gillmor (b. 1936), founded the Society of Wildlife Artists in 1964. Four years later the Society of Animal Artists was founded in North America. Both these two run annual shows and provide a showplace for wildlife art. A similar society has been founded in Australia.

Although there have been commercial galleries devoted to wildlife art on both sides of the Atlantic since the 1950s, it was not until the 1970s that museums were founded to exhibit wildlife art. In England, Dr David Trapnell created the Society for Wildlife Art for the Nations and founded a gallery, *Nature in Art*, in 1979 at Wallsworth Hall in Gloucestershire. In the States in 1976 the Leigh Yawkey Woodson Art Museum was founded in Wausau, Wisconsin, thanks to generous charitable donations by the Forester family, particularly Alice Woodson Forester. Each year the museum mounts an open *Birds in Art* exhibition which attracts entries from across the world and is judged by a different jury each year. The contents of the exhibition change and develop each year, with the most recent exhibitions showing a variety of styles

LOUIS AGASSIZ FUERTES (1874-1927).
Brewer's Blackbird. c. 1914.
Watercolour. 279 x 381mm.
Bird protectionists in the early twentieth century
were keen to communicate the beneficial effects
of birds as destroyers of harmful invertebrates.

and subjects. In May 1987 the National Museum of Wildlife Art opened to the public at Jackson Hole, Wyoming. It now has fourteen galleries, of which six are dedicated to travelling exhibits. Housed in a purpose-built edifice overlooking the National Elk Refuge, it is well-placed for visitors to the famous Grand Teton and Yellowstone National Parks.

The United States also has a wildlife art magazine, *Wildlife Art*, which was founded as *Wildlife Art News* in 1981. It relies on the advertising revenue from commercially produced mechanical prints. The print market appears to have diminished towards the end of the century and the magazine has been moving into a more international field and into original art.

Recognition that artists did have a role to play in conservation has seen some exciting art and conservation projects in North America and elsewhere. To draw attention to the plight of Pacific temperate rain forests, a group of Canadian artists painted the forest with the support of artists of the calibre of Robert Bateman (b. 1930). Bateman has also been involved with the Artists for Nature Foundation, founded in 1990 by Ysbrand Brouwers, Robin D'Arcy Shillcock and Erik van Ommen. ANF organises expeditions to threatened areas and then publishes books and mounts exhibitions to create public interest in them. This is a powerful forum for artists of different nationalities in which to exchange ideas, and draws landscape and wildlife artists out of the ghetto that they have created for themselves.

When a group of wildlife artists is gathered together discussion soon turns to the question of how they can make art critics take their art seriously. To some extent the critic's dismissal of wildlife painting as 'genre painting' is of the artists' own making. They protest the need for understanding of their subjects and scientific faith in pursuing their art. Perhaps they should be concentrating in their paintings on the truth of their feelings and then on the truth of their science. What would John Ruskin have made of modern wildlife painters? He was caustic about Canaletto and it is not difficult to imagine substituting 'wildlife' for 'Venice' and 'fur and feather' for 'bricks and mortar' in the following passage. Having poured scorn on the formulaic nature of the Venetian's brick-by-brick rendering of buildings, he writes:

> And this is what people call "painting nature"! It is, indeed, painting nature – as she appears to the most unfeeling and untaught of mankind. The bargeman and the bricklayer probably see no more of Venice than Canaletti [*sic*] gives – heaps of bricks and mortar, with water between – and are just as capable of appreciating the facts of sunlight and shadow, by which he deceives us, as the most educated of us all. But what more is there in Venice than brick and stone – what there is of mystery and death, and memory and beauty – what there is to be learned or lamented, to be loved or wept – we look for to Canaletti in vain.[34]

The best of modern wildlife painters show us the mystery and death, memory and beauty and show us what is to be learned or lamented, loved or wept for. There are paintings reproduced in the succeeding pages of which Ruskin would have approved.

CHARLES TUNNICLIFFE (1901-1979).
Redwings in Winter. 1948.
Watercolour and bodycolour. 460 x 290mm.
Exhibited at the Royal Academy in 1948, this painting was used as a Christmas card by the RSPB in the same year. For over 20 years Charles Tunnicliffe was the sole artist used for RSPB Christmas cards. Large numbers of his cards in houses throughout the United Kingdom must have contributed towards the growth of the Society's membership, which began to accelerate during the 1960s.

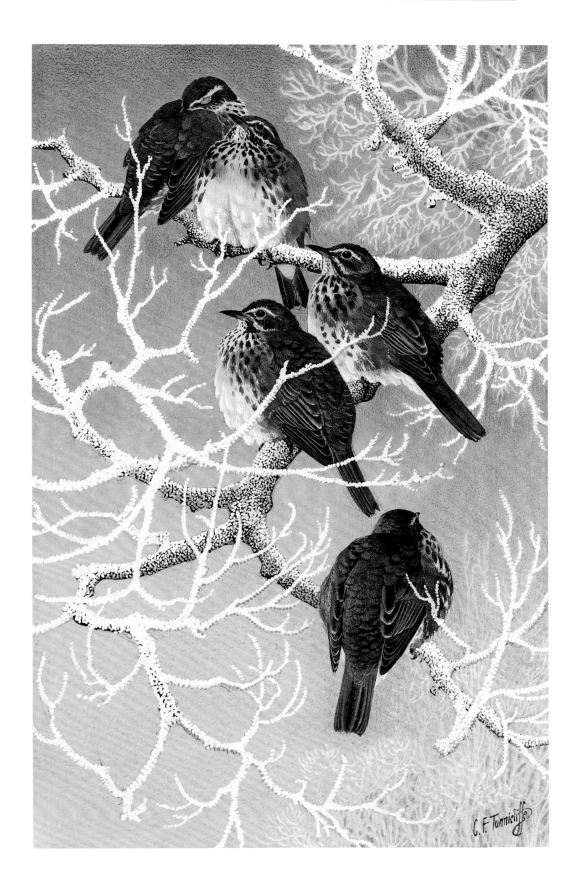

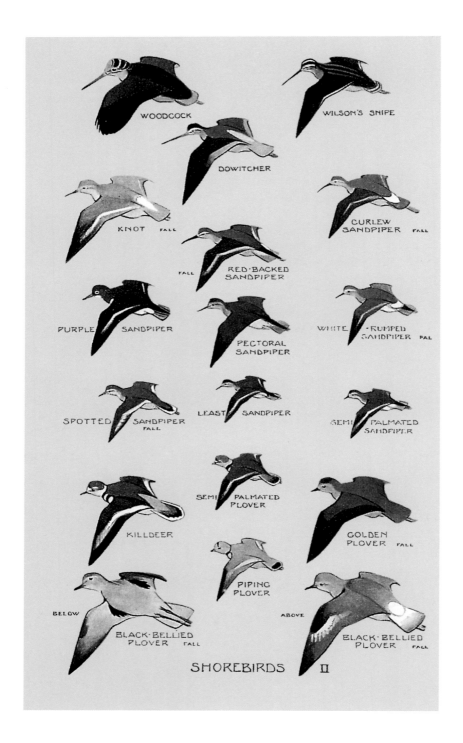

NOTES AND REFERENCES

1 Ruskin, J. (1851-3) *The Stones of Venice*. London, Vol. I, Ch. 2, p.17.

2 Ormond, R. (1981) *Sir Edwin Landseer*. Thames & Hudson, London, pp.134-5 and 141.

3 *The Swannery Invaded by Eagles*, 1869. Oil on canvas. 175 x 270 mm.

4 Ormond (1981) p.215.

5 Ruskin, J. (1843-1860) *Modern Painters*. Smith Elder, London, Vol II, p.46.

6 Christie's *Wildlife Art* catalogue, 3 June 1994, pp.98-9.

7 Hamilton, V. (1990) *Joseph Crawhall 1861-1913: One of the Glasgow Boys*. John Murray/Glasgow Museums and Art Galleries, p.129.

8 *Genesis* 1, 26.

9 Ritvo, H. (1990) *The Animal Estate: The English and Other Creatures in the Victorian Age*. Penguin, London, p.5.

10 Bousé, D. (1995) True life fantasies: storytelling traditions in animated features and wildlife films. *Animation Journal* 3:2 (Spring): 19-39.

11 Bousé (1995).

12 Bousé, D. *in litt.*

13 Bousé, D. *in litt.*

14 Bousé, D. (1997) What is a wildlife film? *EBU Diffusion*, Summer, pp.2-4.

15 Scott, P. (1961) *The Eye of the Wind: an Autobiography*. Hodder & Stoughton, London, p.120.

16 Rose, B. (1967) *American Art since 1900: a Critical History*. Thames & Hudson, London, p.11.

17 Rose (1967), p.7.

18 Welker, R. H. (1955) *Birds and Men: American Birds in Science, Art, Literature, and Conservation, 1800-1900*. Harvard University Press, Boston, p.5.

19 Welker (1955) p.59.

20 Welker (1955) p.61.

21 Welker (1955) p.72.

22 DeKay, J. (1844) *Zoology of New York*. Part II: Birds. Albany.

23 DeKay (1844) p.173.

24 Letter of 21 November 1896, Olin Library, Cornell University.

25 Peck, R. M. (1982) *A Celebration of Birds: The Life and Art of Louis Agassiz Fuertes*. Academy of Natural Sciences, Philadelphia, p.2.

26 Peck (1982) p.8.

27 c. 1896.

28 Hammond, N. (1986) *Twentieth Century Wildlife Artists*. Croom Helm, London, p.100.

29 Welker (1955) p.207

30 Russell, Mrs R. (1955) The plumage trade. *Bird Notes* 26: 162-166.

31 Russell (1955).

32 Mabey, R. (1986) *Gilbert White: A Biography of the Naturalist and Author of The Natural History of Selborne*. Century Hutchinson, London, p.6.

33 Devlin, J. C. and Naismith, G. (1977) *The World of Roger Tory Peterson*. Times Books, New York, p.31.

34 Ruskin, J. (1843-1860) *Modern Painters*. Smith Elder, London, Vol. I, Part II, Sec. I, Ch. VII, p.7.

ROGER TORY PETERSON (1908-1996).
Shorebirds II. 1934.
From *A Field Guide to the Birds*. Houghton Mifflin. Perhaps the single most seminal event in creating an interest in birds and wildlife was the publication of Peterson's field guide, which led to a completely new genre of book.

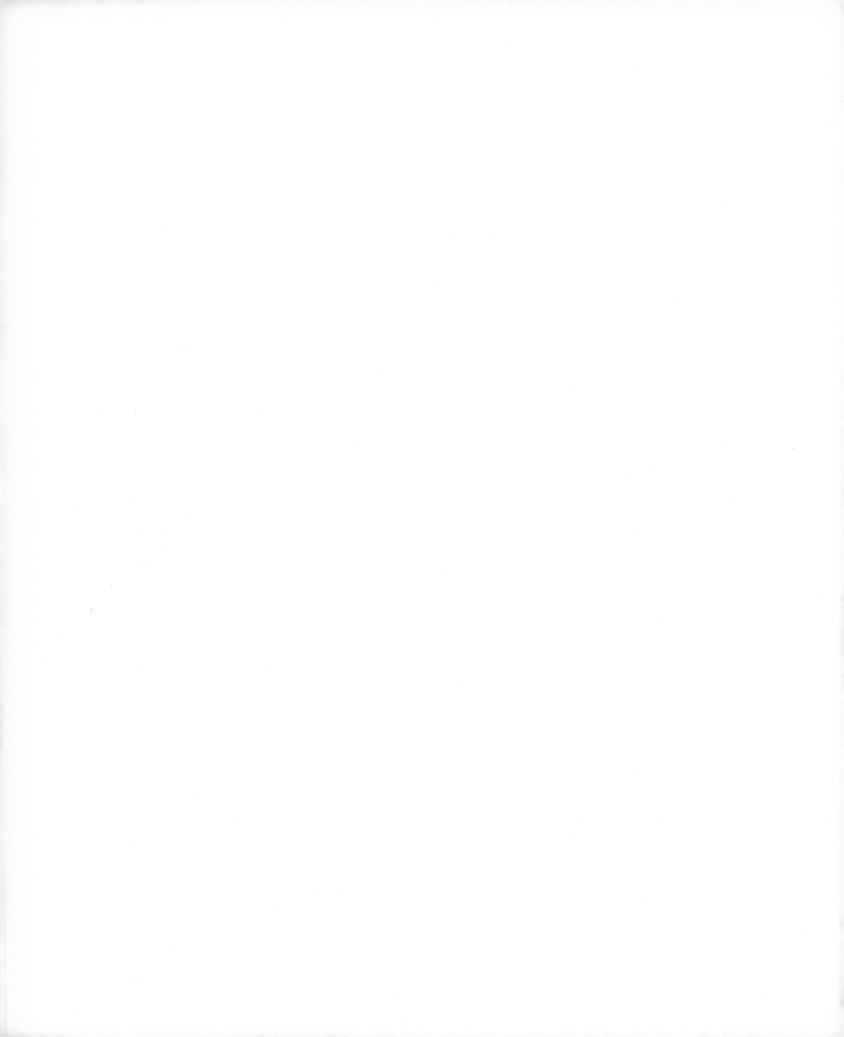

BRUNO LILJEFORS
AND THE GREAT OUTDOORS

*Organic life, especially the animal, is the apex of creation
and movement is the highest expression of natural life.*

Bruno Liljefors[1]

Face pressed into the mud of Flanders, Richard Talbot Kelly (1896-1971) learned what it must feel like to be an animal living close to the earth. His experiences as an artillery officer in the First World War gave him an empathy with nature.[2] Without that he might never have been as good a painter of wildlife. The experience of the mud and blood of a dreadful war, the feeling of being hunted, is one way of getting close to nature. Another way is to be the hunter.

There is an argument, put forward by people in defence of hunting, that it is hunters who are the true nature conservationists and that they possess an understanding of their quarry from which others, even trained biologists or country lovers, are excluded. The successful hunter must in truth have learned to think like his quarry. However, there are many field sportsmen whose outpourings about nature are demonstrably wrong-headed, especially as regards predator-prey relationships. However, one hunter who really did understand his quarry was Bruno Liljefors (1860-1939).

Liljefors is the most important and probably the most influential wildlife painter of both the nineteenth and twentieth centuries. He was a keen hunter all his life: undoubtedly it was the many hours that he spent in the field that gave him the understanding of animals and their place in the environment and enhanced to such an extent his genius as a painter of wildlife. As a hunter he was a predator and he seemed to have a particular interest in predator-prey relationships. 'Liljefors had a special fondness for portraying predator-prey action, such as Fox-Hare, Golden Eagle-Hare, Sea Eagle-Eider, Eagle Owl-Black Grouse and Goshawk-Black Grouse,' wrote Dr Gustav A. Swanson. 'One feels that Liljefors saw these events often, and that his portrayals are true to life...When the bird or mammal, at a distance, is portrayed as seen, the effects of light and shadow blur details, but the total effect is convincing. The viewer feels that he, too was there.'[3]

So high is the regard in which Liljefors is held among painters of wildlife and critics of their work that it is surprising that comparatively few people outside Sweden know of his work. Martha Hill suggests that the reasons for this may be that historically the painting of animals and plants was the province of science rather than art, because before the invention of photography, artists were employed to document exploration. She adds: 'While it is true we have a surfeit of mediocre animal paintings today, most of them based on photographs rather than animals in the wild, there are still great painters of animals whose work deserves recognition.'[4]

The greatness of Liljefors's work lies in his ability to show animals as a part of their environment. It is this link, perhaps an extension of a pantheism in which each species partakes of the spirit of the place it inhabits, that distinguishes the best paintings of wildlife. Liljefors the hunter was the friend of both poachers and landowners. He recalled the experience of a respectable hunting friend, who when trespassing with a poacher found himself hiding and creeping through bushes terrified of discovery. The experience gave this man an understanding of what it is like to be hunted, in a less drastic way than Talbot Kelly's experience on the Western Front. In his many hours in the field Liljefors saw prey being taken many times and his depictions are powerful, but he painted the action between predator and prey without exaggerating the ferocity of the predator or sentimentalising the plight of the prey. Whether these were always successful is debatable: there is a large oil reproduced in Hill's book[5] in which a Pine Marten is

attacking a Capercaillie. The position of the marten is visually uncomfortable. It appears to be propped on a branch, its front paws clinging to the cock Capercaillie with its hind claws flailing the air.

Although in the main Liljefors's work is based on his experiences in the field and on field sketches, he also used other sources of reference. His *Hawk and Black Game,* which was painted in the winter of 1883/4 and was the first of his paintings to be accepted by the Paris Salon, was based on dead specimens of a Goshawk and Black Grouse as well as the artist's personal experience of the birds. His original inspiration arose from his experience while he was living in a farm cottage in the village of Ehrentuna near Uppsala. Large numbers of Black Grouse came to a meadow to feed on newly sprouted oats and the visit of a Goshawk inspired the painting.

'The hawk model – a young one – I killed myself,' the artist wrote in 1921. 'Everything was painted out-of-doors as was usually done in those days. It was a great deal of work trying to position the dead hawk and the grouse among the bushes that I bent in such a way as to make it seem lively, although the whole thing was in actuality a still life.'[6]

'Still' is far from apposite as a description of a painting so full of action. Its success must stem from Liljefors's ability to remember what he had seen in the field. Indeed he would frequently prop up dead animals in the snow to see how the shadows would fall.

The effects of light are a strong element in his paintings. As a hunter he was used to roaming through the countryside at twilight. Many of his paintings feature animals at dawn and dusk. The light is handled with great delicacy: he appears to be fully aware of the risk of overdramatising the effects of light and shade, but he does not shy away from the dramatic opportunity. During the last decade of the nineteenth century there was a brooding quality to his work, which Hill suggests could have been a reflection of the turmoil of his life. He had left his wife, Anna, and taken up with her younger sister, Signe; he was short of cash and he was anxious because at that time he was regarded primarily as a caricaturist. This brooding quality eventually began to attract interest in his work. In 1895 he painted a large canvas (1660 x 1910mm) entitled *Owl Deep in the Forest.* The subject is an eagle owl which was perceived by the critics as a symbol of Swedish nature. Liljefors gained a reputation as a visionary in a country whose intellectuals had embraced the romantic nationalism of Nietzsche.[7]

Liljefors's influences were primarily visual. The French Impressionists and the Swedish artists, foremost amongst whom was Carl Larsson, who worked at Gréz-sur-Longy near Fontainebleau, were leading amongst them. Like the Frenchmen Dégas and Manet, he had studied and absorbed Japanese art and this shows in his paintings of the 1880s and 1890s. Hill quotes Russow's suggestion that it was superficial to claim that he had taken the Japanese for his model: it was 'only their indigenous sense of beauty which often makes them choose the same incidents for their pictures.' But the artist's daughter, Kraka Lundegårdh, in 1987, contradicted this view.[8]

By the end of the nineteenth century Liljefors became aware of Art Nouveau and this is obvious in his famous 1901 oil painting of mallards. The painting is entitled *Evening, Wild Ducks.* It shows three ducks, back-lit by the fast-disappearing sun, dabbling in golden water, whose surface is a swirling pattern of shadowy ripples. The painting has been given the soubriquet *Panterfällen* or *Leopardskin.* As a hunter, Liljefors spent many hours in the countryside at twilight and he was skilful at recreating the quality of the light.

From an early age Liljefors was fascinated by the early morning display of the Capercaillie. Ellenius suggests that he was inspired by the hunters who bought gunpowder from his father's store and that the Capercaillie had been a motif introduced to Sweden by the court painter David Klöcker Ehrenstrahl (1628-1698).[9] Ellenius also suggests that the large 1888 painting of a Capercaillie lek, now in the Gothenburg Museum of Art, was painted in the forest. 'Rocky slabs, lichen and pine trunks detach themselves from the forest gloom and seem to confirm the idea that the painter carried his canvas into the forest in the early dawn light in order to be able to study the changes of light in the typical Capercaillie habitat. The display and the place are perceived as a totality.'[10] The subtlety of the colours combined with

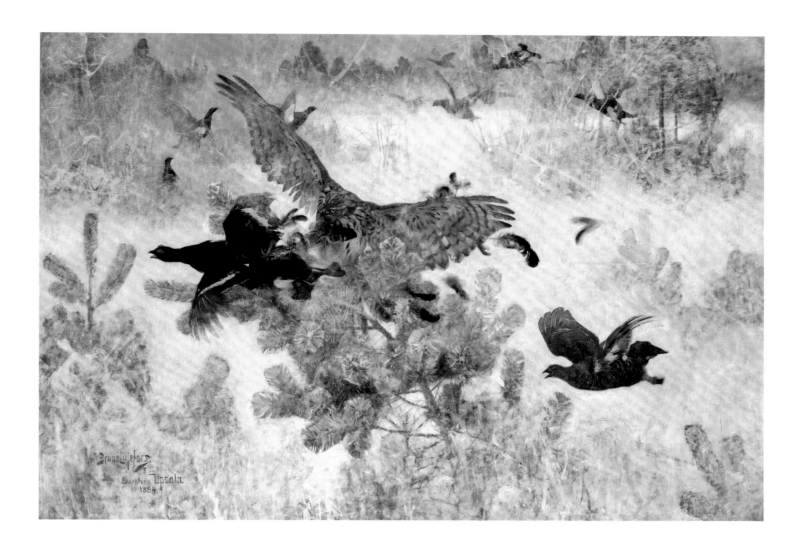

BRUNO LILJEFORS (1860-1939).
Goshawk and Black Game. 1884.
Oil on canvas. 1430 x 2030mm.
This is an example of the artist's ability to catch
the drama of a predator's encounter with prey.
He had witnessed such a scene, but to perfect
the composition he used shot specimens rigged
up in position.

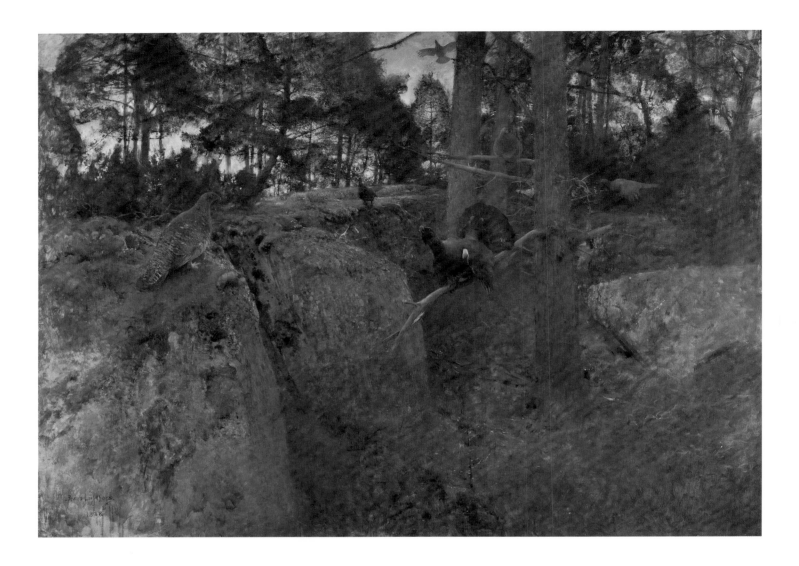

BRUNO LILJEFORS (1860-1939).
Capercaillie Lek. 1888.
Oil on canvas. 1430 x 1990mm.
The display of the capercaillie was a subject to which Liljefors returned frequently, but this large painting is perhaps the one in which he best captures the atmosphere of the forest at dawn. However, to show the birds as anything more substantial than silhouettes he had to assume a source of light in front of the birds, as well as the rising sun behind the trees.

BRUNO LILJEFORS (1860-1939).
Mallards, Evening ('Panterfällen') 1901.
Oil on canvas. 920 x 1930mm.
The strange effects of light at dusk lend themselves to abstraction. This painting can be read as an abstract or as a naturalistic painting in which the ducks can be seen by their shape to be mallards. The pattern of the low sunlight on the water is rendered like the skin of a leopard, hence the Swedish nickname, 'Panterfällen'.

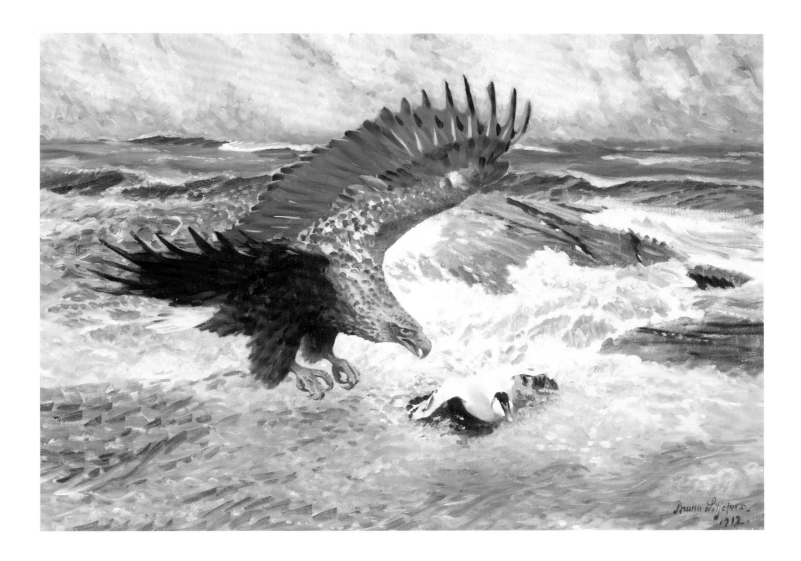

BRUNO LILJEFORS (1860-1939).
Goldfinches. Probably late 1880s.
Oil with gold and silver paint on canvas.
855 x 260mm.
The composition and limited palette of this painting seems to be evidence of Liljefors having been influenced by the work of Japanese artists. The naturalistic approach of the French Impressionists is shown by the positions of the bodies of the goldfinches. Most of his contemporaries would have avoided positions in which the heads of the birds were not visible.

BRUNO LILJEFORS (1860-1939).
Sea Eagle and Eider. 1912.
Oil on canvas. 950 x 1320mm.
Bright sunlight and the sea foaming over a reef add to the movement of the descending eagle and the eider, doomed to be caught before it manages to get airborne. Liljefors painted sea eagles hunting eiders several times, and also a pair of sea eagles attacking a Black-throated Diver.

the light and shade to create an atmosphere in which the dawn sounds of the pine forest can almost be heard and the scents be smelled. The painting succeeds wonderfully when it could have so easily degenerated into romantic make-believe.

Patterns of nature fascinated Liljefors. He loved the earth colours, browns, ochres and greys that are so vital to the survival of animals. These are the colours of camouflage, whose combinations of shades and tones may be the thing that saves an individual's life. Liljefors loved painting the subtle patterns of Greyhens or female Capercaillies against the rusts and browns of autumn woodland, and Mallard ducks, Redshanks, Curlews or Snipes against the sere colours of winter marshland. Perhaps the only other artist to achieve the same effect was Abbott Thayer (1849-1921), who tried to persuade the young Louis Agassiz Fuertes to paint animals as part of the landscape.

One of the strengths of Liljefors's painting is his composition. Although he put considerable thought and effort into this, arranging carcases to obtain the maximum impact and to study the effects of shadows, his paintings never seem contrived. He was skilful in his use of space to convey the fleeting nature of seeing wild animals. Eiders slip into the water from rocks and swim towards the edge of the frame; a Curlew on the left of another painting looks across the canvas as if it might be about to fly off. In *Duckling Brood*, painted in 1901, a Mallard leads her brood into a marsh from a pool still bright against the darkening dusk.[11] All the interest lies in the bottom left quarter of the painting and in the picture, just as in nature, the viewer sees more in the scene the more one looks. *Fox Cubs*, also painted in 1901, has a similar quality. At first the painting looks like a landscape with a watery new moon in the top right corner and a young fox at the mouth of its den. Then one's eye catches another cub in the shadows, and another, and another, and another.

Liljefors' absorption in his subjects went beyond painting them, hunting them and sharing their environment. He kept a menagerie of animals to act as living models. Ernst Malmberg writing in 1942 recalled his affinity for animals:

> The animals seemed to have an instinctive trust and actual attraction to him. It never impressed more than the time Albert Engström and I made our first visit to Kvarnbo. There in his animal enclosure, we saw his inevitable power over its many residents – foxes, badgers, hares, squirrels, weasels, an eagle, Eagle Owl, hawk, Capercaillie and Black Game.[12]

Undoubtedly the proximity of these animals helped Liljefors to appreciate their characters, postures and details of their physiology. He would not have regarded the use of captive animals as cheating, because he had an understanding and knowledge of their lives in the wild and was using the captive specimens as additional sources of information.

He had no inhibitions provided that what he was doing was the means to better wildlife painting. He appears to have used a stuffed specimen in his paintings of Capercaillie leks, a favourite subject. Allan Ellenius, in the book he wrote to accompany the 1996/7 exhibition of Liljefors's work, draws attention to the similarity of the composition of an 1885 painting of Capercaillies with one that Thorburn painted after Joseph Wolf.[13] Each of these features a male with lowered wings. In a photograph of a room at his house Wigwam, which has been reproduced in Martha Hill's book on the artist, above the fireplace there is a stuffed Capercaillie in the same posture. He used binoculars (and remarked in a letter to his fellow artist, Anders Zorn, that the Goshawk and Black Game painting exhibited at the Paris salon was hung so high that binoculars were needed to see it). At Bullerö, an archipelago of 365 islets, which he bought in 1908 after he had achieved financial stability, he mounted a pair of powerful Zeiss binoculars in the studio to watch the waders, ducks and seabirds on the shoreline. There is, however, no clue in his paintings that he was viewing his subjects through optical equipment such as is betrayed in the work of some modern painters.

Photographs, an all-too-obvious snare for artists, were not a problem for Liljefors. A keen cameraman, he built a large collection of photographs for use as reference material and to help him select images to paint. His photographs were all black-and-white and the inadequacies of cameras and filmstock in the

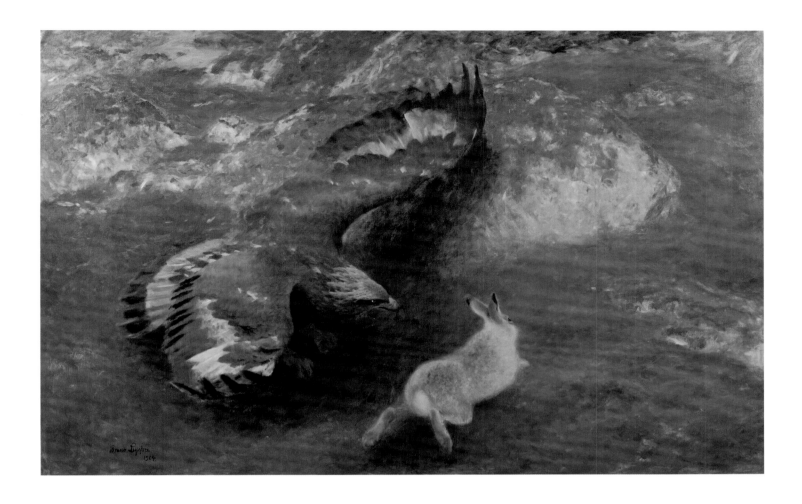

BRUNO LILJEFORS (1860-1939).
Golden Eagle and Hare. 1904.
Oil on canvas. 1500 x 2350mm.
One of the most celebrated of Liljefors' images of predator/prey relationships, but criticised by some because the positions of the primaries on the left wing and the position of the feet are incorrect. On the other hand it is a very dramatic demonstration of the Golden Eagle's technique of hunting close to the ground to flush hares.

early part of the century meant that many of the images were blurred or fuzzy. This did not worry him: indeed, he welcomed the blurred images because they made him concentrate on the shapes rather than the details. Where he liked the composition of a photograph he would draw a grid over it and transfer it to his canvas, sometimes altering the details.

His *Golden Eagle Chasing a Hare*, painted in 1904, shows the flying eagle and the fleeing hare the image of which was quite beyond the scope of the cameras of the day. Russow proposes that the artist was quite correct in his representation of the position of the eagle's wings and tail.[14] As an artist who spent many hours in the field Liljefors had often seen eagles hunting hares and with his retentive memory it was argued that he had painted the aerodynamics correctly. The hare has been flushed by the eagle, an immature bird with a white tail band, flying low enough for its wings to skim the ground vegetation. The outcome of the encounter is not certain. The hare almost certainly knows the terrain better than the eagle and is jinking. To have a chance of catching its prey the bird must turn and is beginning to do so, its first and second primaries on the left wing have turned, the third and fourth are quivering, blurred shadows, while the secondaries on the right wing are slanted to spill air. Ellenius quotes an analysis by Lars Jonsson, which 'weighs the impression of an instantaneous impression against a "heraldisation" of the drama and thereby a deviation from naturalism.'[15]

With the accompanying line drawing Jonsson indicates the apparent inconsistency of the painting:

> A golden eagle has seven primary feathers, the six outer ones are deeply fingered and are more flexible under the effects of air pressure. Liljefors has deliberately portrayed this in the lefthand wing. He has first painted the back fifth, sixth and seventh feathers curving upwards and then painted over them in order to correct what he himself found visually incorrect. But the overpainted feathers show through and reinforce the impression of movement. The righthand wing shows four almost identically shaped feathers, indicating a strong wing beat. However, it is doubtful whether the eagle is turning; rather, it is gliding towards the hare in a straight line. The position is thus impossible and as now represented the eagle would hit the ground. But despite this and other objections – the way the wing feathers allow to slip through has no basis in reality and the positioning of the feet is incorrect – the picture gives balance and beauty to a circling golden eagle and at the same time describes the harmony between the ground and the bird's plumage.

Although Jonsson has been careful not to damn the painting, it does raise the question of how to judge it. Is it acceptable as a dramatic painting, in which the inaccuracies are artistic licence? Or is it in truth unacceptable, because it shows an event that is unlikely to have happened?

Liljefors's identification with the countryside and its animals has closer links with the native people of North America, about whom the boy Bruno read in the stories of James Fennimore Cooper and with the pagan earth spirits of the Nordic world, than with the sentimental and anthropocentric Judaeo-Christian culture of Victorian Europe. Does this animist influence account for his pre-eminence as a painter of animals?

Many modern wildlife painters claim Bruno Liljefors as an influence; few have understood his absorption in his subject matter. Unless an artist can himself become the essence of his painting, he cannot hope to emulate Liljefors's achievement. Others, as Lars Jonsson has indicated, may technically paint better; none will create that oneness with the environment where the artist and his subject merge on the canvas.

In *Twentieth Century Wildlife Artists*[16] American wildlife artist Bob Kuhn listed the artists who had influenced him – Charles Livingston Bull, Wilhelm Kuhnert, Carl Rungius, Frederic Remington and, 'the greatest of them all', Bruno Liljefors. There is much in Kuhn's work that is reminiscent of his idol. Like the Swede he uses photographs; but also television and videotape neither of which was available to Liljefors. In an interview with Terry Wieland[17] Kuhn says that the video on its own is not enough: the artist must have knowledge of the animal. He, in common with Liljefors, likes an imperfect photograph as a starting point for a picture, because 'then I'm not tempted into taking too much of it'. He warns against

BOB KUHN (b. 1920).
Hot Pursuit. 1990.
Acrylic on masonite. 508 x 762mm.
Of living artists perhaps only Kuhn has come
close to Liljefors' ability to show the struggle
for survival between prey and predator. The fox
has sprung over the log and will catch the mouse
in another bound.

reliance on photographs. 'It's sad that so many of my colleagues, some very successful in the marketplace, have allowed the seduction of the photograph to deter them from the often exhilarating, sometimes frustrating process of drawing,' he told Wieland.

'When you sketch outdoors, draw an animal from life, what you see is going directly from your eye to your hand; you're using your mind in a general way – to adjust proportion, for example – but you're really looking and recording what you see directly, without filtering it through your mind. As you do a lot of it, you become less picky and more bold in the way you put down the lines and the tones. Of course, when you're bold, you run the risk of making a horrendous mistake and having to start over. But what you put down from life is a lot more assured, more confident, than what you pull out of your head.'

Since Kuhn uses substantial blocks of colour it is easy to overlook his strength as a draughtsman. He draws in crayon and paints in acrylic on Masonite, his animals having a solidity that is reminiscent of both Liljefors and Wilhelm Kuhnert. As he was a magazine illustrator for 25 years it is not surprising to find a strong narrative element in his work. At the National Art Museum, Jackson Hole, Wyoming, there is an acrylic painting entitled *Flat Out – Coyote and Rabbit*. The rabbit is at full-stretch while the coyote, having rounded a scrubby bush, has its eyes on its prey. This bears comparison with Liljefors – predator and prey, strong composition, effective use of light and the feeling in the viewer of a glimpse of nature. Above all is Kuhn's understanding of the relationship between the two animals and the total concentration of the predator's senses on its prey. Apart from the difference in media, acrylic as opposed to oils, there is also a difference in size: Kuhn's painting is a mere 37 x 47cm.

In *Flat Out* there is nothing superfluous in the painting. The eye concentrates on the action between the animals. The landscape is detailed enough for the viewer to understand the terrain and the quality of local light.

'Something else that really bugs me is the way some realists reproduce the photograph to the letter, including the fact that the background and the foreground are out of focus because a telephoto gives very little depth of field. When you paint that, you are simply certifying the fact that you had one piece of material to work from – a telephoto photograph,'[18] says Kuhn, and recommends the photo-realist to take photographs of the landscape as well as of the animals.

Another of the influences on Kuhn was Wilhelm Kuhnert. Kuhnert was born in 1865, in Silesia, five years after Liljefors. His subjects were large mammals, particularly African big game. His facility in painting lions earned him the soubriquet 'Lion' among his contemporaries and Guy Coheleach, one of today's masters of big game subjects, reckons him to have been the greatest painter of lions. For the people who really know African wildlife Kuhnert is the artist who captures the animals and atmosphere of the savannah. 'Few people in Africa know animals like Tony Henley,' Terry Wieland wrote in 1991[19], 'and he says no one painted animals like Wilhelm Kuhnert. It is an opinion shared among Africa's professional hunters, men who know the animals individually and fondly and who have little tolerance for misrepresentation.' Bob Kuhn, too, is highly rated as a painter of African subjects. David Tomlinson wrote: 'For many, Bob Kuhn is the most accomplished of African wildlife artists, his broad brush strokes and ability to capture movement setting him apart from the more formal, more detailed painters.'[20]

Kuhnert was also a hunter, who made his first trip to Africa in 1891 – a different place from the Africa of today. At the end of the last of century the land of East Africa was being claimed by imperial European powers, the British, Germans and Portuguese. Kuhnert's visit as Wieland points out was 'barely 35 years after Captain Sir Richard Francis Burton's epic two-year exploration from Zanzibar to Lake Tanganyika'[21]. Travel there was a major undertaking and involved a huge baggage train of bearers, very different from Liljefors's usually solitary experience of the Swedish countryside.

Although Kuhnert was familiar with African big game as inhabitants of zoos in Germany, he was determined to see the animals and hunt them and, above all, influenced by the *plein air* approach of the Impressionists, to paint them in their own environment. He had been taught at the Academy of Arts in Berlin by the noted painter of animals in the zoo, Paul Meyerheim, who gave him this dubious advice

WILHELM KUHNERT (1865-1926).
A Lion and Lioness in the Bush. Undated.
Oil on canvas. 775 x 1425mm.
Kuhnert combines his admiration for the power
of predators with the attraction of the light of
the African bush. The viewer feels that this is
an experience being shared with the artist and
not a couple of zoo-painted lions thrust into an
African landscape.

about backgrounds: 'Make them up. Do like I do: place pieces of hard coal on a board, sprinkle sand between, and you have a perfect desert.' Kuhnert ignored this advice, preferring to learn landscape painting under Ferdinand Bellerman. At the Academy he also came under the influence of Richard Friese (1854-1918), who encouraged him to go and draw animals in their own environment, despite Friese himself having only seen the lions and tigers that he painted in zoos. Fred King, who owned Sportsman's Edge in New York City, preferred Kuhnert's work to Friese's.

'Kuhnert was an African field man,' he told Todd Wilkinson, 'Friese never really left town. There's part of a painting missing when you don't go into the habitat.'[22]

Kuhnert was entranced by Africa and returned in 1906, when he became involved in defending the interest of the colonial government of German East Africa against the Maji Maji uprising, as well as making a long safari. He continued his homeward journey via Ceylon. His final expedition was in 1911 when he accompanied King Frederick of Saxony. A photograph of him taken on the 1911 expedition shows a moustached man in bush-hat and puttees sitting on a camp stool, painting with a rifle slung over one shoulder. He made many sketches on these trips, from which he produced finished paintings in his studio in Berlin.

The finished paintings of Kuhnert, while being very good representations of animals, often lack the excitement and atmosphere of Liljefors's European paintings or, indeed, the African paintings of Kuhn, Bateman or Coheleach. Both Kuhn and Coheleach began their careers as magazine illustrators and have an understanding of the dramatic, while Robert Bateman's African paintings with their thoughtful composition and interesting relationships between species are among the most exciting wildlife paintings to have come from Africa.

None of the artists mentioned above is a native of or even a resident of Africa, although Bateman did spend two years in the 1960s teaching geography there. Several artists who live in Africa do paint the wildlife and the most successful of these in recreating the experience of the bush is a South African, Dylan Lewis, who paints in the bush and who has never been a hunter. He uses a portable studio which can be packed and carried on his back. Painting in oils in a warm climate means that he has to work fast, which gives his work a freshness and immediacy that is lacking from many of the more mannered and contrived paintings of African wildlife. Like other fine draughtsmen he has now taken up sculpture.

Atmosphere and fine drawing are to be found in Robert Bateman's paintings. Those from the 1970s are among his best. In them he combines the draughtsmanship of an almost photographic realism with a composition that could rarely, if ever, be achieved in a photograph. The juxtaposition of different animals in the same painting is similar to Kuhn's paintings, although the styles are very different. Bateman has had many imitators since he produced those paintings, but none has managed to imitate his ability to capture the excitement of seeing the animals on the African savanna.

The difference between seeing an animal in its habitat and having to rely on drawing the animal in a zoo comes through clearly in finished paintings. Richard Friese, mentor of Kuhnert and Carl Rungius, was an example of this. His paintings of African carnivores that he knew only as zoo specimens and museum skins are not nearly as convincing as the big game of Europe that he was able to see in the wild in the years before the First World War, when he accompanied Kaiser Wilhelm II on hunting trips in northern Europe. There he was able to paint European bison, moose, polar bears and red stags in the places where they lived. Since he had virtually become the Kaiser's personal field artist he was able to travel in some luxury and to make use of the royal gamekeepers in finding the best places to see the animals he wished to paint.

Friese did not survive the First World War. His frailty was exacerbated by the food shortages in his country and his sadness of the demise of the royal family that had patronised him. When Friese died in 1918 the Kaiser was about to lose his empire and the German society in which this artist had flourished was also about to change dramatically.[23] Compared with his pupils, Kuhnert and Rungius, Friese's forays into the field were luxurious. When in 1908 he joined Rungius on an expedition to New Brunswick, he was appalled to learn that he would have to sleep in a tent. 'I had warned him beforehand what to

CARL RUNGIUS (1869-1959).
Mountain Sheep. Undated.
Oil on canvas. 635 x 762mm.
An emigrant from Germany, Rungius became devoted to the wildlife and landscapes of North America. The Rockies in particular fascinated him and he settled at Banff in Canada. He would spend many weeks in the field absorbing the atmosphere as well as watching and painting the animals.

expect,' Rungius recalled, 'but he simply refused to believe that we were going into a wilderness. In spite of what I had said he expected that, somehow, there would be farmhouses with feather beds every night, as in Norway. There, he had often been the guest of wealthy sportsmen who brought delicacies in abundance. Friese loved good food.'[24]

For Carl Rungius, Friese had been a role model, but this trip to Canada disillusioned him. 'I had looked forward to the association, believing that I could benefit from his field work, but it did not work out that way. The hardships were too much for him to do good work, and he himself said that I could sketch circles around him.'

Carl Clemens Moritz Rungius was born in Germany in 1869, four years after Wilhelm Kuhnert, his fellow student at the Berlin Academy of Art. He too left Germany to follow his art, but he went west to America rather than south to Africa. His uncle had emigrated to the United States and invited the young artist to join him to hunt moose in Maine in 1894. His uncle asked him to stay another year in New York City and according to Tom Davis that year, 1895, was pivotal in Rungius's life.[25] One of his paintings was exhibited in a smart Fifth Avenue gallery and spotted by a leading American conservationist. William Hornaday was impressed by the oil painting of the head and shoulders of a moose set against the background of brooding conifer forest. Hornaday introduced Rungius to New York society, which included the sportsmen-conservationists who were vital to the career of a budding animal artist.

At the inaugural New York City Sportsmen's Show, held in Madison Square Gardens in 1895, Rungius met Ira Dodge, the man who was to introduce him to the West. Dodge was a big game guide from Wyoming, whose wife, Sarah, could speak German with Rungius, whose grasp of English was at that stage still rather shaky. The Dodges invited the artist to Wyoming. 'I headed for Wyoming the following summer, loaded down with art materials, guns and shells, but a little short on English!' Rungius recalled. He was entranced by the Dodge range, which lay in the rolling prairie country, about four miles from the western foothills of Fremont Peak. Antelope abounded and there were elk, sheep and deer. He stayed from June until December. 'I started with the antelope, working my way gradually into the mountains, until I was thoroughly acquainted with the lay of the land and the habits of the game,' Rungius recalled.

He absorbed the landscape by living in it over prolonged periods. He would take a packhorse and stay in the hills for two or three weeks, living off game and a diet of flour, bacon, beans, dried fruit and coffee. He always concealed his camps well, his cooking fires were small and he extinguished them immediately after use, because he wanted his presence to disturb his quarry as little as possible. He used the game he shot as models and would string up dead animals on a framework of poles to make a pose as lifelike as possible, which he then sketched from every angle.

Rungius's contact with Hornaday brought him commissions from the leading American outdoor magazines, *Forest and Stream* and *Recreation*, and introductions to influential sportsmen such as Theodore Roosevelt. In 1904 he was invited by Charles Sheldon to join an expedition to Yukon. From 1914 to 1934 he was commissioned to supply paintings for the Gallery of Wild Animals at the New York Zoological Society. He was elected a full academician of the National Academy of Design in 1920, having achieved this ambition with a tactical determination, choosing to paint the Western subjects popularised by Frederic Remington and Charles Russell. Once he was elected an academician, however, he returned to wildlife and landscape painting.

It was the long periods that Rungius spent in the field that made him such an important wildlife artist. Tom Davis explained this in 1990 as follows:

> Rungius did not paint the wildlife and wilderness of the North American west from the perspective of an occasional visitor. He painted from within. His relationship to his subject matter was every bit as intimate as Wyeth's to Helga. Rungius lived the experience of his art. He studied his adored game animals so long and so intensely that their habits and personalities became a second nature to him; he moved to the ageless rhythms of the mountains.[26]

RICHARD FRIESE (1854-1918).
Bison in a Wooded Winter Landscape. 1890.
Watercolour and bodycolour. 355 x 532mm.
The European Bison disappeared from the wild
in 1919, but has been re-established from
captive stock reintroduced to the Polish forest of
Bialowieza and several other sites in Russia and
Romania. Friese may have seen bisons in the
wild when on hunting expeditions with the Czar,
but this is almost certainly based on a zoo
specimen.

Trips to Wyoming, the Yukon and New Brunswick all added to his knowledge of the wild animals of North America, but it was a visit to Banff, Alberta, in 1910 that introduced him to the Canadian Rockies. Here he found a landscape that excited him as much as the animals he found there. In 1922 he built a home in Banff, where he was to spend summers, hunting, painting and learning more about the place and its wildlife. In winter he would return to New York, where he would paint his large paintings and meet his main customers.

It was Rungius's view that modern, abstract art was a joke – 'just an excuse for not being a good draftsman'.[27] He had been schooled in the nineteenth century tradition of German realism and for the first part of his career, as Martha Hill identified,[28] his compositions were more illustrative than artistic. Between 1909 and 1920 his awareness of the seamless flow of animals and landscape increased. In the next decade his love affair with the Rockies led to an increase in his output and reflected the dominance of landscape. His broad brushwork masks the strength of his draughtsmanship, but the latter is fundamental to his paintings.

Robert M. Mengel writes glowingly of the work of Rungius, rating him the equal in greatness to Liljefors.[29] He tells how Rungius initially failed to be taken seriously by the art establishment. On the advice of artist friends he omitted animals from his paintings and 'his superb landscapes of the Canadian Rockies, unlike any other western American landscape painted, quickly won recognition, numerous prizes (some even *with* animals), and full membership of the National Academy of Design by 1920, he being the only painter of wildlife so recognised.' Mengel adds: 'Having made his point, and with many waiting commissions from the affluent big game hunters who supported him well, Rungius happily returned to his animals, organic elements in landscapes as great as ever.'

Rungius's experience in the field was crucial to his work. Hill recalls that he used to say that he hunted six days a week and painted one, but that in later years the ratio reversed itself and he painted six days and hunted one.[30]

To be at one with the landscape as Rungius was requires an ability to survive, toughness and a happy disregard for personal discomfort. He complained of the mosquitoes on his Yukon trip, not because they bit him, but because they became stuck to his oil paintings (a disadvantage of *plein air* wildlife painting in the brief, far northern summer). Another tough artist who had problems with flying insects was Francis Lee Jaques (1887-1969), who made many trips in North America and elsewhere to paint landscapes for dioramas for exhibits at the American Museum of Natural History in New York. 'He often painted large oil studies by bolting together several canvases that could be then taken for easier transport.'[31]

ROBERT BATEMAN (b. 1930).
Sparring Elephants. 1975.
Acrylic. 1219 x 1524mm.
Without the dust and the Cattle Egrets which have suddenly taken flight, the clash of these African elephants would remain statuesque and undynamic. The birds are positioned in a haphazard way, as Bateman decided to place them by sticking paper cut-outs on the painting with his eyes closed. With detailed paintings there is a danger that composition can become contrived, a trap that Bateman usually avoids.

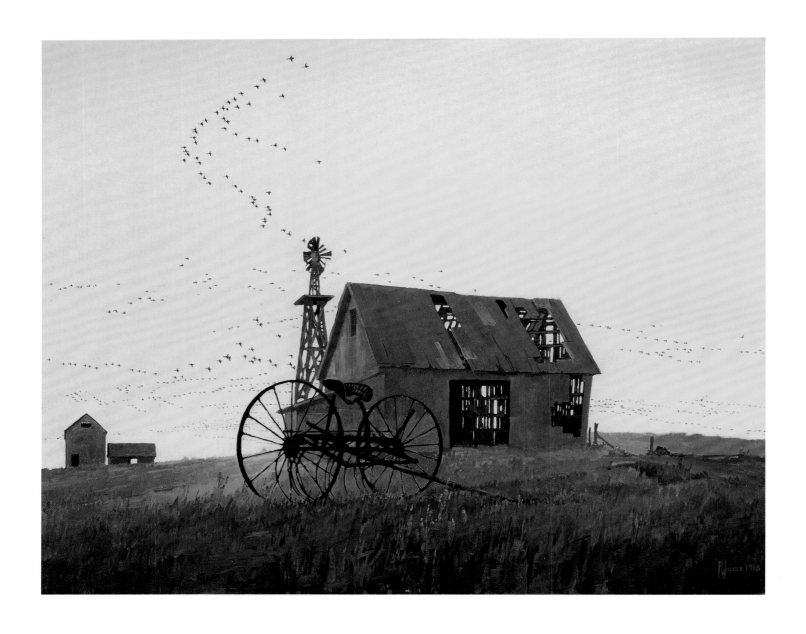

FRANCIS LEE JAQUES (1887-1969).
The Old West Passes. 1968.
Oil on canvas. 610 x 762mm.
Skeins of Canada Geese fly across a sky yellowed
by the sinking sun. Derelict barns and a long-
disused windpump are symbols of the farming
of Jaques' boyhood. Painted at the end of his
life it has the poignancy of a subject about which
he felt extremely strongly.

KEN CARLSON (b. 1937).
Winter Kill. 1987 & 1996.
Oil on canvas. 762 x 1143mm.
That Rungius, Kuhnert and Kuhn are all listed by Carlson as influences may not be surprising. The relationship between all the animals in this painting is also clear. Despite the face of the wolf in the foreground not being visible, the animal's intention is clearly defined by its posture. The viewer's eye is drawn to the wolf by the raven with an open bill.

Several well-known artists tried to paint dioramas and failed to cope with the particular demands. According to Donald T. Luce, curator of natural history art at the James Ford Bell Museum at the University of Minnesota, both Louis Agassiz Fuertes and Carl Rungius were unsuccessful.[32] On the other hand, he suggests that Liljefors's work on museum dioramas in Uppsala and Stockholm in 1889 and 1893 was the catalyst for the Swede's later pictures in which he explored the relationship between predators, prey and the environment.[33] Jaques's style and interests made him an ideal diorama artist. He, too, understood the link between animals and their environment. When he was 12 his family moved from Illinois to Elmo, Kansas, and he became 'the family hunter, shooting game for food, not sport.'[34] Four years later his father, Ephraim, moved the family north-west to Aitken, northern Minnesota: the journey was made in a covered wagon in which rode Jaques's mother and sister with all the family's household goods. The sixteen-year-old and his father walked the 750-mile journey, which took six weeks.

Over half a century later he painted in oils *The Old West Passes*. The landscape is dominated by a derelict horse-drawn hay-rake, a dilapidated barn, a disused wind-pump and a deserted farm. Across the evening sky fly skeins of wildfowl. It is clearly the work of a person who knew the last years of the Old West. He said of this painting, which was his favourite, 'I don't think any other bird artist could have shown the arrangement of geese in flight as well as this. Except maybe Peter Scott in England.'[35] This was a tribute to a younger artist, whose background could not have more different.

An American artist in the line of Kuhnert, Rungius, Jaques and Kuhn is Ken Carlson (b. 1937). Like them he paints comparatively loosely and simply, using his interpretation of the effects of light to give form to his animals. His atmospheric oil paintings recreate the experience of being in the North American wilderness and meeting with grizzlies, moose or bighorns. Carlson is truly a wilderness artist in that he never features man or his artefacts in his paintings. He also shares Liljefors's detachment. His passion is for his subjects, but otherwise he tries to keep man out of his paintings: 'I'm not trying to be an ultra-conservationist, and I'm not trying to impart a message that man is bad or shouldn't be involved. I just prefer nature as it is.'[36]

All painters must be influenced by the work of others, but it is not always clear what those influences are. A feature about James Morgan (b. 1947) in *Wildlife Art News*[37] appeared under the strapline 'The Painter Who Dares to Be Like Himself'. While it is true that the looseness of Morgan's style is reminiscent of Kuhn and Carlson, it is difficult to categorise his work, because his styles seem to be evolving. The constant element is his use of light. In his painting *Sage, Snow and Hare*, the viewer's eye is taken around a seemingly abstract collection of paint-strokes until it alights on a sheltering hare beneath a snow-covered bush. In the 1996 *Wildlife in Art* catalogue he explained his intention:

> Because I am intrigued by the patterns and shapes found in nature, I tend to concentrate on the effects of light on these elements and the resulting array of colors and nature's ever-changing moods. I seek to achieve a balance between the subject and its environment. This harmony is further aided by the play of light, shadow and subtle color changes. Hopefully, this will produce emotional participation from the people who view the painting and help to achieve an awareness of the often overlooked intimate aspects of nature.[38]

Peter Scott was another painter whose work could not be said to have been obviously influenced by other artists. He loved his subjects but he was equally a passionate hunter of wildfowl. The name of Peter Scott is now firmly linked to nature conservation, but in the 1930s it was as a painter that he was best known. At this time he wrote two books on his wildfowling experience, which were illustrated by his paintings.[39] During this period he painted estuaries around the coasts of Britain with huge skies across which flew the ducks and geese that he saw when he was out shooting. The best of these paintings convey the expectation and excitement of waiting in a punt for birds to come within range, in poor light and with the knowledge that there are only two barrels to fire. At this stage his painting style was still experimental. He constantly tried different techniques: some of the most successful paintings were thickly

JAMES MORGAN (b. 1947).
Sage, Snow and Hare. 1995.
Oil on linen. 305 x 457mm.
It is easy to overlook a well-camouflaged animal, but artists often separate the animal from its environment. At first this painting looks like an abstract, but as the form of the bush becomes clearer the outline of the hare can be made out beneath it.

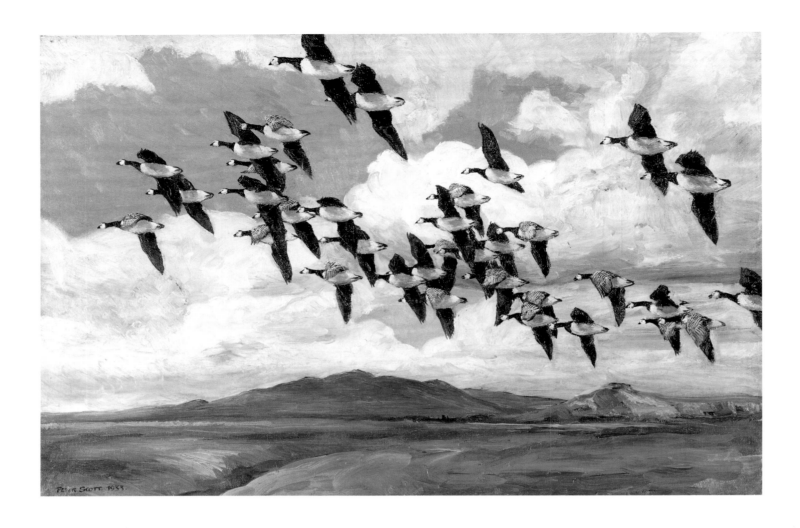

PETER SCOTT (1909-1989).
Barnacle Geese on a Spring Day. 1933.
Oil on canvas. 508 x 762mm.
Bright in the spring sunlight, a skein of Barnacle
Geese flies across a background of the hills of
the Western Isles. This is one of the typical Peter
Scott paintings of flying geese in a skyscape.

JOHN BUSBY (b. 1928).
Gannets Hanging on the Wind. 1993.
Oil on canvas. 870 x 610mm.
One of the seminal figures in British wildlife
painting, John Busby has been very influential
in encouraging artists to paint what they see
rather than what they know is there.

applied with a palette knife.

The combination of skies, landscapes and birds was so much associated with Scott's work that his more adventurous, experimental work was ignored. Scott himself coined the expression 'Standard Formula Scott' to describe his popular work, and his friend Keith Shackleton says that 'SFS' is used even today to comment on a real scene that would have delighted him.[40] After Scott had stopped wildfowling there was a period during the late 1940s and the 1950s when he was absorbed in the creation of the Severn Wildfowl Trust at Slimbridge in Gloucestershire, and many of his paintings showed either the Whitefronts that wintered regularly there or flocks of ducks on the water. There is a passion in these paintings that is absent in later works.

Peter Scott's passion was wildfowling, which in the British context is the form of shooting where the individual is perhaps most closely pitted against his quarry. In the British Isles much of the shooting involves driven birds – grouse or pheasants – or deer-stalking, in which a professional stalker tracks the animal and the 'gun' aims and fires. Archibald Thorburn (1860-1935) is most closely associated with this type of hunting. His meticulously painted watercolours are much prized today and his paintings have fetched prices that are far in excess of those reached by the works of other much more interesting artists.

For a short period Keith Shackleton (b.1923), a *protégé* of Peter Scott, was also a wildfowler. It was after wildfowling with Scott on the Wexford Slobs in Ireland that he gave up shooting. That was on 19 February 1949. 'We shot thirty-three geese between us,' Shackleton recalled, 'and had to carry them all home – we were absolutely festooned with geese. Pete said something like "I don't know about you, but I feel like a murderer." I said "I'm absolutely with you, and they just don't look right, all broken." Between us we were filled with remorse and I certainly never shot again, not for fun anyway.'[41] According to Elspeth Huxley, Scott did not finally forsake wildfowling until the winter of 1951/2.

Shackleton has spent many months in both the Antarctic and Arctic. He is a skilled sailor. These experiences show in his oil paintings. The viewer may infer from them that the animals have more successfully mastered the hazards of their environment than intruding human beings have. It is an environment in which human beings must work hard to survive – just looking at a Shackleton may induce sea sickness. Part of Shackleton's magic is the skill with which he portrays light on water.

Bruce Pearson (b. 1950) has lived most of his life in East Anglia, the English region whose quality of light so inspired Constable and the nineteenth century Norwich School. Pearson paints in both watercolours and oils and appreciates good draughtsmanship, an aspect of painting more emphasised now than it was when Pearson was at art school in the late 1960s and early 1970s. 'I was a square peg in a round hole,' he recalled in the 1980s[42], 'they wanted me to make kites, not to paint them.' He worked for the RSPB and then the British Antarctic Survey in Antarctica, which gave him the chance to work in the field. He still works in the field. I have watched him complete a mixed-media painting on a hot summer day in Extremadura in Spain, starting at eight in the morning and finishing at six in the evening. The work has the unmistakable immediacy of a *plein air* painting, but the composition is necessarily weaker than if the painting had been produced in the studio. Pearson does of course make good use of his wonderful field sketches to produce more composed artwork such as the large oil of Grey Seals and Turnstones on a beach painted in 1995. The bulk of the seals contrasts with the busy activity of the small waders searching for food beneath the stranded seaweed. There is both visual and actual tension between two of the seals. This leads the eye into the top half of the painting which is linked to the bottom half by two Turnstones dropping in to join their companions. The effect of the light on the bodies of the slumbering seals produces an abstract pattern. Pearson is fit and capable of spending hours in the field, watching and drawing animals, and above all absorbing the atmosphere of the place.

The Russian painter Vadim Gorbatov (b. 1940) is another fieldman who captures a sense of place. He worked for many years as a graphic artist in Soviet television, but made for the country outside Moscow and beyond whenever he could. Since 1989 he has visited Poland, the Netherlands, Spain, the USA and the UK. He has a remarkable ability both to withstand the worst of the weather and to complete watercolours

KEITH SHACKLETON (b. 1923).
Snow Geese. 1957.
Oil on board. 1245 x 1827mm.
Although best known as a painter of maritime
scenes, Shackleton can also produce paintings
of flocks of birds in which strong patterns are
created by the effects of light on the shapes of
the birds.

BRUCE PEARSON (b. 1950).
Turnstone among Grey Seals. 1996.
Oil on canvas. 711 x 1016mm.
Sketches made in the field were the basis of the
paintings of the Grey Seals and Turnstones in
this large oil painting. The bulk of the seals is
used as a background against the lightness of
the Turnstones as they drop to the beach to
feed. The painting would have lost impact if
more space had been allowed around the seals.

CHRIS ROSE (b. 1959).
Summer Light – Butterbur and Whitethroat. 1997.
Acrylic. 610 x 767mm.
Animals are not always immediately visible. This Whitethroat is skulking in the shadow of these large leaves and is almost only noticeable because of light reflected from the leaves.

in the field – an ability that drew admiration from other artists on an Artists for Nature Foundation expedition to the Biebrza Marshes in Poland. He is able to conceal himself in vegetation and wait for nature to come to him.[43]

> The moon rises above the horizon and bathes the reeds and quiet channel in a cool light. I've been waiting near a beaver lodge for a long time, hoping to see a beaver, Gorbatov recalls, I've found a dry seat on an old burl among waterways and bushes. The warm May night is full of calling Thrush Nightingales, croaking frogs and from somewhere a Bittern can be heard. A swish of wings and a late Mallard hits the water, shattering the moon's reflection. Quacking softly the drake leaves the scene, but the moon's reflection is now slightly marred by the buzzing flight of insects. I wonder if the lodge has been abandoned, but if so, why are there white shavings lying around? There – a soft splash, a beaver cleaves the surface – leaving a trail of bubbles, all in absolute silence... A sudden whack! of a tail makes me jerk in fright. I lose balance and fall into the channel!

This story typifies the narrative element that is found in Gorbatov's paintings. His paintings reveal unexpected elements, such as a small bird half-hidden by leaves in a corner. A painting may portray an actual experience of the artist. A brown bear is seen in a snowy birchwood. The bear is on all fours, but alert to possible danger in the trees before it. This was how Gorbatov saw such a bear in a forest in Karelia, where he was sketching. He heard a footfall on the snow and, thinking it was his companion returning, turned to greet him. Instead it was a bear. Gorbatov froze, as much with fright as with the need of potential prey to become motionless when danger threatens. The bear, unable to locate Gorbatov, decided to turn back the way it had come and ambled back through the trees.

Few modern wildlife artists measure up to, let alone surpass, the work of Liljefors. Lars Jonsson may come closest. Jonsson (b. 1952) has never been a hunter, but he is one of the world's finest field birders (perhaps today's equivalent to the hunter). Like Liljefors he uses sketches and photographs, although he draws more heavily on his field sketches. No living wildlife artist can surpass Jonsson's ability to convey the effects of light on his subjects. He first achieved prominence when, as a teenager, he published a series of five books which brought a unique insight into the field identification of European birds. The five volumes were eventually published in one volume in 1992 as *Birds of Europe.* Having started his career as a painter of birds, he has, like Rungius, become more interested in landscape painting. Jonsson demonstrates today how working in the field and familiarity with animals and their environment produces the most stunning work.

VADIM GORBATOV (b. 1940).
Brown Bear in Snowbound Woodland. 1993.
Watercolour.
The Brown Bear and cubs were painted after
Gorbatov had encountered a bear with cubs in the
forests of Russian Karelia. The whimsical addition
of a frog in the snow being investigated by one of
the cubs is a reminder of Gorbatov's grounding in
the narrative Russian tradition.

MATTHEW HILLIER (b. 1958).
Kruger Lion. 1997.
Acrylic. 480 x 360mm.
Skilful handling of the low sunlight gives this photorealistic painting an atmosphere that would be missing from a photograph and can only have been achieved by the artist having seen such a lion in twilight.

GEORGE MCLEAN (b. 1939).
Blue Jay. 1990.
Casein on composition board.
A Canadian, McLean is one of several North American artists to be influenced by the work of Liljefors, Rungius and Kuhn. Although very realistic, his approach is one of a picture-maker, using a combination of sketches, skins, dead animals and his own experience of the animals.

GUY COHELEACH (b. 1933).
Brightwater's Creek. 1983.
Oil on canvas. 914 x 1829mm.
Coheleach is in the artist/hunter tradition. This familiar, almost domestic scene is in contrast to many of the dramatic scenes he has painted in several continents.

LARS JONSSON (b. 1952).
Vantage Point. 1983.
Oil on canvas. 889 x 787mm.
Since Joseph Wolf, so many artists have painted Peregrines sitting on rocks that the images merge into an unmemorable blur, but Jonsson's attempt on this subject is successful because he has composed the picture to allow a sense of space, used the effects of light to strengthen the composition and employs all his knowledge of Peregrines to produce a convincing portrait.

NOTES AND REFERENCES

1 Russow, K. E. (1929) *Bruno Liljefors: En Studie.* C. E. Fritze, Stockholm.

2 Talbot Kelly, R. B. (1955) *Bird Life and the Painter.* Studio Publications, London.

3 Swanson, G. A. (1987) The unknown Swedish painter: Bruno Liljefors (1860-1939). *Wildlife Art News* 6 no.5, September/October, pp. 59-67.

4 Hill, M. (1987) *Bruno Liljefors: The Peerless Eye.* The Allen Publishing Company, Hull, p.9.

5 Hill (1987) p.78.

6 Hill (1987) p.26.

7 Hill (1987) p.35.

8 Hill (1987) p.28.

9 Ellenius, A. (1996) *Liljefors: Naturen som Livsrum.* Bonnier Alba, Stockholm, p.95.

10 Ellenius (1996) p.95.

11 Hill (1987) p.97.

12 Malmberg, E. (1942) *Konstnärfolk.* J. A. Linblads Forlag, Uppsala.

13 Ellenius (1996) p.95.

14 Russow (1929).

15 Ellenius (1996) p.75.

16 Hammond, N. (1986) *Twentieth Century Wildlife Artists.* Croom Helm, London, p.117.

17 *Wildlife Art News* Interviews Bob Kuhn. *Wildlife Art News* 13 no.3, p.62.

18 *Ibid.* p.67.

19 Wieland, T. (1991) Wilhelm Kuhnert. *Wildlife Art News* 10 no.4 (July/August) pp.44-64.

20 Tomlinson, D. (1991) *African Wildlife in Art: Master Painters of the Wilderness.* Clive Holloway Books, London, p.23.

21 Wieland (1991). pp.44-64.

22 Wilkinson, T. (1992) The rarefied air: why a single painting by Richard Friese stands to awaken a continent. *Wildlife Art News* 12 no.3 (May/June) p.60.

23 Wilkinson (1992) p.64.

24 Wilkinson (1992) p.64.

25 Davis, T. (1990) This man Rungius. *Wildlife Art News* 10 no.4 (July/August) p.30.

26 Davis (1990) p.30.

27 Davis (1990) p.38.

28 Davis (1990) p.38.

29 Mengel, R. M. (1980) Beauty and the beast: natural history and art. *The Living Bird* 18:66.

30 Hill, M. (1992) Carl Rungius and his artistic legacy. *Value in American Wildlife Art: Proceedings of the 1992 Forum.* Roger Tory Peterson Institute of Natural History, Jamestown, NY, p.68.

31 Luce, D. T. (1992) Francis Lee Jaques: the museum diorama and public education. *Value in American Wildlife Art: Proceedings of the 1992 Forum.* Roger Tory Peterson Institute of Natural History, Jamestown, NY, p.79.

32 Luce (1992) p.81.

33 Luce (1992) p.80.

34 Swanson, G. A. (1994) Interpreting the spirit of the wilderness: Francis Lee Jaques (1887-1969). *Wildlife Art News* 13 no.1 (January/February) p.27.

35 Jaques, F. P. (1973) *Francis Lee Jaques: Artist of the Wilderness World.* Doubleday, New York.

36 Leigh Yawkey Woodson Art Museum (1996) *Wildlife: The Artist's View,* p.16.

37 McIntosh, M. (1994) The art of James Morgan. *Wildlife Art News,* 13 no.6, p.85.

38 Leigh Yawkey Woodson Art Museum (1996) *Wildlife in Art,* p.64.

39 Scott, P. (1936) *Morning Flight: A Book of Wildfowl.* Country Life, London; and (1939) *Wild Chorus.* Country Life, London.

40 The Wildlife Art Gallery (1996) *Peter Scott 1909-1989: The Studio Exhibition,* p.4.

41 Huxley, E. (1993) *Peter Scott: Painter and Naturalist.* Faber & Faber, London, p.178.

42 Hammond, N. (1986) *Twentieth Century Wildlife Artists.* Croom Helm, London, p.149.

43 Shillcock, R. D'A. (1993) *Portrait of a Living Marsh.* Inmerc bv, Wormer, p.102.

LOUIS AGASSIZ FUERTES AND WILDLIFE ART IN NORTH AMERICA

Painting is easy after you've learned sight,
and a painter's greatness is far less dependent on his ability to handle paints
and brushes than on his ability to rightly see the truth.

Louis Agassiz Fuertes[1]

From 1920 onwards Louis Agassiz Fuertes was the most influential wildlife artist in the United States and Canada. He is still cited as a major influence and there are artists working today in the same tradition.

Fuertes had died before the media revolution, and his reputation rests on his skills as an illustrator. His death at the age of 53 in 1927 prevented him from developing in other channels. Some of the paintings made in the last years of his life suggest that he would have expanded his repertoire and a large 1924 oil painting of six Greater Flamingos against a background of mangroves, commissioned by the American Museum of Natural History, demonstrates this. Roger Tory Peterson recalled Fuertes showing him a large oil painting of a Great Horned Owl and saying, 'This is the way I really like to paint. I'm going to do more of it from now on.'[2]

His illustrations in bird books were the inspiration for a generation of ornithologists. Kenneth C. Parkes of the Carnegie Museum of Natural History in Pittsburgh recalls that his first encounter with Fuertes's work was his illustrations for *The Burgess Animal Book for Children*, published by Little, Brown in 1920. 'The animals in these paintings were so true to life alive, so intimately alive, that first I believed them to be color photographs'.[3] Parkes was only five when Fuertes died in August 1927 and it was some years later that he learned of the artist's death by reading an obituary in a back copy of *Natural History*. 'I mourned retrospectively.'[4]

Although Fuertes's interest in animals began at an early age, it became serious when he was in his early teens. In 1888 when he was 14 he was inspired to paint a dead male Crossbill whose curiously shaped bill and strange colouring he wanted to impress on his memory.

The Fuertes family lived at Ithaca, New York, home of Cornell University where his father was professor of civil engineering (and later dean of the Engineering College). The university library had a copy of Alexander Wilson's nine-volume *American Ornithology* (1808-1814) and the Ithaca Public Library held a marvellous four-volume double-elephant edition of Audubon's *Birds of America* (1827-1838), which the young Fuertes frequently consulted. Throughout his life he acknowledged the inspiration of Wilson and Audubon. When the seventeen-year-old George Miksch Sutton wrote to him criticising Audubon, Fuertes's response was a very gentle admonition.

Say what you will of Audubon (much of what you *did* say is just, too) he was the first and only man whose bird drawings showed the faintest hint of anatomical study, or that the fresh bird was in hand when the work was done. His painting was so immeasurably ahead of anything, up to his time or since, until the modern idea of drawing endlessly from life began to bear fruit, that its strength deserves all praise and honor, and its many weaknesses condonement, as they were the fruit of his training: stilted, tight, and unimaginative old David sticks out in the stiff landscape, the hard outline, and the dull, lifeless shading, while the overpowering virility of A. himself is shown in the snappy, instantaneous attitudes and dashing motion of his subjects. While there's much to criticize there is also much to learn, and much to admire, in studying the monumental classic that he left behind him. He made many errors, he also left a living record that has been of inestimable value and stimulus to students, and made an

everlasting mark in American Ornithology. It is indeed hard to imagine what science would be like in this country – and what the state of our bird world – had he not lived and wrought, and become a demigod to the ardent youth of the land.'[5]

Although the strictures on the inability of Audubon's predecessors to produce anatomically correct drawings is unfair to Jacques Barraband, Thomas Bewick and even arguably to Alexander Wilson, the case he made for the pre-eminence of Audubon is justified. Fuertes was in fact very fond of Wilson's work, as is shown in a letter from Fuertes to Witmer Stone of the Academy of Natural Sciences, Philadelphia, quoted by Robert Peck, in which he confesses a great reverence and love for Wilson, who appealed to him 'as a deeper and more ardent, even if more restrained man than Audubon', and, although he could not draw or paint with the same skill, 'he had, unconcealably, the deeper love and longing to express thro' a weaker medium, his passion for nature'. Perhaps Fuertes's recognition of the similarity between his own motivation and Wilson's was the reason for his affection.

Wilson may have had passion in his approach to painting birds, but Audubon certainly had greater ability to make his birds seem to be alive. He did this largely by the strength of his composition and, as has been pointed out by the late Robert M. Mengel[6], by endowing birds with human facial expressions and postures. Marcham claims that where Fuertes differed from Audubon was in 'his photographic memory and his ability to convey with brush and pencil the impression of the living bird'[7]. Once he had moved beyond copying Audubon, Fuertes began to learn about the 'facial expressions' of birds. The faces of birds are less mobile than ours, but the different facial patterns give the appearance of characteristic expressions that inevitably attract anthropomorphic descriptions: the 'fierce' American Robin, the 'cheeky' European Robin, the 'gentle' Audouin's Gull. These characteristics tend to be defined by the eyes, the relationship of the bill to the face and the way in which the bird holds its head.

Painting these characteristic expressions was Fuertes's great strength. Parkes had suggested[8] that something happened to Fuertes's art during an expedition to Alaska in 1899 when the artist was 25 and 'shortly thereafter'. He draws our attention to some of Fuertes's vignettes for the fifth edition of Elliott Coues's *Key to North American Birds* after the Alaska expedition, which 'demonstrate that he had already attained his mastery of the species-specific facial expressions of birds'. This feature was lacking from the Fuertes' pre-Alaska illustrations, which Parkes suggests were 'still pretty crude and perhaps Audubonesque'. He picks out the paintings of heads of White-winged Crossbill and an Alaskan race of Savannah Sparrow as being utterly convincing, 'primarily because of Fuertes' understanding of the proper size and placement of the birds' eyes.' Robert Peck suggests that the noticeable improvement in Fuertes's style took place in the eighteen months between the Alaskan expedition and a trip to Texas in the summer of 1901.[9] He ascribes this maturity to the instruction of Abbott Thayer and to Fuertes's commercial success, but he also hazards that the death on Christmas Day 1899 of Elliott Coues may have altered the young artist's perception of himself as a dependent student into a man with a reputation based on accomplishment.

Elliott Coues was one of the foremost American ornithologists and Fuertes met him when he was still a student in the College of Architecture at Cornell. A sociable young man, Fuertes was an enthusiastic member of the college Glee Club. When the club made a trip to Washington DC, he was introduced by a friend to Coues, the friend's uncle. That meeting in December 1894 changed Fuertes's life, because it enabled him to consider the possibility of becoming a professional bird artist and caused him to change from Engineering to an Art and Science course. Coues was supportive and set about establishing the young man's career. He exhibited about fifty of his paintings at the American Ornithologists' Union meeting of 1895. Three enquiries came from the exhibition and two of these led to commissions – illustrations for Florence Merriam's *A-Birding on a Bronco* and for a newly founded ornithological magazine *The Osprey* – which he undertook in spite of his busy academic and social programme. When Merriam's book was published in 1896 Coues reviewed it for the *New York Nation*. It is not surprising that he was complimentary about the work of his *protégé*. He makes the comparison with Audubon that was almost to

LOUIS AGASSIZ FUERTES (1874-1927).
American Flamingos. 1924.
Oil. 859 x 1270mm.
The bulk of Fuertes' work was illustrative, but
he had begun to paint larger pictures of wild-
life in an environment. Unfortunately he did
not have the opportunity to take this further,
because he died in 1927 when his car was struck
on a railroad crossing in upstate New York.

LOUIS AGASSIZ FUERTES (1874-1927).
House Sparrow with feathers. Undated.
Watercolour. 356 x 254mm.
This watercolour sketch shows how Fuertes was able to reproduce the character of a bird with a combination of posture and the delineation of the head.

LOUIS AGASSIZ FUERTES (1874-1927).
Bannertail Kangaroo Rat. c.1901.
Wash drawing. 163 x 356mm.
Among the wildlife that Fuertes encountered on his expedition to Texas in 1901 was this kangaroo rat. Typically he clearly shows the adaptations that enable this rodent to survive in the harsh conditions of western Texas.

become *de rigueur* in criticism of new American bird artists. 'Thus far,' he wrote, 'his genius overreaches his talent; but his pictures are better than Audubon's were to begin with, and we suspect that the mantle has fallen upon Mr Fuertes.' Then he pinpointed what at the end of the nineteenth century in America made Fuertes so special: 'Ability to draw a live bird instead of a stuffed one, from the very first, is an accomplishment rare enough to deserve more than passing comment.'[10]

Coues was a discerning man. Those early paintings were rather stiff and did owe much to Fuertes's assiduous study of the works of Wilson and Audubon, but his later work was to vindicate Coues's recognition of his promise. What today would Coues have said about those artists who, instead of using stuffed birds as models, draw from photographs?

The second important influence on Fuertes's career was a portrait painter and a keen birdwatcher, Abbott Thayer. The young man first met him at the 1896 AOU Congress which Thayer addressed on the subject of the coloration of birds. Thayer spent as much time in the field as was possible, given the demands of his portrait-painting, and used his artistic sense to formulate 'The Law Which Underlies Protective Coloration', which was the title of his talk and a paper published in the AOU journal, *The Auk*. His theory was that protective coloration concerned more than the animal taking on the colours of its surroundings. Animals were often darker on their upperparts because these were the areas most exposed to the sun and lighter on their underparts which tended to be in shadow. In bright sunlight the effect was for both upperparts and underparts to appear to be the same colour. This theory of countershading he demonstrated in an open-air lecture at the AOU congress. He suspended three sweet potatoes from a wire stretched horizontally a few inches above the ground. Having coated the potatoes with a sticky paste he sprinkled them with dust from the ground to provide them with the local colour. Then two of the potatoes were painted white on their undersides and the third left with the same overall cover of dust. From a distance the uniformly coloured potato could clearly be seen because of the shadow on the underside, but the other two were almost invisible. A second demonstration showed a similar effect when the potatoes were painted green and white and suspended over grass.

The young Cornell student was enchanted with this demonstration. It confirmed his own field experience and experiments that he had carried out. Coloration of birds had been the subject of his senior thesis and he welcomed Thayer's invitation to spend a summer at his summer home at Dublin, New Hampshire. The genuine, mutual admiration that Thayer and Fuertes felt for each other must have been almost palpable. Peck quotes a letter from the older artist to the younger, dated 9 May 1897[11]: 'Your talent makes me itch to train it.'

LOUIS AGASSIZ FUERTES (1874-1927).
Common Potoo. c.1910.
Watercolour. 508 x 349mm.
Fuertes sketched the potoo on an American Museum of Natural History expedition to Yucatan in 1910. The expedition leader, Frank Chapman, would take the sketches back to the museum for the artists working on dioramas to allow spaces for the addition of a painting by Fuertes.

During the summer of 1897 at Dublin and during the following winter at the Thayers' home at Scarborough, New York, the older artist was putting Fuertes through his artistic paces, directing him to improve his skills rather than to produce paintings. The summer at the Thayers' did help Fuertes to sharpen his technique. Peck says that there is a softer outline and improved anatomy in the few paintings that remain from that period.[12] After nine months' work with Thayer, in March 1898 the young Fuertes set off on his first scientific expedition. The destination of the six-week trip was Florida and his fellow travellers were Abbott Thayer and his son, Gerald, and Charles Knight, another young artist. Several expeditions followed and were to be an important part of the artist's life.

In the winter of 1898/9 Fuertes returned to Scarborough enticed by the prospect of seeing the specimens of birds that Thayer and his son had collected on a trip to Europe. As a mentor Thayer did not have total influence. He wanted Fuertes to learn to draw and to paint academically subjects other than birds, but the younger artist stubbornly confined himself to his beloved range of natural history subjects. Thayer reconciled himself to this and, in Peck's words, 'resigned himself to "polishing the diamond" he saw in Fuertes without trying to recut its facets.'[13]

Fuertes remained close to the Thayer family, who lived in an enviably happy and relaxed way, despite Abbott's depressive tendency. A positive man, he seems to have had difficulty in accepting rejection of his ideas. For example, during the First World War he believed, quite reasonably, that his theories on protective coloration could have been usefully employed by the military. He received no support from the US government and when, with the help of John Singer Sargent, he approached the War Office in London his ideas were again rejected. To his chagrin he later learned that the Germans had developed camouflage techniques based on his theories.[14] The British military and naval authorities had perhaps learned their lesson in World War II, because R. B. Talbot Kelly was appointed director of camouflage for the Royal Artillery and Peter Scott, as a serving naval officer, was commissioned to produce some experimental designs for camouflaging warships.

Towards the end of his life Thayer went into deep melancholy. After a disagreement with Fuertes over the theories of coloration there was a breach between the two men who had been so close for more than twenty years. Sadly, it was not properly repaired before Thayer's death from a stroke on 29 May 1921.

LOUIS AGASSIZ FUERTES (1874-1927).
Great Curassow. Undated.
Watercolour. 381 x 279mm.
The detail of the head of the bird in the foreground compels the viewer's eye. Fuertes has also given attention to the eye of the bird on the vine, perhaps exaggerating its brightness with a highlight that is necessary to the composition of the painting, even if it is not a perfect recreation of what would be seen in the field.

The encouragement that Fuertes received from Thayer, Coues and Chapman was later replicated in his own encouragement of younger artists. His involvement was personal and most notable in the cases of Roger Tory Peterson and George Miksch Sutton. The contact between Fuertes and the man who was to take his place as the most famous birdman in North America was brief, but that was probably only because it was cut short by Fuertes's untimely accident. In November 1925 Peterson, a seventeen-year-old furniture decorator earning $8 a week, set out from Jamestown, New York, for the three-day congress of the American Ornithologists' Union in New York City. He had submitted two watercolours, one of a kingbird and the other a Ruby-throated Hummingbird, for the congress's art exhibition, and both had been accepted.[15] At this prestigious meeting at the American Museum of Natural History he was introduced to Louis Agassiz Fuertes. It must have been an overwhelming experience for the small town boy to meet his hero, the artist whose illustrations he copied when he first started drawing birds in grade school, especially when Fuertes asked him to point out his own work.

'Just what the great man said about these drawings I do not remember, but I know he was kind. Later, as we walked down the broad steps to the first floor of the museum, he reached into his inner-coat pocket and withdrew a handful of red sable brushes. Picking out a flat one about half an inch wide, he handed it to me, saying, "Take this; you will find it good for laying in washes." I thanked him and before we parted he added, "And don't hesitate to send your drawings to me from time to time. Just address them to Louis Agassiz Fuertes, Ithaca, New York". The young man never did send the drawings.

> And so, by delaying, I forfeited a priceless opportunity, for less than two years later Fuertes, only fifty-three, met his tragic death, hit by a train at a railroad crossing. As for the brush I never used it. I had discovered some white paint caked in the heel of the brush; the master himself had actually painted with that brush. Therefore, I put it aside as a treasured keepsake.[16]

Peterson appears, latterly at least, to have been aware of Fuertes's shortcomings. According to his official biography, he had concluded that Fuertes 'was primarily a portraitist and a brilliant one who has been the model and inspiration of many a young artist to this day... But somehow, Fuertes could not put a bird into a landscape convincingly. Three-dimensional activity – movement in space – was not his forte.'[17] Was this a reflection of Peterson's feelings about his own work?

Another artist who was inspired by Fuertes was Terence Shortt, a Canadian, who like Peterson saved his cents to go to an AOU congress. His motivation in saving for the 1927 congress was to meet Fuertes. When he learned of the railroad accident a few months before the congress Shortt cancelled his booking.[18]

A third North American artist, George Sutton, was more fortunate than Shortt or Peterson. He, too, was almost seventeen when he forged his personal link with Fuertes, but that was in 1915 and they were to remain close until Fuertes's death. Sutton had discovered the artist's work before he was ten. It was in the *Handbook of Birds of the Western United States* by Florence Merriam Bailey, which he found in the biology library of the University of Oregon, next door to the Eugene Bible University, where Sutton senior taught. It was in Eugene that Sutton began to draw birds seriously. 'My intense admiration for the Fuertes halftones in Mrs Bailey's book had a good deal to do with this,' he wrote some 70 years later.[19] It was not until his fifteenth birthday that he received his own copy. By that time the family had moved to Austin, Texas, and were shortly to move again to Bethany, West Virginia. When he was fifteen he had a short article about roadrunners published in *Bird Lore* and the following year one of his watercolours of a roadrunner appeared in the issue for January/February 1915.

Emboldened by the publication of his work young George Sutton wrote to Fuertes for advice. 'I had admired him for years. I had worshipped him from afar. His very name had fascinated me,' he wrote, 'He answered my first letter promptly, suggesting that I send him drawings for criticism.'[20] Just as he had been helped by Abbott Thayer, so Fuertes offered Sutton tuition if he made the journey from West Virginia to Ithaca. It was not until the next year that Sutton eventually managed to visit Fuertes, having saved money from labouring in a road gang at the very high rate of $3.50 an hour.

LOUIS AGASSIZ FUERTES (1874-1927).
Turquoise-browed Motmot. c.1911.
Watercolour. 229 x 342mm.
Fuertes felt at ease in tropical forests and de-
lighted in the birds he found. This motmot was
probably painted on an American Museum of
Natural History expedition to Colombia in
1911.

GEORGE MIKSCH SUTTON (1898-1982).
Sutton's Warblers. 1939.
Watercolour. 508 x 406mm.
Sutton was encouraged and taught by Fuertes.
As a professional ornithologist he was scrup-
ulously accurate and, following in Fuertes'
footsteps, he encouraged other artists to paint
birds accurately. Sutton's Warblers are now
known to be Yellow-throated Warbler x North-
ern Parula hybrids.

DON ECKELBERRY (b. 1921).
Dowitchers Feeding. 1956.
Oil on canvas.
Eckelberry's skills as a field ornithologist earned him employment with the National Audubon Society at 21. After two years in the field he became a lay-out artist and illustrator on Audubon magazine. Following the tradition of Fuertes as an ornithologist and artist, he was a much better picture-maker as this painting shows.

Sutton was ungrudging in his praise for Fuertes's generosity to him at the time when the great artist was at the height of his career. He reckoned that Fuertes was taking a great risk asking a young man of whom he knew very little to Sheldrake Springs where he and his family were spending the summer. 'He did not know whether I was diligent or lazy. I might for all he knew, be addicted to smoking cigarettes, carousing at night, lying abed mornings, talking incessantly, and whatnot. I was an unprepossessing young man, just past eighteen. My sisters and I knew something about manners. I was not grossly deficient in that field. But I had had very little worldly experience, and this lack must have been apparent in all that I did and said.'[21]

Despite these self-deprecatory remarks, or maybe because of the modest charm that lay behind them, the Fuertes family took to Sutton. Fuertes himself allowed the young man to watch him at work and showed him how to put on a watercolour wash, working fast as he moved a thick paint-laden brush across the paper and tilting the board so that it would flow downwards. When the wash was dry he added a number of dark marks that bewildered Sutton until he realised that Fuertes was starting from the darkest tones and working through to the palest. For Sutton the greatest revelation was that 'not every blessed feather needed to be painted separately.' At the end of Sutton's wonderfully vivid description of the process of Fuertes painting a phoebe he admits that he almost believed that the bird was about to swallow the moth that Fuertes had painted in its bill, so life-like was the painting.[22]

One of the illustrations on which Fuertes worked that summer was of a beaver for *National Geographic*. Having almost completed the illustration Fuertes decided that he disliked everything about the painting except the beaver's head. Aghast, Sutton watched as his idol scrubbed fiercely at the painting with sponge removing every part of the beaver but its head. He then repainted it. 'His new beaver was among the most effective drawings of the series.'[23]

At Sheldrake Springs Sutton was also introduced to the work of European artists. Fuertes expressed his admiration for the work of Archibald Thorburn, noting how soft he managed to make the feathers on his birds. His comments on the work of Bruno Liljefors are especially interesting since he drew attention to the Swede's ability to do something that he rarely achieved himself. '"Every Liljefors painting deserves close study," said Fuertes. "His birds and mammals are part of a habitat. He is just as deeply interested in their habitat as he is in them."'[24]

Before Sutton returned to West Virginia Fuertes gave him one of his old paintboxes, '...a treasure I was to take with me four years later down the whole of the Labrador coast, seven years later down the Abitibi River to James Bay, ten years later down the Missinaibi and the east coast of Hudson Bay, eventually time after time to the New World arctic, repeatedly to Mexico, once to Iceland. Never since the summer of 1916 have I painted a bird without having that battered old paint box close by.'[25] Their correspondence continued until Fuertes's death and his influence was clear in 'Doc' Sutton's painting. He became a museum man, working first at the Carnegie Museum in Pittsburgh for whom he went on collecting expeditions, catching, drawing and stuffing birds. Later he worked for the Pennsylvania Board of Game Commissioners and then went to Cornell University, Fuertes's *alma mater*, where he earned a Ph.D and went on to become Curator of Birds. After the war he taught first at the University of Michigan Museum of Zoology and then as Professor of Zoology at the University of Michigan where he was Curator of the Stovall Museum.

Sutton was an excellent teacher and must have been an engaging man. In 1972 when he was 75 he was described as 'more like an intense graduate student than a septuagenarian professor'.[26] The legacy of Fuertes continued both in his painting and in his encouragement of young artists, which included the practical contribution of $25,000 to enable colour plates to be used in the *Wilson Bulletin*.

Despite his apparently widespread influence few artists manage to match Fuertes's ability to capture the expression of a bird. Artists fail to capture the eye of the bird, which is its most important feature to both predator and prey. Don Eckelberry has not been afraid to show the eyes of the bird as they are. He will not paint the eyes in species in which the plumage pattern obscures them. The eyes of Black Skimmers do not show against their black plumage, but he was encouraged to paint highlights on the eyes of Black Skimmers in one painting at the behest of a print publisher. When the painting was returned he blackened

TERENCE M. SHORTT (1911-1986).
Madagascar Buzzard. 1976.
Watercolour. 356 x 251mm.
This Canadian artist worked for the Royal Ontario Museum and was an artist in the tradition of Fuertes, working both in the studio and the field.

JOHN P. O'NEILL (b. 1942).
Orange-cheeked Parrot. 1997.
Acrylic. 610 x 722mm.
O'Neill is an academic ornithologist who paints.
He has been a member of numerous expeditions and paints portraits of the birds he has encountered.

LAWRENCE B. MCQUEEN (b. 1936).
Golden-cheeked Warbler in Big-toothed Maple. 1991.
Oil on paper. 457 x 510mm.
One of the artists cited by McQueen as an influence is Fuertes. However, he is a stronger picture-maker and paints more often in the field. The looseness of his work gives a quality of immediacy and encourages a feeling of the birds being part of the environment.

JAMES FENWICK LANDSDOWNE (b. 1937).
Surf Birds. 1979.
Oil on canvas. 889 x 787mm.
Influenced by Fuertes' work, Landsdowne has been a leading bird portrait artist for several years.

BARRY VAN DUSEN (b. 1954).
Linnets and Thistle. 1995.
Watercolour. 305 x 254mm.
Among the younger generation of American artists in the tradition of Fuertes is van Dusen. Much of his work is completed in the field and the influence of European artists such as Busby, Ennion and Larson can be seen in his work.

he blackened the highlights. Eckelberry admires Fuertes, describing him as 'probably the best illustrator'[27] and it is possible to see Fuertes's influence in Eckelberry's field guide illustrations. He acknowledges this. 'The one who really impressed me and made me want to continue was Fuertes, because somehow he was so right about birds. His were so much what I saw when I looked at them, that I had a feeling that even if I'd never seen a bird, if I'd seen a Fuertes painting of it, I'd already know what it looked like when I did see it,' he told Todd Wilkinson.[28] However, Eckelberry took his ability beyond illustration into 'picture-making', even if he once wrote self-deprecatingly 'I think I've painted somewhere between six and eight good paintings.'[29]

The quality that several of his followers share with Fuertes is his inspirational ability. Several artists have benefited from Eckelberry's guidance. Wilkinson quotes Karen Allaben-Confer – 'Don has always been like a father with a whole bunch of kids but not doting. He is candidly critical and sincerely interested in our growth as artists... He is a genius and teacher of self-esteem. He never wants us to become other Eckelberrys but the best of ourselves.'[30]

Through the inspirational mentoring of Doc Sutton and Don Eckelberry the Fuertes influence has been carried to another generation as exemplified by Albert Earl Gilbert, Guy Tudor and John O'Neill, whose illustrations of South American birds are difficult to fault. Painting in a looser style, but sharing with both Tudor and O'Neill the ability to catch the expression of a bird, is Lawrence B. McQueen, whose work should be more generally appreciated than it is. Trained in both art and science, McQueen credits Fuertes and Eckelberry as being his major artistic influences. Like them he is a strong draughtsman, and unusually for a North American bird artist he uses this skill to produce very strong watercolours with little obvious line in them.

Interestingly, McQueen says Roger Tory Peterson had the greatest impact on modern bird illustrators. Because of him, according to McQueen, many of today's illustrations are more precise and more revealing of the artist's complete knowledge of birds than those of the past.[31] The contribution of Peterson is discussed elsewhere in this book, but it should be remembered that Fuertes was instrumental in firing the enthusiasm of the 17-year-old from Jamestown, New York. If he had done that alone he would have deserved our thanks, but even more important was the way in which he brought a disciplined combination of science and art to the depiction of birds that look as if they are alive.

Many artists claim Fuertes as an important influence on their work. In the catalogue of the 1979 *Birds in Art* exhibition at the Leigh Yawkey Woodson Art Museum, the 108 mainly Northern American participants quoted 146 artists as influencing them. Among those who received only one mention were Degas, El Greco, prehistoric artists and Chinese artists. Only five reached double figures: Francis Lee Jaques 12, Bruno Liljefors 13, Andrew Wyeth 14, Robert Bateman 18 and Fuertes 22. Four years later 133 artists had work shown, but they only quoted 137 artists as influences: not surprisingly more reached double figures, with Kuhn, Landsdowne and Rungius added to the total, but Bateman mentions had increased to 27, one behind Fuertes, Jaques had almost doubled to 21 and Liljefors reached 20. Looking through the catalogues to find this information, it is often difficult to see the links between the work of the exhibitors and the artists they claimed to follow.

JULIE ZICKEFOOSE (b. 1958).
Skimmers Three. 1997.
Watercolour.
Like many other American painters of wildlife
Zickefoose was inspired by Fuertes, although
subsequently she came under the influence of
other artists such as Lars Jonsson.

NOTES AND REFERENCES

[1] Letter to Keith Shaw Williams, 30 March 1922, Olin Library, Cornell University.

[2] Marcham, F. G. (1971) *Louis Agassiz Fuertes and the Singular Beauty of Birds*. Harper & Row, New York, p.xi.

[3] Parkes, K. C. (1992) Louis Agassiz Fuertes: life comes to art. *Value in American Wildlife Art: Proceedings of the 1992 Forum*. Roger Tory Peterson Institute of Natural History, Jamestown, NY, p.75.

[4] Parkes (1992) p.75.

[5] Sutton, G. M. (1980) *Bird Student*. University of Texas, Austin, p.50.

[6] Mengel, R. M. (1967) Review of *The Original Water-color Paintings of John James Audubon for The Birds of America*, ed. M. B. Davidson (American Heritage). *Scientific American* 216: 155-158.

[7] Marcham (1971) p.16.

[8] Parkes (1992) p.76.

[9] Peck, R. M. (1982) *A Celebration of Birds: The Life and Art of Louis Agassiz Fuertes*. Academy of Natural Sciences, Philadelphia.

[10] Peck (1982) p.32.

[11] Peck (1982) p.37.

[12] Peck (1982) p.42.

[13] Peck (1982) p.50.

[14] Norelli, M. R. (1975) *American Wildlife Painting*. Galahad Books, New York, p.181.

[15] Devlin, J. C. and Naismith, G. (1977) *The World of Roger Tory Peterson*. Times Books, New York, p.26.

[16] Marcham (1971) p.ix.

[17] Devlin and Naismith (1977) p.28.

[18] Peck (1982) p.95.

[19] Sutton (1980) p.19.

[20] Sutton (1980) p.49.

[21] Sutton (1980) p.57.

[22] Sutton (1980) p.57 *et seq.*

[23] Sutton (1980) p.64.

[24] Sutton (1980) p.62.

[25] Sutton (1980) p.64.

[26] Mays, V. (1972) A determined innocence. *National Wildlife* 4 no.2 (March/April), p.40.

[27] Hammond, N. (1986) *Twentieth Century Wildlife Artists*. Croom Helm, London, p.60.

[28] Wilkinson, T. (1993) Rara avis: Don Eckelberry – the rare bird of avian painting. *Wildlife Art News*, July/August, p.42.

[29] Eckelberry, D. (1992) The search for art in nature. *Value in American Wildlife Art: Proceedings of the 1992 Forum*. Roger Tory Peterson Institute of Natural History, Jamestown, NY, p.96.

[30] Wilkinson (1993) pp.40-41.

[31] Hammond (1986) p.137.

THORBURN,
THE ROMANTIC SCOTSMAN,
AND HIS FOLLOWERS

His Highlands are wild and remote fastnesses of golden eagle and ptarmigan,
unmarred by ski-lifts and conifer plantations.
His England is a land of small fields and dense oak woods,
of hedgerows dotted with wild flowers,
of deep snow in winter and glowing days in summer.

Simon Taylor[1]

To modern eyes Archibald Thorburn's appeal is his effortless evocation through his watercolours of birds and mammals of the countryside of late nineteenth and early twentieth century Scotland and England. His work has none of the visceral quality of Bruno Liljefors's, who was also born in 1860. While the Swede put both feeling and observation into his paintings Thorburn concentrated on observation, romanticism and a superb watercolour technique. Thorburn's influence on British painters has been great, but arguably less demanding as a template than was Fuertes's on North American wildlife artists. This may have been because his legacy was effectively modified from the 1940s onwards by Tunnicliffe, Scott, Ennion and Talbot Kelly.

Thorburn's watercolour skills were in the tradition of 'English' nineteenth century painters, but he was a Scot, born at Lasswade, near Edinburgh, on 31 May 1860, the fifth son of Robert Thorburn ARA, a successful miniaturist. Robert was commissioned by Queen Victoria three times to paint her portrait and she kept a miniature by him of Prince Albert on her writing table.[2] Thorburn senior worked in London for twenty years before returning to Scotland in 1856.

As a boy Archibald Thorburn would paint the flowers, twigs and other objects he found in the garden of the family home, Viewfield House. When he was twelve he was decorating hymncards at his local church with pen and ink drawings of birds.[3] Robert taught his son drawing and painting and appears to have been a strict disciplinarian, tearing up any work with which he was not satisfied. Thorburn, however, considered that his father had taught him more than anyone else.[4] Thorburn attended an art school in St John's Wood, London, for a short period. His progress was so swift that in 1880, as he turned twenty, two of his paintings were accepted for the Royal Academy Summer Exhibition. Two years later his first illustrations, one of a Kestrel and another of Blue Tits, were published in *Sketches of Bird Life* by W. E. Harting.[5] These were in black and white only. A year later his first colour illustrations appeared, 144 plates in *Familiar Birds* by W. Swaysland.[6]

The illustrations for Swaysland were apprentice work and occasionally rather clumsy. Within four years his first plates for Lord Lilford's *Coloured Figures of the Birds of the British Islands*[7] had become relatively sophisticated. Taylor[8] attributes this improvement to Thorburn's move to London after his father's death in 1885. He lived first in Stanley Gardens, Belsize Park, and later at Fellows Road near Primrose Hill, where Joseph Wolf, RI, lived and painted. Thorburn admired the Bavarian painter, who was almost certainly the best of the nineteenth century European bird illustrators, and a painter of epic scenes from nature. Wolf was born in Möerz, 15 miles from Koblenz, in 1820 and settled in London in 1848. Indeed, he was a superb illustrator as well as a painter of large and dramatic, sometimes rather sentimental, paintings. When Lord Lilford was looking for an illustrator for his monumental *Coloured Figures*, his first choice was Wolf, but the Bavarian, then in his sixties, declined on the grounds of his age, so Lilford approached J. G.

Keulemans (1842-1912), a Dutch artist living in England. The Dutchman had completed some 150 plates when he became ill and in January 1887 Lilford enlisted the aid of Thorburn.

The effect of the Thorburn plates was dramatic. They are in a different class from Keulemans's workmanlike, rather uninspired illustrations. The book was issued in parts and when in September 1888 Thorburn's first plates appeared in Part VII, demand increased threefold over previous volumes.[9] Southern, an enthusiast for Thorburn and founder of the Thorburn Museum in Cornwall, claims that in these illustrations 'for the first time in ornithological illustration, science and true art had been drawn together. No longer did the subjects resemble the dead skins from which they had been drawn, lifeless and motionless diagrams, unbalanced and often grotesque in posture and proportion.' These plates are indeed very different from most contemporary work and they signal the move from the nineteenth to the twentieth century in style, but since they were printed by chromolithography, a process that had more in common with the lithographs used in Gould's books of an earlier era, *Coloured Figures* has been described as the last bird book in the grand manner. Southern's strictures on nineteenth century illustrations are not quite fair, because they do not give enough credit to either Wolf or the little-known Scottish artist, Jemima Blackburn (1823-1909), each of whom painted birds from life. They also ignore Thorburn's use of skins for some species and his copying (with acknowledgements) three paintings by Wolf. One of these is of a Capercaillie in the drooping wing posture that Liljefors also favoured.

When the seventh and last volume appeared in 1898 Thorburn had completed 268 plates, more than half the total in the book. The work would influence birdwatchers for the next 100 years, because the plates were recycled in the three-volume *The Birds of the British Isles* by T. A. Coward[10] and from 1937 for more than 40 years in *The Observer's Book of Birds* by Vere Benson.[11] His work was therefore seen by a huge number of readers. James Fisher wrote: 'If re-editions, re-workings and re-exploitations be included, Thorburn has enjoyed more posthumous publication than any other bird artist except Audubon.'[12] I wonder if Fisher was correct in this assertion: Thomas Bewick's work would surely have edged slightly ahead by these criteria.

Thorburn's reputation was enhanced by his illustrations for the supplement to Dresser's *Birds of Europe.*[13] The bulk of his illustrative work was undertaken in the 1890s and the 1900s, but his best work was probably *British Birds,*[14] which he both wrote and illustrated and which was published in four volumes in 1915-6 by Longmans. His plates feature several individuals of different but similar species, a feature that has now become familiar in today's field guides, but the four-volume quarto book was never intended (and was far too bulky) for use in the field. Fisher gives a detailed chronology of the publication of the various editions and a bibliography of Thorburn.[15]

ARCHIBALD THORBURN (1860-1935).
White Stork. c.1893.
Watercolour and bodycolour. 250 x 175mm.
It was the illustrations for Lord Lilford's *Coloured Figures of the Birds of the British Isles* that made Thorburn's reputation. This plate shows the artist's debt to Wolf and is a fine example of the liveliness that set the illustrations apart from other books of the late nineteenth century.

This book was followed by *British Mammals*, which was published in parts in 1920. The illustrations, like those for *British Birds*, were painted in watercolour and bodycolour on tinted paper. Since there are far fewer mammals in Britain than birds, Thorburn was able to devote more space to each species. A whole page was given to each of the larger mammals, and he painted the smaller rodents, shrews and bats two to a page. The binocular vision of mammals makes them much easier to anthropomorphise. David Attenborough in his introduction to the 1974 reissue of *British Mammals* notes that Thorburn's illustrations draw on the Victorian tendency to humanise mammals, but he finds it acceptable: 'The hedgehog on Plate 7 does seem to be related to Mrs Tiggywinkle, and yet it remains firmly a real hedgehog and, what is more, a scientifically accurate one.'[16]

Thorburn was one of the first artists to use his skills to support the budding conservation movement. In 1899 his painting of Roseate Tern was the first Christmas card to be published by the RSPB. It was one of the earliest charity cards and included a verse by Alfred Austin, the Poet Laureate. Thorburn was to paint another 18 cards for the RSPB, which was a considerable contribution, because the artwork was donated to the Society and sold by them to raise funds: an exception was the 1933 Chaffinch, which in 1935 was presented to the Society's patron, George VI, on the occasion of his Silver Jubilee. His last card for the Society was a Goldcrest, which he struggled to complete from his bed during his final illness before his death in 1935.[17]

Thorburn continued to paint gallery pieces. His work hung in the Royal Academy on fifteen occasions in the last twenty years of the nineteenth century, but the pressure of his illustrative work and commissions, combined with disappointment at the way in which his work was hung high up where it was difficult to view caused him to stop submitting. Scott suffered similarly in the 1930s.

Thorburn's mentor, Wolf, insisted on the importance of drawing from life. He wrote to Jemima Blackburn on 11 January 1868 to congratulate her on the illustrations in her book, *Birds from Nature*. He included a reference to John Gould's (for whom he was painting at the time) never having drawn from life and therefore producing birds in conventional and uncharacteristic postures. He added, 'it is only the deplorable state of general ignorance in the matter even among naturalists which stands in the way of making this apparent at a glance.'[18] In mid-Victorian Britain an interest in natural history was more likely to be pursued in the study rather than the field and, among the wealthy, very likely to be pursued vicariously by employing 'lesser mortals' to go into the field, both at home and abroad, to collect specimens. Artists such as Wolf, Blackburn and Edward Lear painted from life, but they tended to use captive animals. By the end of the century naturalists were turning to fieldwork, which usually involved collecting specimens. Liljefors and Thorburn were among the first artists to paint and sketch in the field.

ARCHIBALD THORBURN (1860-1935).
Stag Beetle on Fly Agaric. 1928.
Watercolour and bodycolour.
This is typical of the romanticised view that Thorburn sometimes took. He has painted an extremely unlikely event. Stag beetles fly in midsummer, while fly agarics appear from late summer and there is no reason why the beetle should clamber over the fungus.

Liljefors was a hunter and Thorburn shot regularly in the 1890s, but he gave up after hearing the screams of a brown hare he had wounded.[19] Nevertheless he continued to paint gamebirds for the flourishing market among sportsmen. During the second half of the nineteenth century the nature of game-shooting changed. Rearing techniques had improved and the practice of driving the game over the guns increased the size of the bags. The Prince of Wales's enthusiasm for shooting made it a fashionable pursuit and that provided a market for paintings of their quarry. This was a market that Thorburn could satisfy, but his customers were well acquainted with the subjects, because they spent many hours in the field. Thorburn made regular trips to Scotland, particularly to Gaick in Inverness-shire and Loch Maree in Ross-shire. There he would paint Red Grouse, Ptarmigan, Black Grouse and Red Deer as well as the landscapes.

London, although convenient to an artist in many ways, was not ideal for field excursions, and in 1902 he moved to the village of Hascombe which nestles in a fold in the Surrey Hills. From High Leybourne, his fifteen-acre estate, he was able to wander through the woods down to the Juniper Valley to sketch birds, mammals, insects and plants. These sketches were of high quality and have an immediacy that many of his larger works lack.

The best of his larger works are stunning both in composition and execution, but he was a busy artist and, like his contemporary Liljefors, some of his work is of a lesser standard. Sometimes his rendition of plants falls from his highest standards. The relative sizes of individuals in different planes of a painting at times also caused him problems. This is especially noticeable in his paintings of meres and marshes where there are distant birds which have been painted too large in comparison with the birds in the foreground.

Comparing these larger paintings the same individual animals may be spotted, which suggests that they were based on sketchbook references. This is an inevitable result of being a prolific and popular artist, but weaknesses in the original drawing tend to be exaggerated each time they are copied. A male Teal with a very large head appears in several paintings. This is a feature copied by at least one other artist. Copying other artists' mistakes can create a very misleading form of 'Chinese whispers', as demonstrated by an experiment in which a student copied an Egyptian hieroglyph of an owl. His drawing was copied by another student, whose drawing was copied by a third and so on until nine copies had been made. By the tenth generation the hieroglyphic owl had turned into a pussy-cat with a bow.[20]

ARCHIBALD THORBURN (1860-1935).
Starling, Rose-coloured Starling, Nutcracker, Jay and Chough. 1913.
Watercolour and bodycolour. 540 x 400mm.
From *British Birds* (1915-1916). Longmans.
The metallic sheen on the Starling and the Chough show Thorburn's skill as a watercolourist. The bright colours and characteristic postures are typical of the four-volume book that Thorburn completed during World War I and which is now eagerly sought-after by ornithological book collectors.

Pl. 19.

Starling. (Summer & winter)

Rose-coloured Starling.
(adult & young)

Nutcracker
Jay.

Chough.

BASIL EDE (b. 1931).
Lady Amhersts's Pheasant. 1997.
Oil on canvas. 915 x 610mm.
A popular modern bird painter who has been
influenced by Thorburn is Basil Ede. Originally
working in watercolour, he now paints in oils.

ARCHIBALD THORBURN (1860-1935).
Wigeon and Teal in Winter. 1919.
Watercolour and bodycolour. 280 x 380mm.
The male wigeon in the centre of the painting
is a beautifully drawn bird of real substance, but
when he painted wigeon and teal Thorburn
tended to exaggerate the size of their heads.
Another feature of his duck paintings is the
tendency of the ducks to sit too high in the
water.

As a young artist Thorburn matured very rapidly and throughout his life he worked quickly. The speed with which an artist works does not mean that he or she is slapdash or indeed physically paints any faster than other apparently 'slower' artists. Speed usually denotes the concentration of the artist's work, while the slower artist may spend a far greater time in contemplation, or day-dreaming, or those household chores that really must be completed instead of painting. By the early 1890s, when he was in thirties, Thorburn had established a style that was immediately recognisable and which was to have many imitators, but his work varied over the years. Taylor suggests that it was during his thirties and early forties, between 1895 and about 1907, that Thorburn produced his greatest work, atmospheric, monumental double imperials,[21] but Southern favours the watercolours of the 1920s. One of my own favourites is a large water-colour of a Peacock with tail outspread looking at a Peacock Butterfly on the ground in front of him. This was commissioned in about 1914 by Vincent V. Vickers and passed into the hands of Philip Rickman (1891-1982), in whose drawing room I first saw it. When I admired it Rickman told me that Thorburn said he had had nightmares painting in the 'eyes' on the outspread tail. He also pointed out that when a Peacock spreads its tail it falls forward, sometimes obscuring its head. The painting is now at the Thorburn Museum.

The great artist appears to have been a modest, gentle man, 'very reserved and shy, quite unassuming and singularly modest when faced with praise, gentle and charming and invariably helpful and kind.'[22] With a neat full beard and white hair he seemed old to the young Peter Scott, who recalls in his autobiography meeting him as he was setting out on his own career as a painter. 'Old Archibald Thorburn, who painted the feathers of birds with exquisite truth (and may in that field, never be surpassed), had come to Leinster Terrace at the age of eighty. His advice had been wise and useful at the time, but it was not his road that I now wanted to extend into the jungle.'[23] (Thorburn died at the age of seventy-five, so Scott must have miscalculated the age of this grey-haired man.)

There are three artists who are particularly associated with Thorburn. These are George Lodge (1860-1954), Phillip Rickman and J. C. Harrison (1898-1985). Lodge, who was a contemporary, eight months younger than Thorburn, was a hunter, shooting birds and hunting them with falcons. Donald Watson suggests that Lodge had more in common with Liljefors than did Thorburn, who 'disliked all killing in spite of being greatly admired as an artist by the sporting public'.[24] Thorburn admired Lodge's ability to paint birds of prey and to capture their character so well. Watson, who lived in Surrey as a boy, recalled meeting Thorburn. 'Many years ago, when my brother and I were very young, we spent a glorious afternoon with Thorburn in his studio. He told us that some drawings on a side table were by his friend George Lodge and that he regarded him as the master at birds of prey.'[25] It is indeed as a painter of raptors that Lodge is best known. Watson says he was less happy at some groups than others;[26] this is noticeable in his illustrations for Bannerman's multi-volume *The Birds of the British Isles*.

With the exception of coveys of grouse or partridges, Thorburn found it difficult to paint birds in flight convincingly. His flying eagles are not at all lifelike, but then Wolf's flying birds were not always convincingly airborne either. Wolf, in common with Lodge, was a falconer and both of them were better at painting flying raptors than Thorburn. As Watson writes, drawing birds in flight is a special challenge and must have been more so when natural history photography was only in its infancy.[27] Lodge's brother, R. B. Lodge, was one of the pioneers of bird photography, but the artist denied that he either took photographs himself or that he had ever copied anyone else's.[28] He wrote: 'in painting pictures of birds, photographs should be used with the greatest caution.' His *Memoirs* has a chapter entitled 'Some Observations on Painting Birds' which contains comments about drawing and painting animals that are as pertinent today as they were when the book was published in 1946.

He discusses the problems of painting landscapes with birds or birds in landscapes and the problems of making pictures with the birds out of proportion to their surroundings. His solution was to be clear. 'If a *landscape with birds in it* is to be the subject for a picture, then paint the landscape first and put the birds in afterwards, taking care to keep them in proportion. But if it is to be a *picture of birds*, paint the birds first and add just sufficient landscape and foreground to give verity to the size of the birds.'[29]

ARCHIBALD THORBURN (1860-1935).
Common Terns and an Arctic Tern. 1921.
Watercolour and bodycolour.
When painting relatively small birds in open landscapes it is not easy to give an accurate indication of size. Thorburn has done it by including the remains of mollusc shells. The yellow flowers of the silverweed add colour and give depth to the painting.

ARCHIBALD THORBURN (1860-1935).
Study of a resting Mallard drake. Undated.
Watercolour and bodycolour. 267 x 314mm.
In his sketches Thorburn's skill as a draughts-
man can be seen very clearly. This is an aspect
of his work that can be obscured by the skill
with which he used paint in his larger paintings.
This study of a male mallard catches the
character of the bird.

GEORGE E. LODGE (1860-1954).
Peregrine Falcon on Rocky Outcrop. Undated.
Bodycolour. 405 x 534mm.
A contemporary and friend of Thorburn, Lodge
was better at painting birds of prey. In his long
life he produced a huge output and painted
almost all the bird species found in Europe.

JOHN CYRIL HARRISON (1898-1985).
Partridges in Flight. Undated.
Watercolour and bodycolour. 405 x 534mm.
Harrison at his best rivalled Thorburn and here
he has captured both the image of the birds
and the experience of seeing a covey of Grey
Partridges on a winter's day in Norfolk.

JOHN CYRIL HARRISON (1898-1985).
Peregrine Striking a Rook. Undated.
Bodycolour. 405 x 534mm.
Harrison was better at painting birds in flight
than Thorburn as this dramatic picture shows,
but compared with Liljefors' depictions of a
predator and prey this is rather clinical and slow.

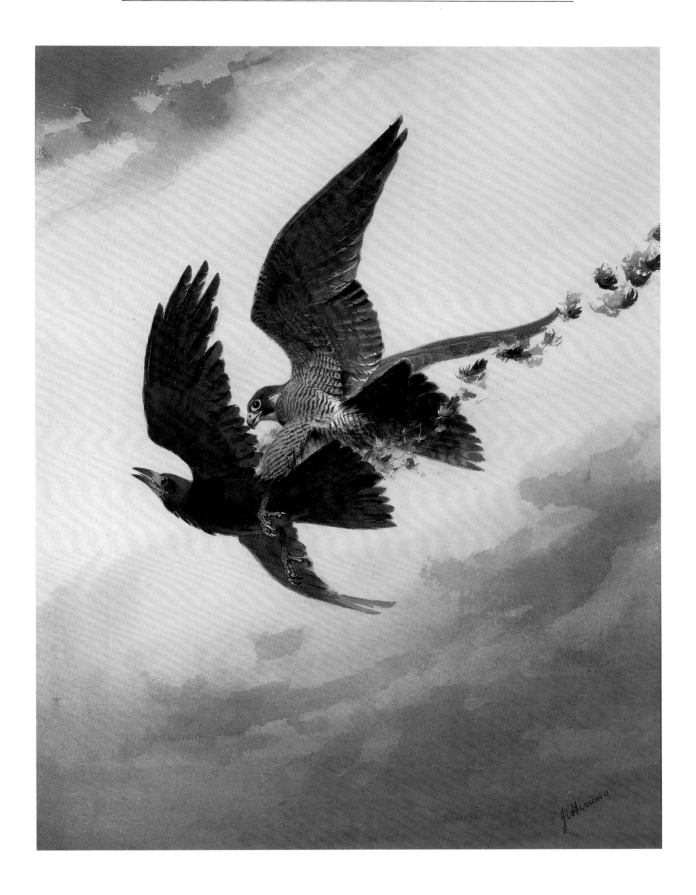

RODGER MCPHAIL (b. 1953).
Red Grouse. 1998.
Oil on canvas. 1016 x 1676mm.
Too often paintings of grouse give no idea of the size of the birds, because they are shown flying high over the moor with no points of reference. In this painting the birds on the bank on the right are put in context and none of the birds is allowed to dominate the painting. This painting catches the atmosphere of a grouse moor in a way that many more grouse paintings do not.

PHILIP RICKMAN (1891-1982).
Long-tailed and Eider Duck in the Surf. 1961.
Watercolour with bodycolour. 540 x 794mm.
A pupil of Thorburn, Rickman developed a first-
class watercolour technique. Although many of
his paintings are pretty rather than atmospheric,
this watercolour has movement and atmosphere.

Although Lodge claims to have got birds out of proportion to their surroundings 'many a time', he tended to avoid this snare more often than his friend Thorburn. When young much of his work was in oils and he made innumerable sketches in the field. His pictures were built up over several visits to a site. It was a great mistake 'unless you can hit off exactly the same kind of weather at the same time of day as when you started.'[30] The labour of carting his oil-painting equipment into the field became too much for him and, as he was unable to cope with watercolour, he decided that a pencil and small-sized sketchbook were the sensible field equipment.

Lodge's finished paintings rarely achieve the liveliness and immediacy of his field sketches. He used tempera to paint small pictures and book illustrations. When painting illustrations he became too absorbed in the structure of the birds' feathers, but his illustrations for Witherby's *Handbook of British Birds*[31] are only exceeded in liveliness by those of Peter Scott. Several artists were used in this classic five-volume book published in 1940, but the birds in Lodge's plates have a character of their own, with rather deep-set, expressive eyes and well-painted and atmospheric suggestions of landscape in the background.

All the plates in Bannerman's *The Birds of the British Isles*[32] were painted by Lodge. Each species was given a plate to itself and placed in a landscape. In some plates mammals were also depicted and it is these that Watson singles out for praise.[33]

Rickman was taught by Thorburn and painted with him at Gaick. He was another watercolourist of great skill, who could capture brilliantly the metallic sheen of the plumage of male ducks and pheasants. Like his master he sometimes drew ducks that appeared to ride very high in the water.

John Cyril Harrison was a skilled painter both of landscape and of birds. His flying birds were better than Thorburn's. You can almost hear the whirr of the wings of his partridges and his Golden Eagles, which he watched regularly in Skye with his friend, Seton Gordon.

Of the several imitators of the Thorburn school, skilful artists who exploited the market for gamebirds in landscapes, two artists stand out. Both hail from Scotland. Donald Watson (b. 1918) lived in Surrey as a boy where he met Thorburn. For many years he has lived in Galloway and his landscapes depict the rolling Galloway hills and the birds that may be found there, particularly the Hen Harriers. The other is Rodger McPhail (b. 1953), whose birds have a solidity that Thorburn never managed, and whose treatment of light and shade is superior.

Because Thorburn was an almost exact contemporary of Liljefors it is tempting to place them together. However, a more exact comparison is with Fuertes. In the early part of the century both these two great masters may be said to have inspired a school of wildlife painters. Liljefors, however, is the solitary master. Many may claim his influence but none has been touched with his genius.

DONALD WATSON (b. 1918).
Wigeon. 1956.
Watercolour and bodycolour.
As a boy Watson met Thorburn and watched him work. This watercolour of wigeon should be compared to Thorburn's painting on page 97. All of Watson's birds are substantial and each is painted with care. By restricting the field of view to omit the horizon he has reduced the difficulties of the comparative size of the individuals. Depth has been suggested by his having altered the directions in which some of the birds face.

NOTES AND REFERENCES

[1] Sotheby's (1993) *Works by Archibald Thorburn from the Thorburn Museum.* London.

[2] Southern, J. (1981) *Thorburn's Landscapes: The Major Natural History Paintings.* Elmtree, London, p.7.

[3] Sotheby's (1993) p.4.

[4] Southern (1981) p.7.

[5] Harting, W. E. (1883) *Sketches of Bird Life.* Allen, London.

[6] Swaysland, W. (1883) *Familiar Birds.* Cassell, London.

[7] Lilford, Lord (1885-1898) *Coloured Figures of the Birds of the British Islands.* Porter, London.

[8] Sotheby's (1993) p.4.

[9] Southern (1981) p.8.

[10] Coward, T. A. (1920) *The Birds of the British Isles.* Warne, London.

[11] Benson, S. V. (1937) *The Observer's Book of Birds.* Warne, London.

[12] Fisher, J. (1967) *Thorburn's Birds.* Ebury Press/Michael Joseph, London, p.6.

[13] Dresser, H. E., Sharpe, R. B. and Hay, A. W. (1871-1896) *A History of Birds in Europe.* London.

[14] Thorburn, A. (1915-1916) *British Birds.* Longmans, London.

[15] Fisher (1967) pp.7-9.

[16] Thorburn, A. (1974) *Thorburn's Mammals.* Ebury Press and Michael Joseph, London, p.8.

[17] Fisher (1967) p.5.

[18] Blackburn, J. (1993) *Blackburn's Birds* (ed. R. Fairley). Canongate, Edinburgh, p.13.

[19] Sotheby's (1993) p.6.

[20] Bartlett, F. C. (1932) *Remembering: A Study in Experimental and Social Psychology.* Cambridge University Press, Cambridge, p.180.

[21] Sotheby's (1993) p.7.

[22] Southern (1981) p.11.

[23] Scott, P. (1961) *The Eye of the Wind: An Autobiography.* Hodder & Stoughton, London, p.166.

[24] Savory, J. (1986) *George Lodge: Artist Naturalist.* Croom Helm, Bromley, p.80.

[25] Savory (1986) p.81.

[26] Savory (1986) p.82.

[27] Savory (1986) p.82.

[28] Lodge, G. E. (1946) *Memoirs of an Artist Naturalist.* Gurney & Jackson, London, p.87.

[29] Lodge (1946) p.81.

[30] Lodge (1946) p.83.

[31] Witherby, H. F., Jourdain, F. C. R., Ticehurst, N. F. and Tucker, B. W. (1938-1944) *Handbook of British Birds,* Witherby, London.

[32] Bannerman, D. A. (1953-1963) *The Birds of the British Isles.* Oliver & Boyd, Edinburgh.

[33] Savory (1986) p.89.

WORKING IN THE FIELD

It is only by drawing often, drawing everything, drawing incessantly,
that one fine day you discover to your surprise that you have rendered something
in its true character.

Camille Pissarro[1]

In the nineteenth century lack of effective optical equipment forced artists when composing their paintings to rely on dead specimens or captive animals in zoos. Today's artists work on drawings made of wild animals as they are observed in the field or use photographs on which to base their paintings. The paintings based on field sketches and those based on photographs differ both aesthetically and commercially.

Nineteenth century wildlife artists did venture into the field and saw the animals in their natural environment, but they rarely sketched them alive, preferring to shoot them and then paint them in death as if in life. Audubon must be the classic example and, wonderful though the finished plates are, most of them remain representations of dead creatures arranged in striking postures. Louis Agassiz Fuertes went a stage further and, although much of his work was based on dead specimens, he infused his paintings with vitality, because he had spent many hours watching his subjects in the field and impressing their images on his mind.

In the nineteenth century all zoological research was based on specimens shot and collected in the wild. The principle that 'what's hit is history, what's missed is mystery' still has its followers and until recently no new species could be added to the American Ornithologists' Union North American bird list unless evidence of its presence on the continent was supported by a dead specimen. Having the body is no guarantee that the specimen was collected at the claimed spot, however, as the case of the Hastings Rarities[2] shows. Between 1903 and 1919, twenty-eight new species of bird were added to the British list as a result of specimens that had been prepared by the Hastings taxidermist, George Bristow. He claimed that they had been collected in Kent and East Sussex, within 40 miles of Hastings. Although not all of these specimens may have been fraudulently presented, it is now thought that some at least had been imported from Siberia and other parts of the Palearctic in the new refrigerated ships. It was sufficient that in the 1960s seventeen of these species should be removed from the British list. Now all but one has been re-instated. George Bristow, himself, was probably an innocent dupe. The privileged upper-class clique that was responsible for the Piltdown man hoax may well have been involved in this hoax as well. Piltdown is a mere 25 miles from Hastings.

Working *en plein air* was a feature of the landscape painting of the French Impressionists. Their work had a noticeable influence on Bruno Liljefors. Although much of his work was done in the studio, there is a photograph of the Swedish artist, when quite elderly, sitting in a duck-punt, painting the rapidly changing effects of light on water[3], and there is another showing him, even later in life, painting *plein air*[4]. His field sketches were just one component of his reference material alongside shot specimens, captive animals, photographs and, above all, his knowledge absorbed through many hours' observation.

George Lodge was an expert field-sketcher but he used to carry a gun as well as painting equipment into the field. In the 1880s in Sweden, while painting at a frozen lake, to warm himself he went skating and heard a call similar to that of a Great Spotted Woodpecker. Curious, he went ashore and carrying a shotgun and still wearing skates he 'waddled' after the cry. The first woodpecker he encountered was a Green Woodpecker, which he shot; but he pursued another and shot that too. 'He turned out to be a White-backed Woodpecker and the first of this species I had ever seen. I was probably more pleased with the results of this diversion than of my sketching.'[5]

Not all wildlife artists rely on field sketches. Images become etched on memory and artists' eyes and minds are trained to retain what they have seen. Some need to do this through the process of committing

the image to paper. Others have the ability to absorb all the details of an animal through their minds. As the oriental artists did, they concentrate on the essentials, discarding anything extraneous. Joseph Crawhall (1861-1913) was a painter of people and animals, especially horses, and a member of the group known as 'The Glasgow Boys', which included Lavery, Guthrie and Walton. His biographer, Vivien Hamilton, can find no documentary evidence of the influence of oriental art on his painting, but she acknowledges that many aspects of his painting reflect its values: '...a brilliant and sensitive perception of colour, including the use of black as a colour; flattening forms by stark contrasts; stressing simplicity and refinement of form and line; daring to isolate a motif against an empty background; selecting fragmented images and unusual viewpoints; challenging traditional perspective and experimenting with distance and proportion.'[6] She adds that he shared with oriental artists the 'enduring love of nature and the ability to study, observe and record from memory the vital principles of motion and life as seen as natural forms'. She quotes his obituarist in the *Morning Post* (27 May 1913): 'In a word he did not copy the letter, but strove to aspire or attain the revealing spirit of oriental art. Long before he had seen a Japanese print or picture he did drawings which in marvellous degree unite objective and subjective realities – interpretative drawings that in negligible measure only depend for their appeal on factual accuracy, or mere verisimilitude.'

By concentrating on his subject without putting pen or pencil to paper, Crawhall was able to absorb its character. Cunninghame Graham wrote that he hardly ever saw him draw direct from nature. 'When he had to paint a horse, a dog, a goat, or any other animal... he would go and look at them for a full hour, with a look so intense it seemed to burn a hole into their skin. Then, perhaps, but rarely, he would take a pencil or a piece of coloured chalk out of his pocket and, on the back of an old envelope, set down cabalistic signs or dabs of colour... Next day, he might, or he might not, return and gaze another hour, and when one thought he had forgotten all about the animal, produce a drawing so life-like... that it forced one to regard the animal he had limned just as he must have seen it for ever afterwards.'[7]

Crawhall did not paint many wild animals, but those that he did paint are memorable images. In *The Rook's Nest* he gives us a view of a young Rook, possibly making its first flight in a whirr of wings, and in *A Trout Rising* a plump fish breaks the surface, its head shown in some detail, but the rest of its body is a shadowy submerged shape. Each of these is painted in gouache on linen and demonstrates how he has reduced the paintings to essential elements.

Crawhall has been a particular influence on some of today's wildlife artists. Richard Talbot Kelly, Eric Ennion and John Busby share his ability to dispense with anything but the most important parts of the image.

JOSEPH CRAWHALL (1861-1913).
The Rook's Nest. c.1908.
Gouache on linen. 562 x 437mm.
By stripping away detail Crawhall produced paintings of great action. Here a young Rook makes its first flight. The tension is shown in the clenched toes and the blur of the wings. By allowing the bird to fill the frame Crawhall has given the painting impact, but there is sufficient background to create the idea of the height of the nests in the rookery. Paintings such as this were influential on several wildlife artists including Talbot Kelly and Busby.

RICHARD TALBOT KELLY
(1896-1971).
Oystercatcher. Undated.
Oil on canvas. 483 x 584mm.
Talbot Kelly watched and absorbed what he saw
in the field. Back in the studio he would exag-
gerate features of the bird which he wished to
emphasise. Here the bill and the eye contrast
with the blackness of the plumage and the angle
of the head indicates the alertness of the bird.

RICHARD TALBOT KELLY
(1896-1971).
Grey Heron. Undated.
Watercolour and ink. 749 x 546mm.
The water and the vegtation have been reduced
to the simplest forms in order not to distract
attention from the heron, which in turn has
been simplified. More detail on the bird would
have destroyed the sense of movement.

Talbot Kelly was a professional soldier, joining the Royal Horse Artillery in 1915 and staying until 1929, when he resigned his commission to become art master at Rugby School. Painting was in his blood. Both his father and his grandfather were professional artists. He illustrated his experiences in the mud of the Western Front and started to paint seriously when posted to India in 1919, being elected to membership of the Royal Watercolour Society in 1923. He was compulsively active, as his son, Giles, recalled in a catalogue of an exhibition of his father's paintings. 'He would talk to you while he painted. I can never have seen him sitting still; even in his older age, he would be looking at other artists' work if he was not working himself.'[8] He must, though, have stood or sat still when he was looking at animals, because he believed in drawing from memory:

> Both Chinaman and Egyptian drew from memory, and I believe that is the secret recipe for preserving liveliness. Any way birds do not "sit" for one, not active free ones, that is. And it is their daily activities which provide the subjects and patterns for the painter. Cultivation of visual memory is the first requisite. It is a lifetime's work: more than an ordinary life span, in fact, is needed. This should be an encouragement to the painter for no staleness will occur so long as the answer is still to be found.[9]

Because he had such a clear impression in his mind of his subjects, and because he was so economical with line, he was able to paint very quickly. However, to judge a painting on the time it takes to put paint to paper would be to ignore the importance of the mind in the process. Giles Talbot Kelly describes his painting at a flat desk on 'dull, rough David Cox stock... and how he was able to make it shine with great heat or glaring light was nearly miraculous!'[10] He would stand and sit frequently, 'his mouth moving all the time, painting with both hands, using a mirror to verify tones and composition'. His son often watched him working:

> The concentration was total, the expertise astonishingly simple in the watching, at least. The paint was applied with brushes that always appeared some sizes too large to my eye, but were exactly suited to him. There was much water, and a cunning dextrous use of sponge and paint rag. He was an incredibly fast worker – after all, he would say, all he was doing was painting the picture; he already knew in his head what it should look like![11]

A striking aspect of Talbot Kelly's work is the limited palette that he used. A brighter, more varied palette would have made some of his simpler drawings appear rather cartoon-like. He believed that caricature could be used legitimately in making pictures, and he would exaggerate features, particularly the eyes, to achieve the features he wanted.

John Busby (b. 1928), Andrew Haslen (b. 1953), John Paige (b. 1927) and Peter Partington (b. 1941) give Talbot Kelly as a major influence on their work. John Paige was a pupil at Rugby School, but was never taught by Talbot Kelly, because when Paige was there he was back in the Army on war service as Chief Instructor in Camouflage for the Royal Artillery. In Paige's schoolboy notebooks, though, there are schematic paintings of birds that are reminiscent of Talbot Kelly. Paige, too, joined the Army and became a full-time painter later in life. Among wildlife artists he is unusual in the range of subjects he undertakes, regularly developing his drawing through figure studies.

Given Talbot Kelly's belief in painting from memory, it is interesting that each of his four disciples is adept at drawing in the field and fills many sketchbooks. Is the ability to draw from memory a rare skill or must these artists commit their sightings to paper as a way of fixing images in their memories? In the introduction to *The Way of Birds*, which contains drawings that are vibrant with his enthusiasm, Talbot Kelly asks:

> I believe that for many the appeal of bird-life is very real indeed. In the written work of men like Hudson, Selous and Williamson, the emotion has flowered magnificently into splendid prose, vibrant with natural beauty and truth. Have our painters felt this great joy of birds also? In their work in this country [United Kingdom], they seldom or never show it if they have. Yet in the ancient past, in Egypt and China, were many artists, schools of artists, who felt that same divinity in the life of the birds about which Selous and Williamson have written.[12]

ERIC ENNION
(1900-1981).
Greenfinch. Undated.
Watercolour.
The facility with which Ennion drew and the apparent simplicity of the result puzzles those for whom time spent on a painting is a criterion by which to judge it. Ennion's sketches did not take long to complete, but they represented a lifetime's experience of birds and drawing techniques.

JOHN BUSBY (b. 1928).
European Cranes Dancing. 1996.
Watercolour. 343 x 279mm.
This painting shows Busby's ability to capture the 'jizz' of a bird through studies made in the field.

JOHN BUSBY (b. 1928).
Red-necked Phalaropes in the Rain: Benbecula. 1996.
Watercolour and ink.
Another example where Busby has succeeded in capturing a bird's 'jizz' based on field observations.

JOHN PAIGE (b. 1927).
Angry Bull Grey Seal. c.1988.
Pastel. 457 x 508mm.
Paige has limited his palette to capture the bulk and solidity of the seals in contrast to the liquid texture of the sea.

DAVID DALY (b. 1956).
Aquatic Warbler. 1992.
Watercolour. 350 x 280mm.
The lack of detail in the background concentrates the mind on the bird and the fact that it is singing. If the artist had painted more detail the effect of the bird on his consciousness would have been diminished. The result is that the viewer is more convinced that he has really seen what he painted, because if he had been copying a photograph he might have been tempted to add realistic vegetation behind it.

DENIS CLAVREUL (b. 1955).
Barn Owl. 1997.
Pencil and watercolour. 420 x 300mm.
A watercolour of a hunting owl at twilight with half a sheet of sketches of the bird in flight. The shadowing Magpie in the painting can only have been the result of the artist really having witnessed this in the field.

ANDREW HASLEN (b. 1953).
Green Woodpecker. 1997.
Watercolour. 737 x 533mm.
Haslen's draughtsmanship and skilful use of paint gives this bird a solidity and by providing an extensive foreground of leaves and dandelion clocks gives a feeling of place to the painting without having to include an extensive landscape.

Four years his junior, Eric Ennion (1900-1981) has influenced more artists than Talbot Kelly. Not all of these are British: his followers include a Swede, an Irishman, two Americans and a Dutchman. All of the artists mentioning Ennion are exponents of drawing and painting in the field. Busby in the introduction to *The Living Birds of Eric Ennion* wrote: 'I doubt if any animal or bird painter has ever logged so many hours of watching. In this he saw more "subject matter" in the way of behaviour and the shapes and patterns of birds than perhaps any artist has ever done.'[13] Ennion himself explained his painting technique thus:

> I paint in the field as much and often as possible, but you can't take all your studio clobber out with you. I use as large a sketchbook as I can manage and one has to evolve rapid ways of painting. You obviously have to learn to draw very quickly, very accurately, and to develop a retentive memory of what you see. This comes with practice until, even with a bird in flight, you can put down exactly what you saw although the bird was moving the whole time... After I have been watching, say, a flock of birds I would probably come home with anything between 50 and 100 sketches, most of them no more than a slant of the wing or tilt of a beak. As soon as your memory runs out (or the bird has flown) never go on with the sketch. Don't try to fill in: be content with what you have got and, later, looking through your sketches, probably you will find three or four sufficiently advanced to make a final drawing from; and sometimes you can piece various bits together. In this way you are almost literally sketching direct from nature.[14]

Both Talbot Kelly and Ennion were gifted teachers, communicating enthusiastically and encouragingly. Ennion, who was a medical doctor, retired from practice after the Second World War and became the warden of a field centre in Suffolk. Later he ran a private field study centre on the coast of Northumberland. Its emphasis was on bird study and the days were full. John Busby recalled: 'At the dinner tables (presided over by the Doctor at one end and his wife at the other), the atmosphere was one of enormous good will and enthusiasm – bracing as the wide and windswept beach outside the windows.'[15]

Busby developed into an artist whose work is well-rooted in his ability to record what he sees in the field. 'I actually see more to record if I leave the house with a sketchbook in my hand and a pencil behind my ear (not literally) than I do if the means of drawing are packed away out of sight,' he wrote in the best modern book about drawing birds.[16] In the same book he also points out that as a drawing progresses the artist's perception alters: '...your eyes are giving you contrary information all the time. What you see after three minutes' drawing will be quite different from your immediate impressions, and from your understanding half an hour later, when your eyes have travelled over, through, and around the object of your drawing many times.'[17] Crawhall and Talbot Kelly, by preferring to concentrate on the subject, committing it to their memories avoided the confusion of gradually developing perception because the mental process they went through deleted the extraneous. For those interested in the creative processes of the artist, the absence of field sketches is the absence of evidence of the process of creation. Busby says 'The sketchbooks of Leonardo, of Constable, Braque, Andy Wyeth, Henry Moore, or of Fuertes or Tunnicliffe, are rightly prized for the light they shed on the artist's thoughts in search of expression.'[18]

The spontaneity of field sketches communicates the enthusiasm of the artist for what he is painting. Irish artist David Daly explains and confirms how important the action of drawing is in the process of picturemaking. 'When I go out into the "field" nature dictates what I draw. To me drawing is a way of expressing my feelings and what I see. There's always an image that triggers the desire to draw. The drawing forces a more intimate knowledge of the subject which in turn inspires the final painting.'[19]

Sometimes the artist can be overwhelmed by the opportunities presented in the field. Denis Clavreul, one of the members of the expedition by the Artists for Nature Foundation to the Biebrza Marshes, recalled being overwhelmed by the possibilities. 'When I arrived in Poland, I was like a child – there were so many things to draw. After a few days I calmed down and tried to be selective about what to draw.'[20]

ROBERT GREENHALF (b. 1950).
Curlews and Starlings, Pett Level. 1992.
Watercolour.
Many of Greenhalf's paintings are completed
in the field. Here he has painted the dry grasses
of a winter grazing marsh, where curlews roost
at high tide alongside starlings foraging for
seeds and invertebrates around them.

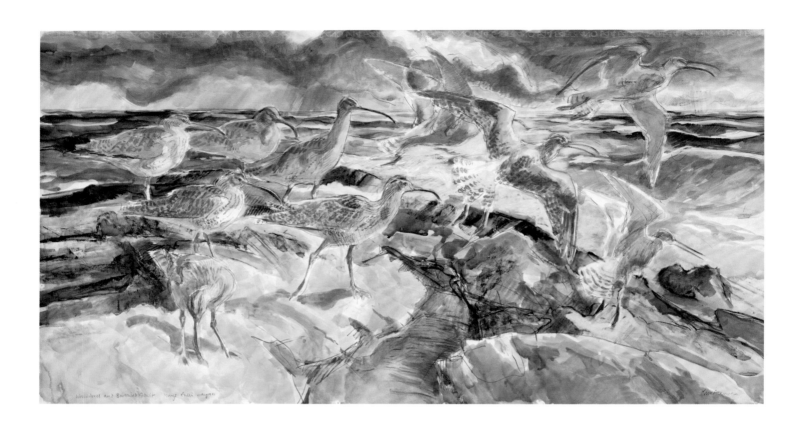

KIM ATKINSON (b. 1962).
Whimbrels and Black-tailed Godwits, Ynys Enlli. 1991.
Watercolour. 1270 x 685mm.
The reef on which these shorebirds have been
roosting is about to become covered by the tide.
Atkinson manages to convey the wind as well as
the tide. The limited palette used increases the
drama by omitting any distracting detail.

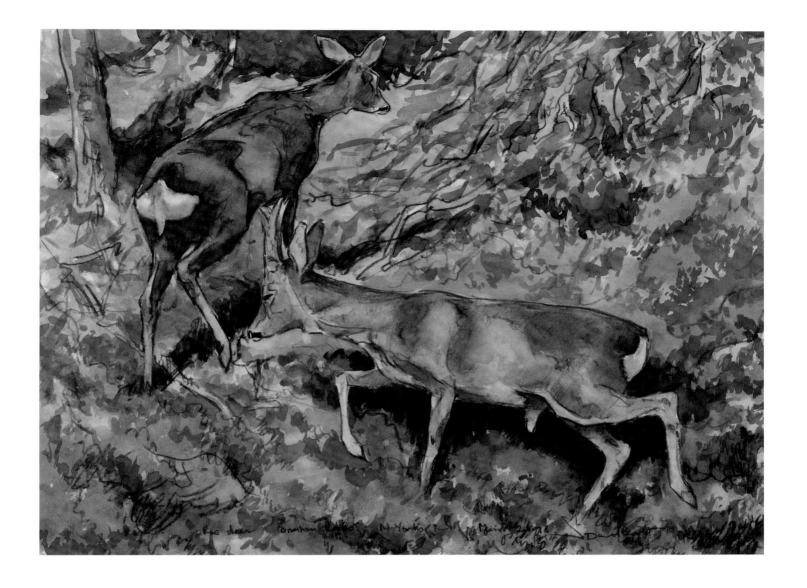

DAVID BENNETT (b. 1969).
Roe Deer: Brimham Rocks. 1998.
Watercolour.
This watercolour records an incident seen by David Bennett at Brimham Rocks in North Yorkshire. It has a narrative element that makes it more than a record of a single moment because these deer are clearly sentient animals which have appeared from the forest and are about to disappear into the forest again.

DAVID MEASURES (b. 1937).
Red Admiral. 1995.
Watercolour and ballpoint. 300 x 210mm.
All these drawings were completed in the field
and the butterflies have a liveliness that would
be impossible in a more detailed drawing based
on a dead specimen.

DARREN REES (b. 1961).
Chough and Bluebells. 1992.
Watercolour.
The unusual combination of a chough and
bluebells derives from Rees' experience in the
field. Unless he had seen the bird among the
bluebells no artist would have considered it.

EILEEN SOPER (1905-1990).
Badger. Undated.
Watercolour. 780 x 574mm.
This sketch was completed with a living badger
as the model and combines Soper's ability to
draw what she could see and her knowledge of
mammals.

KEITH BROCKIE (b. 1955).
Mountain Hare. Undated.
Watercolour.
As a field naturalist, Brockie brings his enthusiasm and knowledge to the subjects that he sketches in the field as a basis for his finished work.

PETER PARTINGTON (b. 1941).
Rock Pipit. 1992.
Watercolour. 127 x 279mm.
A field observation of a Rock Pipit on a clifftop
appearing from behind a clump of thrift was
the inspiration for this watercolour.

CHRISTOPHER SCHMIDT (b. 1965).
Siskin. 1997.
Watercolour.
Schmidt uses watercolour wash to give depth to this painting of a bird feeding in a snowstorm.

JEAN CHEVALLIER (b. 1961).
Wild Cat, Champagne. 1997.
Watercolour. 400 x 300mm.
These studies of a Wild Cat were made in the
wild in the Champagne region by French artist
Jean Chevallier.

BARRY VAN DUSEN (b. 1954).
Goldfinches. 1994.
Watercolour. 280 x 370mm.
American artist, Barry van Dusen, visited Europe for the first time in February 1994. In Spain he was faced with unfamiliar species and was able to draw them without his view being obscured by previous images, either within his own experience or from other artists' paintings of particular species.

MICHAEL WARREN (b. 1938).
Redstarts. 1994.
Watercolour. 306 x 187mm.
Many of Warren's paintings are completed in
the field, while others are based on meticulous
field sketches drawn in coloured crayons.

Another problem of ANF expeditions is the presence of other artists in the field: the enthusiasm is contagious. Some artists may even be rather intimidated by the speed and apparent ease with which others work. Bruce Pearson, Michael Warren, Kim Atkinson and David Bennett all work very rapidly and vigorously. Others may be more measured in their field sketching and like Keith Brockie and Barry van Dusen produce work that is as detailed as their finished paintings.

David Measures's field sketches may never be translated into finished paintings. He has sketchbooks covering many years of butterfly-watching. 'My work is not an attempt to make saleable paintings, it is a personal field notebook,' he wrote in the introduction to his beautiful *Butterfly Season, 1984.* 'What I record are the outdoor, free-flying, daytime activities in the wild, and something of the location in which I find them.'[21] He stops drawing the moment the subject disappears. He cannot rely on his memory even within minutes of the flight of the insect. 'I find that if I continue from memory I begin to generalise. My drawings are, therefore, often unfinished.' Because these drawings record what he has seen, they include plants and other animals in them, as they are an integral part of his perceived experience.

Barry van Dusen, on his first trip to Europe, found it best not to travel beyond the boundaries of the farm on which he was staying: '...all the birds of Extremadura were new to me, and I was as enthralled by the Robins, Goldfinches and Stonechats as by the Great Bustards and Black Vultures. For this reason, and because I found the finca's environments charming, I spent a good deal of time near the farm.'[22]

The principal references used by Charles Tunnicliffe were field sketches and measured drawings of dead specimens. His field trips produced a large number of sketchbooks, but he took the detail of the plumage of birds and the pelage of mammals from measured drawings made from dead specimens brought to him by local people or discovered on his field trips. These were the essential props of his craft and until 1974, when the Royal Academy mounted an exhibition of the drawings in its Diploma Galleries, most people were unaware of their existence. Two hundred and six measured drawings were exhibited with 103 pages from sketchbooks. Although he created these as a store of information for the future, Tunnicliffe achieved the most pleasing composition for each sheet. A comparison could be made with the fine florilegia commissioned by rich patrons from artists such as Redouté and Ehret, in which botanical information is presented in an aesthetically pleasing form.

Tunnicliffe regarded changes in plumage as 'an indispensable part of a bird artist's equipment'[23] and he advised would-be bird artists to visit museums to look at skins. However, he preferred to use freshly dead specimens, which he drew life-size if possible. In *Bird Portraiture* he described how he arranged the specimen to show various features including its wing outspread from both sides, the front of the head, legs and feet, and drawings of single feathers. His birds had to be as fresh as possible, because the colour of legs and bills begins to change soon after death.[24] 'Always record the colour of legs and bill from a live bird if possible.' Many of his models were road victims or gamekeepers' 'vermin'. One keeper he supplied with stamped addressed postcards so that he could be told quickly of any newly killed carcasses. His friend Reg Wagstaffe, curator of the Stockport Museum, would allow him to make drawings of fresh specimens as they arrived at the museum.

Writing the introduction to the book of measured drawings published in 1984, fellow-artist and friend Noel Cusa suggested that the drawings became an end in themselves and 'he was happy to devote unstinted time to make a careful record of a bird that he was highly unlikely to use.'[25] This is understandable, because for many the Tunnicliffe drawings eclipsed his commercial paintings, which tended to be too flowery.[26] Because of the high regard in which the measured drawings were held the quality of his field drawings might have been overlooked; but several volumes of the sketchbooks in various forms have now been published.

A countryman by birth and upbringing, Charles Tunnicliffe left Cheshire to study at art schools in Manchester and London. He illustrated Henry Williamson's *The Peregrine Saga*,[27] which started his interest in birds. Robert Gillmor, who has edited several of his sketchbooks, suggests that it was the opportunity to study the birds at a meeting of the Falconry Club that showed him the practical possibilities.[28] Later Tunnicliffe consulted Reg Wagstaffe, who instilled in him the need for a scientific approach. From thence,

CHARLES TUNNICLIFFE (1901-1979).
Bullfinch, Shorelands, 25th July 1954.
Watercolour and bodycolour.
This cock Bullfinch was sketched by Tunnicliffe
in his garden at Shorelands on Anglesey. Typical
of the observation is his noting of the stretched-
neck posture of the bird reaching forward to
eat the heads of Heart's-ease, and that the colour
of the breast was less vivid than in spring.

CHARLES TUNNICLIFFE (1901-1979).
Bullfinch (Measured drawing). Undated.
Watercolour. 470 x 584mm.
The accuracy of Tunnicliffe's representations of
birds was based on his field sketches and the metic-
ulous measured drawings of dead specimens.

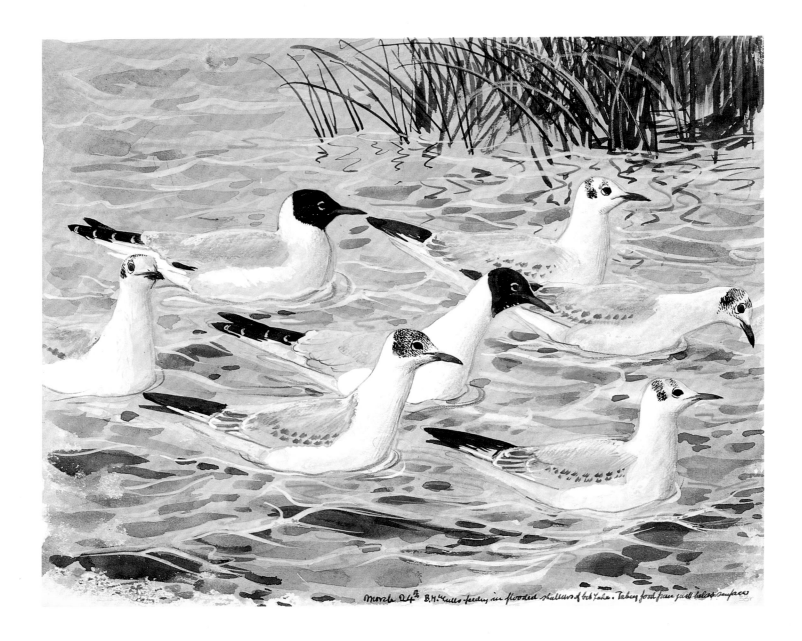

March 24th B.H. Gulls feeding in flooded shallows of Cob Lake. Taking food from just below surface

CHARLES TUNNICLIFFE (1901-1979).
Black-headed Gulls (Sketchbook). 1951.
Watercolour.
The handwritten note at the foot of this sketch notes that the gulls were taking food from just beneath the surface of the flooded shallows of the Cob Lake near his home on Anglesey. By his frequent excursions into the field Tunnicliffe was able to portray accurately such details as the position of birds in the water.

KEES DE KIEFTE (b. 1935).
Great Crested Grebes. Undated.
Watercolour. 215 x 185mm.
A series of sketches used by de Kiefte to build up a final painting of a pair of Great Crested Grebes.

138

BRUCE PEARSON. (b. 1950).
Sea Otters and Cub. 1997.
Watercolour. 290 x 410mm.
Artists on an expedition to the Copper River
Delta in Alaska were able to watch Sea Otters
closely from boats. The otters were so close that
it would have been tempting to rely on photo-
graphy for the detail, but Pearson chose to
sketch the animals as he saw them, not as the
camera saw them.

ROBERT GILLMOR (b. 1936).
Brooding Avocet Alarmed. 1997.
Watercolour. 155 x 225mm.
Sketched from life at the RSPB nature reserve at Titchwell, this painting catches the quality of light of the North Norfolk coast in spring as well as showing an aspect of bird behaviour.

he moved to his measured drawings, which he described as 'feather maps', and the small sketchbooks in which he drew in pencil, pen and crayon. Later he had sketchbooks made to his own specifications at Manchester Grammar School, sheets of heavier watercolour paper in different colours and tones. These he used in the studio after a day in the field to work up the sketches made during the day. For those whom the process of creating pictures fascinates, Tunnicliffe's sketchbooks are a delight.

Tunnicliffe was aware that birds have a low tolerance of human presence and, even when the human being is well-concealed, the subject is often lively and unlikely to hold a pose for many minutes. His advice is 'to watch, and watch, and watch again.'[29] He advises not to attempt to draw while the bird is in view, but to 'try to get accurate impressions photographed on your mind, so that when the bird finally disappears you can get to work on your sketch book, and set down impressions at once.' Other artists prefer to draw while the bird is in view, concentrating on the subject and making rudimentary sketches almost without looking down. Kees de Kiefte draws with his left hand and writes explanatory notes with his right.

Two developments of the latter part of the century have made life easier for the artist in the field. First came the improvement in telescopes, which has made them into an important birdwatching tool. For the wildlife artist the telescope has two advantages over binoculars. It can be fitted onto a tripod and does not have to be held to the eyes, leaving the artist both hands free, and it has greater magnification, bringing the bird even closer. In the 1960s Robert Gillmor, when painting seabirds on the island of Skokholm off the west coast of Wales, mounted his binoculars on a tripod; but he now uses a telescope. Another twentieth century development is the increase in the number of nature reserves and the provision of hides or blinds. The artist can sit in comparative comfort, usually dry, with the birds coming very close.

Working in the open brings many hazards. Albert Earl Gilbert (b. 1939), who has made several expeditions to the Neotropics, says that sweat stains on paper make drawing and painting in rain forests a difficult task. Bruce Pearson was unperturbed when a gust of wind deposited his sketch on a cowpat. It could be used as a reference in spite of its disfigurement. Darren Rees (b. 1961), claimed that rain spots improved his watercolour of a Grey Seal and he did not do anything to change it.[30]

In northern maritime climates painting *en plein air* demands great speed, because the constant shift in weather patterns makes it impossible to guarantee the same light at the same time from day to day; but where the weather is more settled the same painting can be extended over several days. Dylan Lewis (b. 1964), a sculptor and painter in oils, carries his studio with him into the African bush and because of the constant climate paints over several days. Bruce Pearson is another wildlife painter who carries his equipment into the field but, when working with oils, he uses field drawings to build up information for canvases painted in the studio.

There are no records of wildlife artists being attacked by their subjects (insect stings and bites are the worst injuries). Vadim Gorbatov, had a close encounter with a brown bear (recounted on p.60). Earlier artists who routinely took with them a gun as part of their equipment would have been appalled that Gorbatov had had no gun both for self-protection and for obtaining specimens to paint. In 1997 in the Bandavgarh National Park while on an Artist's for Nature expedition one artist seated on a young elephant was charged by a male tiger. On another occasion at one of the few places in the park where visitors are permitted on foot, Kim Atkinson and I strayed from the path to obtain better views of a party of junglefowl. Even in this place that was regarded as relatively safe, we found the front leg of a sambar and a recent tiger's dropping. Chastened, we returned to the track talking very loudly. It was not worth becoming a tiger's breakfast in exchange for a drawing of a flock of wild chickens.

DYLAN LEWIS (b. 1964).
African Heat, Impala. 1992.
Oil. 500 x 750mm.
Painted in the field, this small oil painting has an almost abstract composition as well as recording the artist's experience of seeing Impala seeking shelter from the heat of the sun.

NOTES AND REFERENCES

[1] Letter to his son, Lucien, translated by Lionel Abel, 21 May 1883.

[2] Nicholson, E. M. and Ferguson-Lees, I. J. (1962) The Hastings Rarities. *British Birds* 55: 281-384.

[3] Hill, M. (1987) *Bruno Liljefors: The Peerless Eye.* The Allen Publishing Company, Hull, p.58.

[4] Ellenius, A. (1996) *Liljefors: Naturen som Livsrum.* Bonnier Alba, Stockholm, p.76.

[5] Lodge, G. E. (1946) *Memoirs of an Artist Naturalist.* Gurney & Jackson, London, p.83 and p.87.

[6] Hamilton, V. (1990) *Joseph Crawhall 1861-1913: One of the Glasgow Boys.* John Murray/Glasgow Museums and Art Galleries, p.31.

[7] Cunninghame Graham, R. B. (1932) *Writ in Sand.* Pp.86-7, in Hamilton (1990).

[8] Wildlife Art Gallery (1992) *R. B. Talbot Kelly RI, SWLA, 1896-1971.* Lavenham.

[9] Talbot Kelly, R. B. (1955) *Birdlife and the Painter.* The Studio, London.

[10] Wildlife Art Gallery (1992) p.8.

[11] Wildlife Art Gallery (1992) p.8.

[12] Talbot Kelly, R. B. (1937) *The Way of Birds.* Collins, London, p.10.

[13] Ennion, E. A. R. (1982) *The Living Birds of Eric Ennion.* Victor Gollancz, London, p.8.

[14] Hammond, N. (1972) Eric Ennion. *Birds* 4(2) (March/April), p.41.

[15] Ennion (1982) p.9.

[16] Busby, J. (1986) *Drawing Birds.* Royal Society for the Protection of Birds, Sandy, Beds, p.19.

[17] Busby (1986) p.27.

[18] Busby (1986) p.28.

[19] Wexford Wildfowl Refuge (1996) *Drawn from Nature.* Exhibition catalogue.

[20] Hammond, N. (1994) Pushing back the barriers – Denis Clavreul. *Wildlife Art News,* January/February, pp.80-84.

[21] Measures, D. (1996) *Butterfly Season, 1984.* Arlequin Press, Chelmsford, p.11.

[22] Hammond, N. (1995) *Artists for Nature in Extremadura.* Wildlife Art Gallery, p.169.

[23] Tunnicliffe, C. F. (1945) *Bird Portraiture.* The Studio, London, p.29.

[24] Tunnicliffe (1945) pp.29-31.

[25] Tunnicliffe, C. F. (1984) *Tunnicliffe's Birds.* Victor Gollancz, London, p.8.

[26] Tunnicliffe, C. F. (1981) *Sketches of Bird Life.* Victor Gollancz, London, p.8.

[27] Williamson, H. (1934) *The Peregrine's Saga.* Putnam, London.

[28] Tunnicliffe (1981) p.7.

[29] Tunnicliffe (1945) p.14.

[30] Rees, D. (1993) *Bird Impressions.* Swan Hill Press, Shrewsbury.

ILLUSTRATION FOR IDENTIFICATION

Recognition is the first step toward preservation.
Every birder, for example, becomes to some degree an ecologist.
In political terms he is a conservationist.

Paul Brooks[1]

In earlier centuries safe identification of bird and mammal species relied on the collection of dead specimens. In the nineteenth century butterfly and bug hunting, not to mention field botany, were far more popular pursuits than birdwatching. But as binoculars improved, the appeal of field identification of birds increased.

In the late eighteenth century, Sir Joseph Banks had employed Sydney Parkinson as expedition artist to HMS Endeavour. He died aged 25 on the expedition, but not before he had produced exquisite drawings of the fauna and flora of Australasia. Later, in the nineteenth century, Louis Agassiz Fuertes went as an artist on private expeditions within the United States to Florida and Alaska before joining an American Museum of Natural History expedition to the Bahamas. Other expeditions in the United States and beyond followed; his last in 1926 was to Abyssinia (now Ethiopia). While the plates Fuertes completed for Elliott Coues's *Key to North American Birds* and for Edward Howe Forbush's *Birds of Massachusetts and Other New England States* were intended to aid bird identification they were not intended to be taken into the field. The earliest candidates for books to be regarded as field identification guides were published more than 30 years before Fuertes' death in 1927.

In Britain from the earliest years of the nineteenth century many books on ornithology had been published, and identification from the illustrations in Bewick and Yarrell could be made, but it was Thorburn's plates for Lord Lilford's *Coloured Figures of the Birds of the British Islands* that brought to life the birds of the British Isles. Of course this seven-volume book could never have been used in the field, but the illustrations could be used to learn the main field characters of the birds and to check them against field descriptions made by observers. Amazingly, in 1937 the Keulemans and Thorburn plates formed the basis of the *Observer's Book of Birds*. This was a genuine pocket-sized book and the inadequacies of the illustrations as an aid to field identification will be all too apparent to an older generation of British birders. Another pocket guide to the birds of Britain which this generation might have used was Edmund Sandars's *A Bird Book for the Pocket* published in 1927. Its illustrations by the author fall far short of the standard that might be expected in a reasonably accomplished birder's field notes and yet the *Glasgow Herald* when reviewing it said: '...for the purpose of the ordinary man who, taking a walk in the country, desires to identify the birds he encounters and to learn something about them, it would be impossible to imagine anything more suitable...' This review appeared less than ten years before the first Peterson field guide.

In 1996 Lars Svensson, the Swedish ornithologist and publisher, in a lecture to the British Ornithologists' Union, drew attention to books published in Europe which could be claimed as early field guides long before adequate books in English had been published. I. Ad. af Ström's *Svenska foglarna*[2] is described as being arranged systematically 'with names and brief fieldmarks as a guide for beginners in ornithology, and for sportsmen and game-lovers.' Its illustrations by Wilhelm von Wright included some excellent black and white plates of bill and head shapes. Henri Berthoud's *L'Esprit des Oiseaux*,[3] published in 1867 with illustrations by D'Argent, was also arranged as a field guide, while the first book to convey the notion of 'field guide' in the title was Alwin Voigt's *Exkursionsbuch zum Studium der Vogelstimmen*,[4] published in 1894.

Peter Tate in 1979[5] proposed *Our Country Birds* by W. J. Gordon, published in 1892 with illustrations by G. Willis and R. E. Holding, as the first field guide in English. Each plate gave the reader a chance to

compare similar-looking species, but the quality of the illustrations was not good. His second candidate was W. B. Alexander's *Birds of the Ocean*, published in 1928, with photographic illustrations, brief descriptions and notes on range and identification characters.

J. A. Shepherd's *The Bodley Head Natural History* (1913) could be the precursor to the field guide as we know it, but the book's pocket size was coincidental. It was not designed for use in the field, but the illustrations scattered through the broad margins of the page were intended to aid identification. The simple schematic illustrations drew attention to the field characters of each species. Shepherd was an illustrator and a prolific contributor of cartoons to *Punch*. These illustrations in *The Bodley Head Natural History* were very different from the plates of birds with which most readers would have been familiar. The publisher gives a cautious warning in a prefatory note:

> Mr Shepherd's illustrations to this volume do not aim so much at scientific accuracy as at giving a general impression of character, habits and appearance of the animal depicted. It is believed that in this respect they will be found certainly more artistic and probably more suggestive than elaborate plates or even photographs. All the studies with the exception only of those of one or two very rare birds are drawn from life.[6]

It is the suggestion in the drawings that makes them so admirable. They suggest the combination of shape and movement that make up the hard-to-define quality now described as 'jizz' by some naturalists. This is a quality that is difficult to translate to an immobile, two-dimensional medium, but Shepherd was one of the first artists to come near to achieving it (excepting of course the Cro-Magnon cave-painters, Chinese and, later, Japanese painters of animals). Shepherd was aware that the person trying to identify birds has to contend with a living animal liable to change its position and possibly its shape in a fraction of a second. His illustrations allow for this, and as the reader is plunged into a description of the Song Thrush depicted in five different postures, of which the most notable is that upright, calculating posture in which the bird sizes up its next meal, an oblivious garden snail. The succeeding pages feature large-eyed, round-bodied, tailless juveniles, clearly drawn from life. Each depiction builds a picture of the whole bird in all its aspects.

Because his birds are drawn from life, Shepherd's book is an ideal tool for the birdwatcher who draws the birds as he or she sees them in the field. An amateur non-artist's field sketches are necessarily schematic and the detailed plumage maps in some books may be discouraging. There is no better way of forcing the observer to look analytically at an animal than for him to record all the obvious characteristics in a combination of notes and drawings. Remarkably few contemporary naturalists do this. There is no time today for such a painstaking procedure. We want to travel on as far as we can to see as much as we can, and there is no time to sit and draw what is in front of us. Round the next hill or the next piece of marsh there may be another species to add to our list. Field guides make it relatively easy to identify (not necessarily always accurately) different species, and thus the observer may feel that it is not necessary to try to record on paper what he or she is looking at. The ordinary person's competence to draw has declined, and the ability to make a passable drawing is no longer regarded as a desirable skill. And why should it be? Cameras have eliminated the need for drawings to act as the record of objects or landscapes.

While field guides may have made some people lazy, they have opened millions of people's eyes to the animals around them. That an estimated 80 million people watch birds regularly in North America[7] is largely the result of a conversation between two young naturalists watching ducks on the Hudson River in December 1930. Within four years the world's first proper field guide was published, whose title, *A Field Guide to the Birds*, symbolised the simplicity of its conception and execution. Its author and artist was Roger Tory Peterson. It requires a particular creative genius to devise a scheme that with hindsight seems obvious.

The 25-year-old Peterson was counting Canvasbacks on New York's Hudson River with his friend, William Vogt, a young drama and nature columnist on five Westchester newspapers. Later the journalist described the day as 'Whistlerian gray'. 'Roger possessed a prodigious keenness of sight and hearing, and

46 GOLDEN CRESTED WREN

another uttering his insect-like "si-si-si." His voice is weak, but he uses it incessantly on fine days. He is sociable, and frequently hunts in company with tits as well as his own species, particularly in winter.

It is in autumn that the Gold Crest attracts most notice. The migrating hosts sometimes appear on our shores in early August, but the usual time of arrival is from September to October. A memorable year was 1882; the "migration wave" began on the 6th August and continued for 92 days reaching from the Channel to the Faroes. In 1892, after it had been blowing half a gale from the east from the early morning of 14th Oct. to the morning

GOLDEN CRESTED WREN 47

of the 16th, Mr. John Cordeaux thus described the autumn influx:—"During this time the immigration was immense; greatest in number were the golden-crested wrens. First I heard their notes on opening my window on the morning of the 14th and soon saw some in the garden below; they swarmed in every hedgerow; but on Saturday the 15th the number had enormously increased. Gold crests everywhere, in hedges and gardens, dead thorns and hedge-trimming, rubbish heaps, beds of nettles, and dead umbelliferæ, the reeds in ditches, sides of haystacks, and the thorn fences of sheds and yards. The sallow thorns were densely crowded, many

J. A. SHEPHERD
Goldcrests.
From *The Bodley Head Natural History* (1913). The lively illustrations by Shepherd for *The Bodley Head Natural History* were years ahead of any other book illustrations and predated the schematic illustrations of Peterson's first field guide by twenty years.

AMERICAN MERGANSER

RED-BREASTED MERGANSER

HOODED MERGANSER

BUFFLEHEAD

GOLDENEYE

BARROWS GOLDENEYE
MALE

ROGER TORY PETERSON. (1908-1996).
Mergansers and Goldeneyes. 1934 .
From *A Field Guide to the Birds.* Houghton Mifflin.
Peterson's original field guide was not illustrated in colour
and the patterns of the birds' plumage were schematically
represented. When later editions contained new artwork,
more conservative readers criticised the new illustrations as
being less life-like, an example perhaps of life imitating art.

ROGER TORY PETERSON. (1908-1996).
Bay Ducks (Divers). 1990.
From *Western Birds*. Houghton Mifflin.
In later editions of his field guides, Peterson's
illustrations became less schematic and showed
the moulding of the birds more clearly.

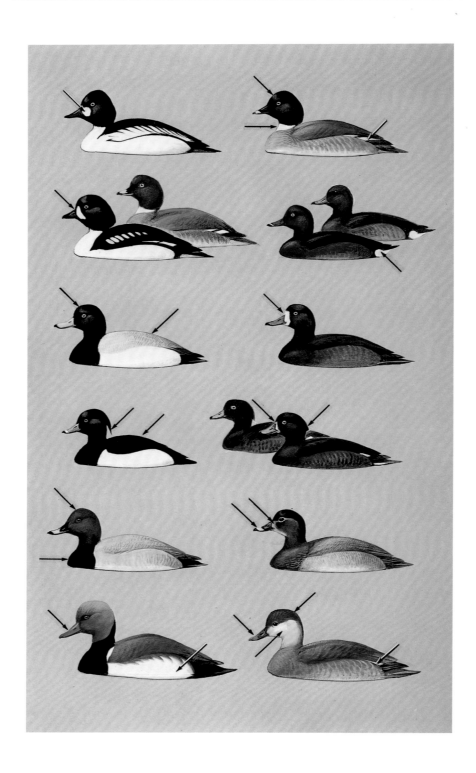

ROGER TORY PETERSON. (1908-1996).
Diving Ducks. 1954.
From *A Field Guide to the Birds of Britain and Europe.*
(Collins.)

on this particular December morning I was again impressed by his expertness. I was a mere bumbler by comparison. "Roger," I said to him, "you know more about identifying the birds of this region than almost anyone else, and you can paint. Why don't you pass on your knowledge to other people in a book?"[9] The artist at first had less enthusiasm for the project than Vogt, but the idea was developed as they walked the mile back to their car. Peterson could not believe that they could find a publisher but Vogt guaranteed to find one, if he would do the book 'with no justification whatever'.[10]

For the next two years Peterson, working as a teacher at a prep school in the Boston suburb of Brookline, painted and wrote his field guide in the evenings. When his colleague Al Maley saw some of the drawings and Peterson explained what they were, he was enthusiastic. 'Roger showed me the silhouette drawings on ten-by-sixteen Whatman board, and I knew it would be a great help in identification. I didn't know it would revolutionize the art.'[11]

Vogt kept his promise and took the book to five publishers. Peterson remembered the identity of three, two of whom rejected the book because it would cut across projects they were working on; Houghton Mifflin, of Boston, accepted it, but were hesitant, seeking advice from the National Audubon Society's Richard H. Pough, who was thoroughly enthusiastic. A cautious print-run of 2,000 was decided. Within a week of publication it was being reprinted. Peterson's reputation was assured and the first of the Peterson/Houghton Mifflin series of field guides that were to inspire a new genre of identification guides, from many publishers in many lands, was underway.

Why did no one come up with idea before? Until the 1930s birdwatching was the interest of a small minority. And why was it in North America that the idea arose? Despite being a minority interest, ornithology was pursued with much more verve in North America than in Europe. At that time the American ornithological establishment was more encouraging to artists than their equivalents in Europe. The National Audubon Society used the work of artists extensively and the two premier ornithological societies, the American Ornithologists' Union and the Cooper Ornithological Society, both had art exhibitions at their congresses. Art shows at ornithological conferences in Britain and Ireland seem only to have been introduced in the 1960s, thanks largely to the efforts of Robert Gillmor, who has done so much to promote the cause of wildlife art in the United Kingdom.

Peterson's field guide increased substantially the number of birders in the United States and changed their habits. William H. Thompson III, editor of *Bird Watcher's Digest*, has written:

> Shotgun bird identification fell into deserved disfavor in 1934 when Roger Tory Peterson, considered the father of modern bird watching, published the first modern field guide... No longer were birds identified over the sights of a shotgun – now, the magnified view of the bird as seen through binoculars was all that was needed... Once separated from the shotgun, the popularity of bird watching soared, and the birds breathed a collective sigh of relief.[8]

European birdwatchers had to wait another twenty years before *A Field Guide to the Birds of Britain and Europe* was published. Peterson collaborated with two leading British ornithologists, Guy Mountfort and P. A. D. Hollom, on this book. Its publication changed birdwatching in Europe as it had in the States. It has been translated into most European languages, the German translation selling best of all. 'Peterson' revealed how you could identify birds from drawings executed in flat colours with an emphasis on shapes. It made identification so much easier than had all previous bird books, which were mostly illustrated with romantic feather detail, feather-maps by cartographers who allowed their fascination with barb and barbule to obscure the shapes and colours that the birdwatcher sees.

In the European 'Peterson' the authors in their preface to the first English edition said they tried to meet three seemingly conflicting requirements. 'Peterson' was to be an authoritative reference book for the serious birdwatcher small enough to carry in a pocket; a guide for beginners who wanted to identify the birds they saw around their homes; and a guide for the increasing number of people who were travelling abroad and wanted to identify the birds they saw in Europe. 'Absolute simplicity is its keynote,' they wrote.[12]

Simplicity, however, has not been maintained in all the succeeding field guides. Graduations of light and shade have entered those schematic illustrations. In 1950, Peterson repainted the illustrations for a new edition of the Northern American *Field Guide*, but the original illustrations had taken on their own reality. Peterson thought that his new illustrations were better than those he painted as a twenty-five-year-old, but many of his followers did not agree. Those Peterson images had become engraved on their minds. A similar confusion of image and reality occurred in Europe. When I saw my first Alpine Accentors I was disappointed that the birds in the flesh did not match up to the illustrations painted by Thorburn and Peterson. When I told Peterson this, he smiled and replied that he had never seen one in the wild and that he had had to work from skins. The odd aspect of my disappointment was that the bird itself disappointed rather than the illustration.

In 1941 Peterson published *A Field Guide to Western Birds*. Guides to other subjects followed with Peterson as the editor, but not as the artist. He painted the illustrations for the European bird guide and for *A Field Guide to the Birds of Texas and Adjacent States* (1960); thereafter he painted the plates for *A Field Guide to Wildflowers (Northeastern and North-central America)* in 1968 and for *A Field Guide to Mexican Birds* published in 1973. Although it was field guides that made his name, they did not come easily. Writing an appreciation after his death and recalling his kindness to her as a young artist, Julie Zickefoose wrote:

> He freely expressed his deep admiration for painters of wildlife in the landscape, past and present – Bruno Liljefors, Bob Kuhn, Robert Bateman, Lars Jonsson – and lamented the time he himself spent on the comparatively stultifying field guide plates that were the backbone of his work. "Painting field guide plates is like sweating blood," he once told me. "Sometimes I have to force myself to sit down at the drawing table to do it." Why, then, didn't he just quit? He had more than earned the right to rest, to wander the meadows and marshes of Old Lyme with easel and paintbox, camera and binoculars.
>
> His artist's soul saw only one goal, and that was perfection. A less dedicated person might have sized up the maelstrom of bird identification books that rose up in the wake of his field guides and slipped quietly aside. Roger Peterson never quit. He was in the game for life.[13]

While Houghton Mifflin dominated the market for field guides in the USA, in Britain James Fisher, the natural history editor of Collins, initiated a series of guides that swept the European market. Fisher himself was a charismatic figure in international ornithology. He was, as it happens, a close friend of Peterson, and it was natural that he should take up his ideas and adapt them for Europe. As a naturalist and broadcaster, Fisher had a reputation far beyond that of a mere publisher, although he was grateful to Billy Collins, the chairman of the publishing company, for his enthusiastic support. Fisher too had written arguably the most influential book on British ornithology in the mid-20th century. Published in 1966, *The Shell Bird Book* is an unchallenged source of the history of ornithology in the British Isles and its insights still inspire a new generation of birders.[14]

Collins worked through a network of European publishers. In 1967, *The Field Guide to the Mammals of Europe*, written by F. H. van der Brink from the Netherlands and illustrated by Paul Barruel, the leading French wildlife artist, was published. It was followed the same year by *A Field Guide to Freshwater Fishes* and in 1974 by *Animal Tracks and Signs*. Because these guides were essentially European, they were all translated into the major European languages.

In 1946 Richard Pough's *Audubon Bird Guide*, with illustrations by Don Eckelberry, then a young artist employed by the National Audubon Society, was published. Eckelberry, like Fuertes, could breathe life into bird paintings and his plates are still among the most attractive of all field guide illustrations. The book sold over a million copies. He later illustrated *Birds of the West Indies*, published by Collins in 1963.

A second American illustrator to compete with Peterson was Arthur Singer, whose *A Guide to Field Identification of Birds of North America* was published in 1966 by Golden Press. In 1970 *The Hamlyn Guide to Birds of Britain and Europe*, also illustrated by Singer and the first direct competitor in Europe to 'Peterson',

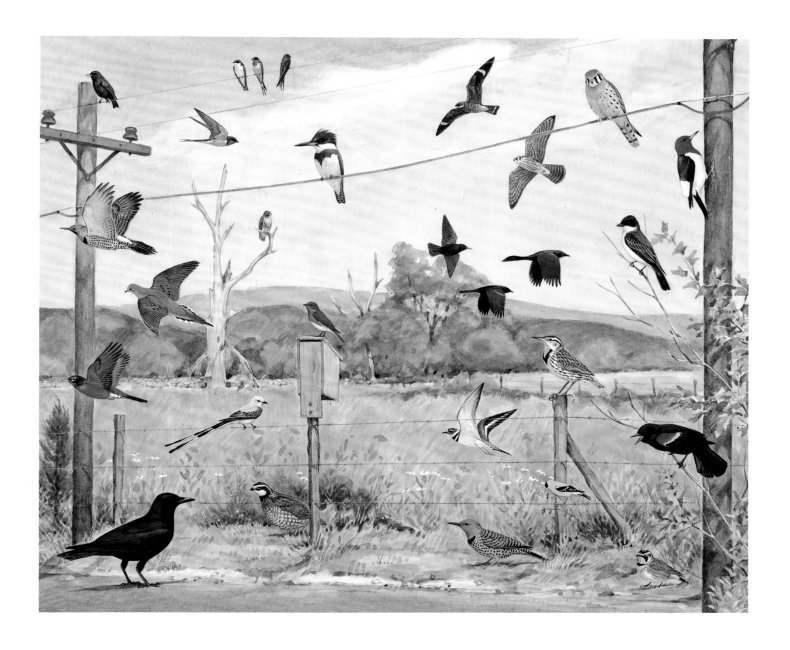

JAMES COE. (b. 1957).
Common Roadside Birds.
From *Eastern Birds: A Guide to Field Identification of North American Species* (Golden Press, 1994).
Watercolour.
A feature of Coe's field guide is a series of plates showing a variety of birds in a single habitat. This helps the newcomer to put the birds into context within the habitat and to give an idea of the comparative sizes of different species.

was published and welcomed because the text relating to the birds was opposite the illustrations. Singer's European birds were not as good as his North American birds; but a feature of his field guide was the inclusion of small vignettes demonstrating typical bird behaviour. This, of course, was not an innovation. It had been a feature of the plates in the books published by John Gould in the nineteenth century, where in the background beyond the portrait of the bird would be an incident of behaviour. These hints of a distant countryside are one of the most attractive aspects of the lithographs.

Habitat plays an important role in James Coe's first-class illustrations in his *Eastern Birds: A Guide to Field Identification of North American Species* (Golden Press, 1994). He has painted plates of species that share the same habitats, and plates of species which might be confused with one another despite not being taxonomically closely related. One plate includes Osprey, Black-crowned Night Heron, first-winter Great Black-backed, Herring and Laughing Gulls, Gannet, Caspian and Common Terns, Great Shearwater, immature Black Skimmer and Snowy Owl.[15] For the newcomer such a plate begins to clarify the importance of studying the different shapes of birds.

In 1983 the *Field Guide to the Birds of North America*[16] was published by the National Geographic Society. As might be expected, the National Geographic's huge resources and production know-how made possible a field guide which was a guaranteed bestseller. The field guide itself is a joint effort. Twelve main artists were involved and a score of writers and editors. The National Geographic has now, if not replaced 'Peterson', challenged it as the best selling field guide to the birds of North America, particularly perhaps amongst more skilled birders. Does it deserve to do so? As it is the work of so many hands, predictably its quality is uneven. Is its main appeal to listers the fact that all North American birds are included? But Singer's 'Golden Guide' also included all North American species with moderate success.

Behaviour as a guide to identification is a feature of Peter Hayman's illustrations. His birds do not appear in a convenient portrait profile with the females dutifully lurking behind their more colourful mates. Many of them are shown from the rear, a view all too familiar to many of us, in flight and searching for food. An architect by profession, his illustrations are meticulously painted – the plumage is based on museum skins and the behavioural aspects on field sketches. *The Birdlife of Britain* (1976) was too large for the pocket or even the rucksack, but in his foreword the Prince of Wales said that he would make sure that the book would accompany him at all times, 'on the bridge of my ship and in the front of my car'. Since not all the readers had ships' bridges on which to keep their copies of the book, the publishers produced a pocket version, smaller even than the standard field guide but arranged according to similarity of species rather than a recognised taxonomic order. *The Mitchell Beazley Birdwatcher's Pocket Guide to Birds* (1979) is one of the most practical of bird guides. A series of guides on other areas of natural history followed, including a pocket guide to butterflies with superb illustrations by Richard Lewington. As well as the standard spread-wing the butterfly is also shown with closed wings, as it is most often encountered and when it must be identified by the pattern of its underside. As yet few illustrations of insects have been drawn which assist identification at a distance, and yet butterflies and dragonflies may be frequently identified from their behaviour. Bjorn Dal in *The Butterflies of Northern Europe* (1979) is one of the few illustrators who has tried to show butterflies in their habitat as a means of identification.

Another landmark in bird illustration was reached with the publication of *Birds of Europe* by Lars Jonsson. Lars Jonsson's talent was spotted by the Swedish publisher Per Gedin of Wahlström and Widstrand. Per Gedin was not a birdwatcher, let alone an ornithologist, but when the young Jonsson was brought to his attention he immediately spotted his talent. Originally published in five volumes starting in 1978, after a great deal of tribulation and revision, the combined volume *Birds of Europe* was eventually published in 1992. Jonsson is perhaps only rivalled by Fuertes in his ability to be at the same time an illustrator and an artist. *Birds of Europe* is recognised now as the standard by which all field guides, whether American or European, should be judged. Even so, it is not a book to put in the hands of a beginner.

More specialised field guides have featured the finer points of identification. Alan Harris and the late Laurel Tucker in *The Macmillan Guide to Bird Identification* (1989)[17] focus on points of difference between

RICHARD LEWINGTON (b. 1951).
Southern Hawker (top) and *Brown Hawker* (lower).
From *Field Guide to the Dragonflies and Damselflies of Great Britain and Ireland* (British Wildlife Publishing, 1997).

species. Despite its title it is not really a field guide. Its best use is as a reference against which the observer can compare his or her own notes and drawings made in the field, and the coverage of species is confined to those that look similar to each other. Whereas many field guides are aimed at making identification seem easier than it really is, this book and its companion volume – the more appropriately titled *The Macmillan Birder's Guide to European and Middle Eastern Birds* (1996)[18] – demonstrate clearly that separating certain species is extremely difficult, but not impossible.

A benchmark in the publication of regional guides was reached in 1976 with the publication by Princeton University Press of *Birds of Panama*[19] by Bob Ridgely and illustrated by John. A. Gwynne Jr. *Birds of Panama* was printed in larger format and so was not a pocket guide in the tradition of the Peterson guides and their imitators. It also commanded a higher price. *Birds of Panama* was quickly followed by *Birds of Venezuela*[20] and *Birds of Colombia*.[21] These new guides catered for a more affluent and adventurous birder who travelled to the tropics. Portability was sacrificed to the need to portray accurately a large list of species. Colombia alone has over 1,700 species compared with the modest 850 or so on the AOU North American list. Since 1976 several notable regional guides have been published, prominent amongst which are *Birds of Thailand* (1991)[22], *A Field Guide to the Birds of the Middle East* (1996)[23] and *A Field Guide to Birds of The Gambia and Senegal* (1997).[24] These last three guides are 'midi' guides, not quite pocket-sized but on the other hand still portable in the field. The apotheosis of the 'Princeton' guide was reached in 1995 with the publication by Oxford University Press of *A Guide to the Birds of Mexico*[25] written by Steve Howell and illustrated by Sophie Webb. In 1996 this volume was followed by *Birds of Kenya and Northern Tanzania*[26] from the Christopher Helm stable. The text and plates in each are superb and they make some of the original Princeton guides appear lightweight. Innovations in bird identification techniques will lead to other similar volumes, but there will still be a need for handy pocket guides to tropical regions. An innovation in this area is *An Illustrated Checklist to the Birds of East Africa*[27] by Ber van Perlo. This book is designed for field use and although it cannot claim anything like the authority of the *Birds of Kenya and Northern Tanzania*, it is the volume that birders will take with them into the field.

In 1966 the first volume of the colossal *Handbuch der Vögel Mitteleuropas*[28] was published and although strictly speaking middle Europe is not a distinct zone, it was probably the inspiration for the *Handbook of the Birds of Europe, the Middle East and North Africa* (1977-94)[29], also known as *The Birds of the Western Palearctic* (BWP). This in turn spawned the *Handbook of Australian, New Zealand and Antarctic Birds*[30], the first volume of which was published in 1990. Another monumental series still in progress is *Birds of Africa*[31], begun in 1982 and to be completed in seven volumes. Unusually for a modern work of this kind, virtually the entire artwork is the work of a single illustrator, Martin Woodcock. Handbooks have been published in the past but they have involved countries rather than regions. The incomplete *Handbook to the Birds of North America*[32], begun in 1962, might be cited as a regional handbook, but earlier series such as *The Handbook of British Birds* (1941)[33] clearly could not be. The publication of these regional handbooks has created a new opportunity for the dissemination of plates by a whole range of artists. A recent handbook is a particularly magnificent showcase of artists' work. The *Handbook of the Birds of the World*[34], which first appeared in 1992 and was published in Barcelona, deserves most of the encomia heaped upon it. It is a continuing project and although the plates are not intended for identification purposes, they must stand comparison with any of those published in identification guides.

Guy Tudor and John P. O'Neill are two artists who have worked extensively in South America. Guy Tudor trained at the Yale School of Fine Arts, but as a wildlife artist he describes himself as 'self-taught'. He has illustrated guides to the birds of Venezuela and Colombia, but his *magnum opus* is *The Birds of South America*[35]. His meticulous illustrations are the result of extensive field experience in thirteen Neotropical countries, the West Indies, Western Europe, Senegal, Kenya, Malaysia and Indonesia: his life list is now over 3,700 species. Like all illustrators he checks details with references and maintains a reference library of photographs that presently covers almost 6,000 bird species. Living in New York he is a frequent visitor to the study skin collection at the American Museum of Natural History. O'Neill is a professional

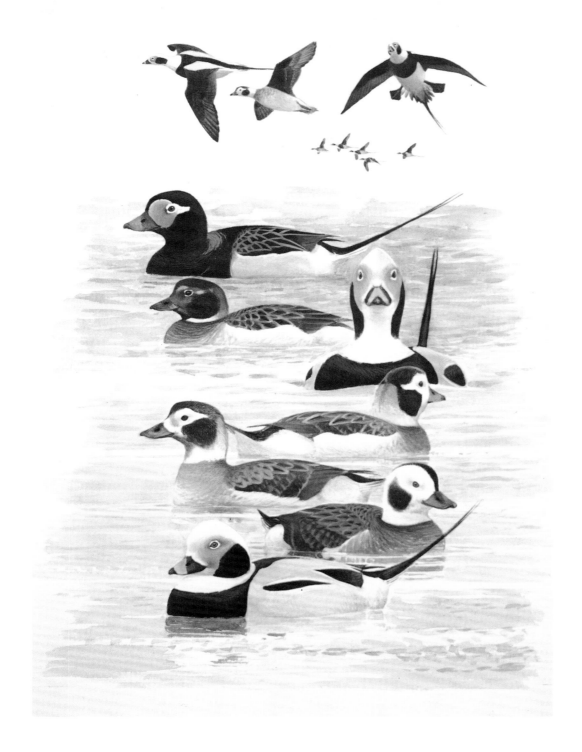

LARS JONSSON (b. 1952).
Long-tailed Duck.
From *Birds of Europe* (Helm, 1992).

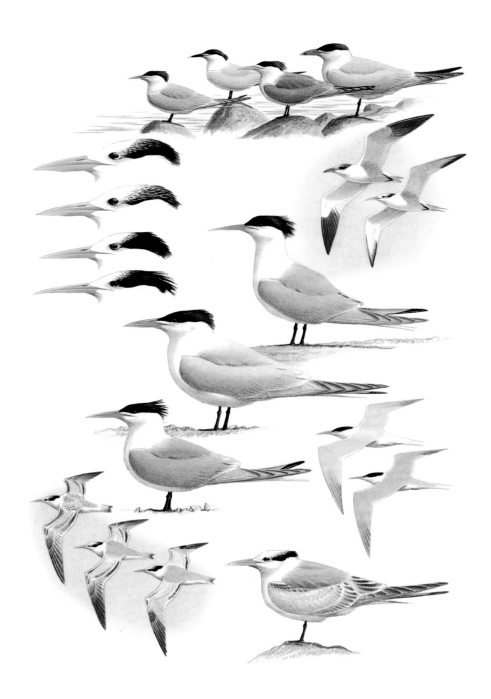

ALAN HARRIS (b. 1957).
Orange-billed Terns.
From *The Macmillan Birder's Guide to European
and Middle Eastern Birds* (Macmillan, 1996).

MARTIN WOODCOCK (b. 1935).
Blue-banded Pitta and Garnet Pitta Group.
From *Pittas, Broadbills and Asities.* (Pica Press, 1996).

ornithologist who has published an impressive array of papers on South American avifauna. In 1964 his first bird paintings were published and his many years of experience in the field in both the United States and Central and South America have been subsequently distilled into plates in several field guides.

As well as geographically based identification guides there are guides concentrating on orders or lower taxonomic groups. Some of the great monographs of the Victorian age have been revisited. Peter Scott illustrated Jean Delacour's four-volume book *Wildfowl of the World* [36] (1954-64). Scott also wrote and illustrated *A Coloured Key to the Wildfowl of the World*,[37] published by the Wildfowl Trust in 1957 and designed to aid identification of birds in the Trust's collection – a zoo guide rather than a field guide, but nonetheless an excellent identification guide. During the 1970s there was an upsurge in monographs on families or orders of birds. Leading these was *Parrots of the World* [38] with superb plates by William Cooper. This book, like others of this period, is not primarily intended as an identification book. It is a superb celebration of all the parrots of the world and it follows the ancient tradition that started with Audubon. Albert Earl Gilbert, who painted the plates in Delacour's *Currasows and their Allies*, also had field experience of the birds he was illustrating. This knowledge of the birds sets these books apart from the nineteenth century monographs in which the plates were based almost entirely on museum specimens.

In 1974 one of the first books concerned solely with the identification of a specific group of birds, *Flight Identification of European Raptors*,[39] was published. It was based largely on observations made at the Bosphorus in Turkey of raptors migrating from Europe to Africa. Ian Willis provided monochrome line drawings. Colour is not an essential factor in identifying birds of prey in flight. When in 1988 *Hawks in Flight* [40], covering North American species, was published the delicate subtlety of David Sibley's line drawings added greatly to the authority of the book. Few groups of species can be illustrated quite so satisfactorily without the use of colour.

In 1983 another important landmark in the publication of identification books was reached. *Seabirds* (1983) [41] was both written and illustrated by Peter Harrison. Harrison's illustrations are clear and perform their identification function admirably. It was to be the first in a series of identification guides dealing with families and groups of related species. *Seabirds* was published by Croom Helm, a small publisher to whom Peter Harrison had been introduced by Mark Beaman, a leading English birder who was at that time advising the company. Croom Helm subsequently became Christopher Helm Publishers which in turn became an imprint of A & C Black. Christopher Helm himself went on to set up Pica Press, and both companies continue to publish volumes of identification guides. A new genre of ornithological books had been created and artists such as Peter Hayman, Hilary Burn, David Quinn and Martin Woodcock helped to ensure the success of subsequent volumes in the series. Peter Hayman's illustrations to *Shorebirds* (1986) [42] are both accurate and beautiful, meticulously executed and carefully measured against skins. Hayman works on field experience as well as skins. The groups of birds covered in the series have diversified. Recent volumes have included *Tits, Nuthatches and Treecreepers*,[43] *Buntings and Sparrows*,[44] *Woodpeckers*,[45] *Shrikes*,[46] *Skuas and Jaegers*,[47] and even *Pittas, Broadbills and Asities*,[48] a group confined to the tropics. The emphasis on identification in this series of monographs is well illustrated by the recently published volume on *Parrots* [49], which includes almost four times as many individual images as in Forshaw and Cooper's much acclaimed *Parrots of the World*.

The Peterson Field Guide Series has not ignored the publishing opportunity offered by identification guides to small groups of birds that pose special identification problems. In 1987 the *A Field Guide to Hawks of North America* [50] and in 1997 *Warblers*,[51] illustrated by Thomas R. Shulz and Cindy House, have both been successful.

In recent years other groups of animals, with the possible exception of Lepidoptera, have not been blessed with identification guides of the same sophistication as those to birds. However, Jonathan Kingdon's illustrations for *The Kingdon Guide to African Mammals* [52] set new standards. He is a zoologist who paints with accuracy and compositional skill, a rare combination. His big cats are drawn from life and are not overweight specimens from zoos, while his smaller mammals, such as genets, show the subtle distinctions between species.

ALBERT EARL GILBERT (b. 1939).
Toucans. 1994.
From *Toucans, Barbets and Honey-guides.*

Some species of reptiles and amphibians can often only be identified with any sureness by the pattern of their scales, but the behaviour of others can give a clue to their identity. Illustrations in field guides to reptiles tend to be detailed portraits whilst the behavioural details are described in the text. Denys Ovenden's plates for *A Field Guide to the Reptiles and Amphibians of Britain and Europe*[53] have probably not been surpassed.

Too revolutionary a treatment of identification problems may not be what the market demands. Perhaps the most imaginative guide to European birds was Rob Hume's *Birds by Character: The Fieldguide to Jizz Identification*.[54] Despite being applauded by many keen birdwatchers, it was not a commercial success, maybe because the illustrations were sketchy and the text was a series of short descriptions epitomising the character and movement of the species. The illustrators, Ian Wallace, Darren Rees, John Busby and Peter Partington are all birdwatchers who spend many hours in the field and have caught the character of the species they have drawn. One day another publisher may be courageous enough to revisit this idea.

JOHN COX (b. 1967).
Green Pigeons. 1997.
From *Pigeons and Doves: A Guide to the Pigeons and Doves of the World.* (Pica Press).

NOTES AND REFERENCES

[1] Brooks, P. (1996) Roger Tory Peterson 1908-1996. *Bird Watcher's Digest*, November/December, p.20.

[2] af Ström, I. Ad. (1839) *Svenska foglarna* [The Swedish Birds], Stockholm.

[3] Berthoud, H. (1867) *L'Espirt des Oiseaux* [The Spirit of Birds], Marne et Fils, Tours.

[4] Voigt, A. (1894) *Exkursionsbuch zum Studium der Vogelstimmen* [Fieldguide to Bird Voices], Berlin.

[5] Tate, P. (1979) *A Century of Bird Books*. Witherby, London, pp.179.

[6] Cuming, E. D. (1913) *The Bodley Head Natural History*. John Lane, The Bodley Head, London, p.24.

[7] Thompson, W. H. (1997) *Bird Watching for Dummies*. IDG Books, Foster City, California, p.14.

[8] Thompson (1997) p.13.

[9] Devlin and Naismith (1977) *The World of Roger Tory Peterson*. Times Books, New York, p.65.

[10] Devlin and Naismith (1977) p.66.

[11] Devlin and Naismith (1977) p.56.

[12] Peterson, R., Mountfort, G. and Hollom, P. A. D. (1954) *A Field Guide to the Birds of Britain and Europe*. Collins, London, pp.viii and ix.

[13] Zickefoose, J. (1996) Roger Tory Peterson. *Bird Watcher's Digest*, November-December, p.32.

[14] Fisher, J. (1966) *The Shell Bird Book*. Ebury Press, London.

[15] Coe, J. (1994) *Eastern Birds: A Guide to Field Identification of North American Species*. Golden Press, Racine, Wisconsin. p.17.

[16] National Geographic Society (1983) *Field Guide to the Birds of North America*. National Geographic Society, Washington D.C.

[17] Harris, A., Tucker, L. and Vinicombe, K. (1989) *The Macmillan Field Guide to Bird Identification*. Macmillan, London.

[18] Harris, A., Shirihai, H. and Christie, D. (1996) *The Macmillan Birder's Guide to European and Middle Eastern Birds*. Macmillan, London.

[19] Ridgely, R. S. (1976) *Birds of Panama*. Princeton University Press, Princeton.

[20] Meyer de Schauensee, R. and Phelps, W. H. (1978) *A Guide to the Birds of Venezuela*. Princeton University Press, Princeton.

[21] Hilty, S. L. and Brown, W. L. (1978) *A Guide to the Birds of Colombia*. Princeton University Press, Princeton.

[22] Boonsong Lekagul and Round, P. D. (1991) *A Guide to the Birds of Thailand*. Saha Karn Bhaet, Bangkok.

[23] Porter, R. F., Christensen, S. and Schiermacker-Hansen, P. (1996) *Field Guide to the Birds of the Middle East*. T & A.D. Poyser, London.

[24] Barlow, C. and Wacher, T. (1997) *A Field Guide to Birds of The Gambia and Senegal*. Pica Press, Robertsbridge, Sussex.

[25] Howell, S. N. G. and Webb, S. (1995) *A Guide to the Birds of Mexico*. Oxford University Press, Oxford.

[26] Zimmerman, D. A., Turner, D. A. and Pearson, D. J. (1996) *Birds of Kenya and Northern Tanzania*. A. & C. Black, London.

[27] van Perlo, B. (1995) *Collins Illustrated Checklist to the Birds of East Africa*. HarperCollins, London.

[28] Glutz von Blotzheim, U. N. and Baner, K. M. (1966-1997) *Handbuch der Vögel Mitteleuropas*. Akademische Verlagsgesellschaft, Wiesbaden and AULA-Verlag, Wiesbaden.

[29] Cramp, S. *et al.* (1977-1994) *Handbook of the Birds of Europe, the Middle East and North Africa*. Oxford University Press, Oxford.

[30] Marchant, S. and Higgins, P. J. (1990-) *Handbook of Australian, New Zealand and Antarctic Birds*. Oxford University Press, Melbourne.

[31] Brown, L. *et al.* (1982-) *The Birds of Africa*. Academic Press, London.

[32] Palmer, R. S. (1962-) *Handbook to the Birds of North America*. Yale University Press, New Haven.

[33] Witherby, H. F. *et al.* (1938-1944) *The Handbook of British Birds*. Witherby, London.

[34] del Hoyo, J., Elliott, A. and Sargatal, J. (1992-) *Handbook of the Birds of the World*, Lynx Edicions, Barcelona.

[35] Ridgely, R. S. and Tudor, G. (1989-) *The Birds of South America*, University of Texas Press, Austin.

[36] Delacour, J. (1954-1964) *The Wildfowl of the World*. Country Life, London.

PRISCILLA BARRETT (b. 1944).
Aquatic Rodents and Porcupine.
From *Collins Field Guide to Mammals of Europe*
(Collins, 1992).

[37] Scott, P. (1957) *A Coloured Key to the Wildfowl of the World.* Wildfowl Trust, Slimbridge.

[38] Forshaw, J. and Cooper, W. T. (1973) *Parrots of the World.* David & Charles, Newton Abbot.

[39] Porter, R. F., Willis, I. R., Christensen, S. and Nielsen, B. P. (1974) *Flight Identification of European Raptors.* T. & A. D. Poyser, Berkhamsted.

[40] Dunne, P., Sibley, D. and Sutton, C. (1988) *Hawks in Flight.* Houghton Mifflin, Boston.

[41] Harrison, P. (1983) *Seabirds: an identification guide.* Croom Helm, London.

[42] Hayman, P., Marchant, J. and Prater, T. (1986) *Shorebirds: an Identification Guide to the Waders of the World.* Croom Helm, London.

[43] Harrap, S. and Quinn, D. (1996) *Tits, Nuthatches and Treecreepers.* A. & C. Black, London.

[44] Byers, C., Olsson, U. and Curson, J. (1995) *Buntings and Sparrows.* Pica Press, Robertsbridge, Sussex.

[45] Winkler, H., Christie, D. A. and Nurney, D. (1995) *Woodpeckers.* Pica Press, Robertsbridge, Sussex.

[46] Lefranc, N. and Worfolk, T. (1997) *Shrikes.* Pica Press, Robertsbridge, Sussex.

[47] Malling Olsen, K. and Larsson H. (1997) *Skuas and Jaegers.* Pica Press, Robertsbridge, Sussex.

[48] Lambert, F. and Woodcock M. (1996) *Pittas, Broadbills and Asities.* Pica Press, Robertsbridge, Sussex.

[49] Juniper, T. and Parr, M. (1998) *Parrots.* Pica Press, Robertsbridge, Sussex.

[50] Clarke, W. S. (1987) *A Field Guide to Hawks of North America.* Houghton Mifflin, Boston.

[51] Dunn, J. and Garrett, K. (1997) *Warblers.* Houghton Mifflin, Boston.

[52] Kingdon, J. (1997) *The Kingdon Field Guide to African Mammals.* Academic Press, London.

[53] Arnold, E. N., Burton, J. A. and Ovenden, D. W. (1978) *A Field Guide to the Reptiles and Amphibians of Britain and Europe.* Collins, London.

[54] Hume, R. A., Wallace, I., Rees, D., Busby, J. and Partington, P. (1990) *Birds by Character: the Fieldguide to Jizz Identification.* Macmillan, London.

WILDLIFE AND PRINT-MAKING

O there is no limit to the good which may be effected by rightly taking advantage
of the powers we now possess of placing good and lovely art
within the reach of the poorest classes.

John Ruskin[1]

Ruskin, when lecturing at Oxford University in 1870, saw that good art could be introduced to a new public through cheaply produced prints. In the mid-nineteenth century work by Hokusai (1760-1849) and Hiroshige (1797-1858) in the form of woodcuts had begun to arrive in Europe from Japan. It was greeted with enthusiasm by art-lovers, for whom it was a novelty. The Japanese cognoscenti took a rather lofty view of these prints, regarding them as plebeian, and they were collected more enthusiastically in North America and Europe. Arty disdain for *ukiyo-e* prints in Japan is an echo of the sixteenth century Spanish dismissal of still life as *bodagone* (or pub art). There was a proletarian or at least a less than exclusive dimension to print-making that Ruskin admired; but in Europe in the nineteenth and early twentieth centuries it was still the bourgeoisie who formed the market for prints. In the early part of the twentieth century wildlife artists began to sell prints of their work. North American wildlife artists, such as Allan Brooks and 'Ding' Darling published etchings, and in the second part of the century the production of signed, limited edition photo-mechanical prints developed into a thriving business.

Prints can be made in several media, all of which require a high degree of skill. Some prints are single colour; others may involve the use of several colours printed either separately or as part of one printing. From the dawn of printing in the fifteenth century in Europe until the invention of lithography in the last years of the eighteenth century, illustrations were printed either in relief from blocks of wood or from lines engraved in the surface of a metal plate.

The first relief prints were made from wood. The original form is the woodcut, in which an image is drawn on a block of wood cut from a plank sawn from the length of a trunk, so that it is cut into the side-grain. The wood around the image is cut away to leave it in relief from the rest of the block. It is not easy to show detail in a woodcut, because the grain runs along the surface from which the cut is made. The skilled artist can use the grain to create flowing effects. Further detail can be enhanced by the use of several blocks that are then printed in separate colours.

The Japanese wood-block prints that were part of the *ukiyo-e* school first came to Europe via Holland in the early nineteenth century. Their direct shapes and flat colours were quite different from anything European eyes had seen, and they were to influence a number of artists such as the French Impressionists and Bruno Liljefors. An artist who made good use of wood-block prints to depict wildlife was Allen W. Seaby (1847-1953). At the turn of the century he joined the staff of Reading Art School. The art school was part of the University College of Reading and when in 1910 W. G. Collingwood retired as head of the school Seaby took over. In 1926, when the University College became a university, he was its first Professor of Fine Art.

Seaby admired the Japanese print-makers and Joseph Crawhall (1861-1913), the Glasgow Boy, whose watercolours had a spare Oriental quality to them. Seaby's wood-block prints used several colours to build up the moulding on the bodies of the birds he depicted. He exhibited his prints at the Royal Academy and international exhibitions in Paris, New York, Los Angeles and Milan, where he was awarded a gold medal in 1906 in the decorative arts section, but he was a compleat artist working in several media on a variety of subjects, an excellent draughtsman and an excellent teacher of art.

Woodcuts have not been popular among wildlife artists for much of the century, but Wolfgang Weber (b. 1936), one of Germany's leading living wildlife artists, in the 1970s produced some striking woodcut

prints when he lived in Kenya. In one print the movement of a herd of sable antelopes reflects Neolithic cave painting. Like the cave-painters the range of colours available in the print-maker's palette is limited and, where the moulding of the rock was used by the cave painter to enhance his painting, Weber has used the texture of the grain in the wood. Weber works mainly in watercolour now, but his work in whichever medium is underpinned by his drawing skills. He draws fast in soft pencil and is as comfortable drawing trees and buildings as he is drawing wild animals.

The Californian Andrea Rich (b. 1954) is one of the few wildlife artists working in woodcuts. A variety of sources have influenced her including Kollwitz, Dürer, Bewick, Munch, Kathë and three contemporary printers – Carol Summers, Masami Teraoka and Berry Moser – as well as the Japanese *ukiyo-e* artists. The major importance of these artists' work to Rich is to see how they overcame particular problems in their work that she also encounters. 'I am not able to know exactly what technique was used,' she said, 'but seeing what they have accomplished triggers a solution for my own work.'[2] She uses as many as five colours in the creation of her prints.

Printmakers are resourceful in discovering new material in which to take impressions. A twentieth century development has been the linocut in which linoleum takes the place of wood. The even surface of the lino and its comparative softness allow the cutter more manoeuvrability and consequently more detail. It has been widely used in schools to teach the principles of printmaking, and for this reason may have come to be rather lightly regarded. However, four modern exponents, each with a very different style, show the unique effects that can be achieved in creating linocut prints of wildlife.

Some of the prints by James Osborne, R.E. (1907-1979), are comparatively large (up to 60cm x 30cm). After studying at Hastings School of Art he won a scholarship to the Royal College of Art Sculpture School, but transferred to the Print School. He won the Prix de Rome in engraving. He taught at the Polytechnic School of Art in Regent Street and was elected to the Royal Society of Engraver-Painters. Osborne was a keen experimenter, using different papers and inks. Experimentation was extended to the printing process itself; there is considerable variation between each print of an edition. He made sketches in watercolour before tackling the linocut, and despite the simple outlines he successfully captured the character of animals. In the print *Hare and Fieldfares*, exhibited at the Royal Society of Painters-Printmakers in 1967, he captures the alert posture of the birds and the contrasting flattened outline of the hare resting on a cold winter day.

In the linocuts of Robert Gillmor (b. 1936) first-class and first-hand field knowledge of birds, draughtsmanship of the highest order and compositional ability combine with a high level of technical skill. Gillmor is the grandson of Allen Seaby. Although he is perhaps best known as an illustrator, it is as a print-maker that he excels, producing linocut prints of great power. Although many other artists have copied the style of his illustrative painting, few appear to have tried to imitate his print-making. The careful printing and his adherence to register between the solid colours make his prints quite distinctive. He prints on a nineteenth century Albion press which he swapped with the Fine Art Department at Reading University for a rather cumbersome Columbia press purchased in the 1960s for £25. Boldly coloured Gillmor designs have been used by HarperCollins for the jackets to the New Naturalist Series. Although these designs are executed in gouache, they have the effect of block prints and follow in the tradition set by the classic jacket designs of Clifford and Rosemary Ellis.

The bright flat colours of linocuts suit the style of Andrew Haslen (b. 1953), whose work features birds and mammals such as hares. They show the high degree of draughtsmanship necessary for creating prints and an understanding of form that could be expected from an artist who also sculpts. A feature of Haslen's prints is their size.

One of the most experimental of today's English wildlife artists is John Paige, who employs several print-making techniques including linocuts. His small print of a Woodchat Shrike having just impaled a large grasshopper on a thorn uses just four colours, but has a three-dimensional quality as well as liveliness.

In the 1920s wood engraving once again became a fashionable medium. This skill had become lost

ALLEN WILLIAM SEABY (1867-1953).
Grey Heron. c.1920.
Woodblock print. 149 x 210mm.
Influenced by the Japanese *ukiyo-e* woodblock
prints, Seaby used birds as subjects for his own
woodcuts, in addition to the illustrative work
for which he is better known among naturalists.

WOLFGANG WEBER (b. 1936).
Colobus Monkey. 1969.
Woodcut. 711 x 457mm.
By emphasising the white fur of the monkeys
Weber has created a feeling of the movement
of the troop through the trees.

ANDREA RICH (b. 1954).
Coypu. 1994.
Woodcut print in four colours. 145 x 210mm.
Although she has been inspired by the *ukiyo-e*
artists, Rich sees the work of other practising
print-makers as sources of solutions for the
problems she encounters.

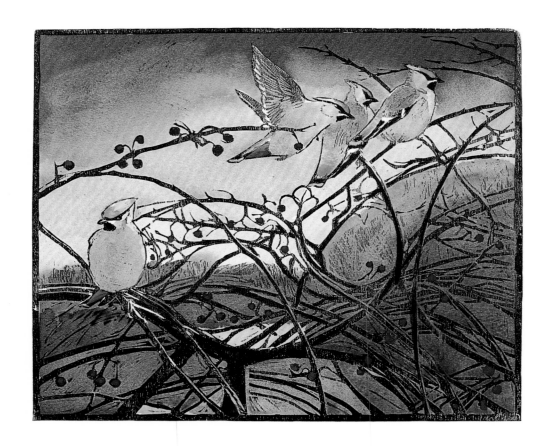

ROBERT GREENHALF (b.1950).
Waxwings. 1997.
Hand-coloured woodcut. 254 x 279mm.
Having used the grain of the plywood block to
create texture within the outlines, Greenhalf has
then applied watercolour washes that do not
detract from the line.

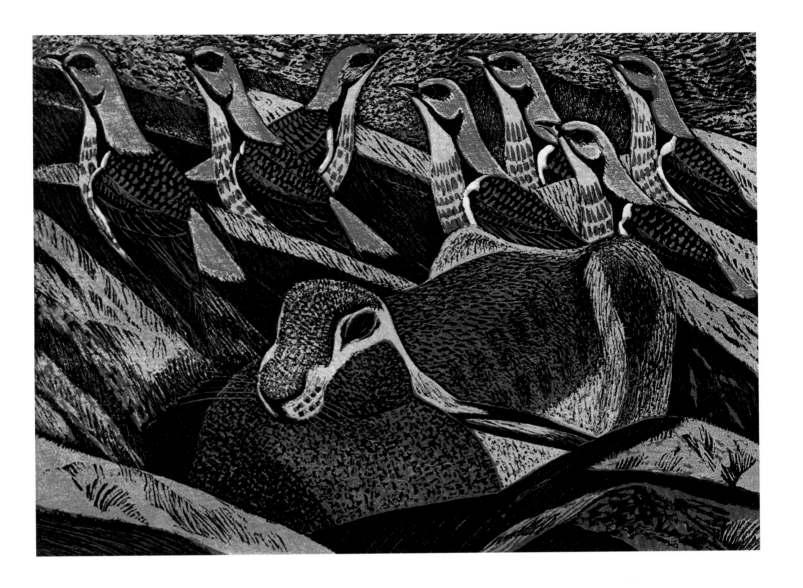

JAMES OSBORNE (1907-1979).
Hares and Fieldfares. c.1967.
Linocut. 279 x 381mm.
Making coloured linocuts requires the artist to
identify and reproduce the essential elements
of the picture's subject. The Fieldfares have a
typically upright stance that contrasts with the
flattened ears and body of the Brown Hare.

during the seventeenth and eighteenth centuries, when it had been replaced by steel engravings. However, towards the end of the eighteenth century a Newcastle metal engraver, Thomas Bewick (1755-1825), revived and improved the process. He used a burin (a metal engraving tool) to cut into the tightly grained wood, which unlike the timber used for woodcuts has been sawn across the grain. The cutting surface is highly polished. All the wood is carved away except for the lines from the image that will be printed. The hardness of the material and the smoothness of the surface give a detailed modelling and fine tones that are not possible when cutting into the side-grain. During the nineteenth century wood engraving became a popular, utilitarian medium, and artists such as Tenniel and Doré would draw their images usually in pencil with detailed cross-hatching and stippling to achieve the effect of tone. The block was then sent to an engraver. By the end of the nineteenth century engravers reached a high degree of skill in achieving the subtleties of tone. But with the advent of photography, the engraver could work directly from the photographic image and the need to draw illustrations was diminished. As the engraving process became speedier with the invention of the metal half-tone block, wood engraving died out as a commercial medium.

The techniques pioneered by Bewick were taken up in the 1920s by artists in order to produce editions of signed prints and books printed on private presses. One of the leaders of the resurgence in wood engravings was Robert Gibbings (1889-1958), the son of a canon at Cork Cathedral. After spending two years at medical school in Cork he studied at the Slade School of Art in London. While serving with the Royal Munster Fusiliers during the First World War, he was hit in the throat by a piece of shrapnel at Gallipoli. After being invalided out of the army he became a freelance engraver. Along with Eric Gill, Gwen Raverat, Noel Rooke and John Nash he was a founder member of the Society of Wood Engravers, which was initially called 'The Bewick Club'. Gibbings exhibited twelve prints at their first exhibition in 1920 and he ran the Golden Cockerel Press from 1924 until 1933. On the recommendation of Allen Seaby he joined the staff of Reading University as a lecturer in book production in 1936.[3]

Gibbings, who was a close friend of Eric Gill, had a distinct, lively style, but never achieved the clarity of Gill's engravings. He tackled all manner of subjects, but many of his engravings were of animals and plants. Although he was a countryman and a member of both the Royal Geographical Society and the Zoological Society, the birds he engraved might have been better observed. Like Gill he was a skilled typographer and the Golden Cockerel Press enjoyed critical, though not financial, success. His original landscapes and animal engravings were contrasting blocks of black and white, but although he gradually became more subtle in his use of tone, he never achieved the economy of line that characterised Gill's work. Hodnett believed that he was too prolific:

> Had Robert Gibbings limited himself to one-tenth of his output, he might have been a much better wood engraver, but there is little reason to believe that he might have been more a sensitive interpretive illustrator.[4]

Another early member of the Society of Wood Engravers was Eric Fitch Daglish (1894-1966), who read science at London and Bonn Universities. After the First World War he became a lecturer in zoology and learned engraving from his friend, Paul Nash, exhibiting three prints at the 1920 Society of Engravers' Exhibition. His subjects were used as book illustrations and at their best, as in the Red Deer from his *Animals in Black and White* (1929)[5], had the dramatic contrasts found in Gill's nudes. When he tried more complex subjects he was less successful.

Nora Unwin (1907-1982) studied with Leon Underwood, who taught wood engraving at a school he ran in Brook Green, London. She also studied at Kingston School of Art and the Royal College of Art. Her career as an illustrator was no doubt helped as the Unwin name was one to conjure with in printing and publishing. Many of her illustrations featured animals and her first commission was for *Exploring the Animal World*,[6] published in 1933. After the Second World War she went to live in the United States, where she continued to work as an engraver, producing some fine illustrations for *Footnotes to Nature*,[7] which Horne[8] rates as some of her finest.

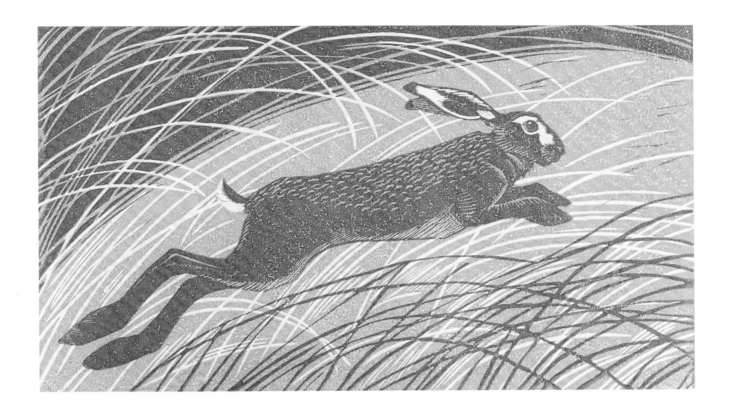

ROBERT GILLMOR (b. 1936).
Lepus Leap. 1997.
Linocut. 190 x 330mm.
This two-colour linocut by Gillmor shows a hare
moving, the action accentuated by the sloping
strokes of the grasses in the background.

CHARLES TUNNICLIFFE (1901-1979).
Tarka the Otter. c.1932.
Wood engraving. 128 x 84mm.
The frontispiece of Tarka the Otter has the
book's hero about to snatch a trout. The sinuous
shape of the otter adds to the feeling of movement
which, as other artists have shown, can be very
difficult in the medium of wood engraving.

AGNES MILLER PARKER (1895-1980).
Otter. 1937.
Wood engraving. 187 x 123mm.
From *Down the River*. (Gollancz).
Miller Parker's underwater view of the otter is much brighter than Tunnicliffe's, because she has cut away larger areas of wood to reveal white paper when the block is printed.

The best of Unwin's work shows the influence of the wood engravings of animals and country scenes made by Agnes Miller Parker. Having studied at Glasgow School of Art from 1914 to 1918 she taught engraving and worked at the Gregynog Press, another renowned small press of the 1930s, in Wales. One of her first commissions was to illustrate *Fables of Esope* for Gregynog, dated 1931, but published in 1932[9] and containing thirty-seven large engravings. These engravings are delicate, with extensive cross-hatching and a striking contrast between light and shade. Her illustrations to H. E. Bates's *Through the Woods*[10] and *Down the River*[11] are perhaps her best known works. Her engraving of an otter for the latter is a powerful swirling composition with five fishes swimming away from the diving hunter.[12] Compare this with Tunnicliffe's frontispiece to *Tarka the Otter*.[13] Tunnicliffe has given an even more sinuous shape to the otter's body, and the trout it is chasing is swimming to the left of the illustration. The drama in this illustration is not as high as in Parker's because Tunnicliffe has kept his engraving rather dark, but there is a much greater feeling of being beneath the water.

None of the pre-war engravers of wildlife could compare with Charles Tunnicliffe (b. 1901). Although he is best known now for his watercolour paintings, his reputation as a wildlife artist was built on the wood engravings he cut for Henry Williamson's *Tarka the Otter* (1932). Son of a small farmer in Cheshire, he went to art schools in Macclesfield and Manchester before winning a scholarship to the Royal College of Art in 1921. In his fourth year he joined the RCA's engraving school. He chose the countryside and farming as his subjects, and he made no concessions to any romanticised views that his potential buyers may have had. Indeed, these earlier etchings and wood engravings were much less romanticised than his later watercolours of birds and other animals.

Tunnicliffe's experience of wildlife in the early 1930s was that of the average countryman who for some years has lived in cities. His wife suggested that Tunnicliffe offer a series of sample of illustrations for *Tarka the Otter*, a book that he admired greatly and which since its publication in 1927 had enjoyed critical and commercial success. He sent some aquatints of otters to the publishers, Putnams, who liked the idea of an illustrated edition, but preferred the illustrations to be wood engravings. They also decided to re-issue three books of Williamson's nature stories and asked Tunnicliffe to illustrate them. Tunnicliffe went to stay with Williamson in Devon to follow otter hounds and to make preliminary sketches for his illustrations. The author was deeply in the thrall of mysticism and was both eccentric and egocentric. Ian Niall, Tunnicliffe's biographer, describes Tunnicliffe's memories of a meet of the Cheriton and Dartmouth Otter Hounds.

> He recalled a lady with a booming voice, and a great enthusiasm for inspiring others, telling the world in general, "I think we shall have blood today!" Greatly encouraged the pack moved off and "Captain" looked for Tarka in the tree roots. Alas for the tweedy lady, there was no blood that day. The non-subscribers paid half-a-crown for nothing. Later in the week the object of the exercise was achieved. "Deadlock" crossed on Tarquol, the whips lashed thin air. The Huntsman waded in to rescue the remains of the wretched otter, hard to find in the mêlée of snarling, yelping hounds. Tunnicliffe hurried forward to take a photograph, which would be the best reference for what were fleeting seconds in which the otter was torn apart. Williamson seeing him with the camera rebuked him. "Get sketching, Tunnicliffe!" he yelled above the sounds of slaughter. Williamson expected instant sketches. As it happened the snapshots did not come out and Tunnicliffe relied on his photographic memory which served him just as well.[14]

Williamson's treatment of the artist veered between exaggerated praise to insulting criticism, which led eventually to Tunnicliffe refusing to do any more work on his books. Niall describes a dispute over the drawing of the adipose fin of a salmon, in which Williamson took a magnifying glass to one of the illustrations for *Salar the Salmon*, but in the face of the artist's furious response he backed down.

The wood engravings that Tunnicliffe executed for Williamson's nature books helped to confirm Tunnicliffe's reputation and encouraged a serious interest in birds and other wild animals. No other

ANDREW HASLEN (b. 1953).
Brown Hare. 1997.
Hand-coloured linocut. 533 x 737mm.
By using the linocut printing technique and then hand-colouring with watercolour, Haslen has found a method of creating a work in which the artist has been engaged at all stages, but at a much cheaper price than an original water-colour would command.

COLIN SEE-PAYNTON (b. 1946).
Young Otters. 1994.
Wood engraving. 126 x 178mm.
See-Paynton is a leading wood-engraver. Many of his subjects are animals, and otters underwater lend themselves to the abstract patterns he creates and which contrast with the naturalistic representations of the animals themselves.

COLIN SEE-PAYNTON (b. 1946).
Sudden Movement. 1995.
Wood engraving. 507 x 303mm.
The size of blocks available limits the size of wood engravings. This is the largest engraving that See-Paynton has completed. The block was made of lemonwood. The patterns of the water are treated in an abstract way, while the ducks and the pike are naturalistic.

artist of the period could have produced such atmospheric wood engravings of a wide range of country subjects. He is equally at home with boys bird nesting or starving crows; hard-faced otter hunters; hounds trailing in pursuit of a stag on Dartmoor and an otter with a fluke above Bideford Long Bridge. The most disappointing of these engravings are those that portray birds. Some like the jacket of *The Lone Swallows* are good, but others, such as the red kites in *The Old Stag*, show that he was unfamiliar with this species and failed to capture its astounding beauty in flight. More than thirty years later he produced a watercolour for the cover of *Birds*,[15] evidence that after he moved to Wales in 1948 he gained experience of the bird.

Working on *The Peregrine Saga* stimulated his interest in birds. But contrast the wood engravings for this book with his post-war wood engraving of a peregrine. In the later engraving he captured the character of the bird in a way that, despite many hours with falconers on Salisbury Plain, he never managed in the earlier book illustrations. In 1943 because of his wood engravings he was made an Associate of the Royal Academy. Subsequently he began to exhibit large watercolours at the Academy's summer exhibitions and was elected a Royal Academician in 1954.

Despite the efforts of the Royal Society of Painter-Printmakers the art of wood engraving is not popular. The need for good draughtsmanship that underlies the work of Gertrude Hermes, Blair Hughes-Stanton, Agnes Miller Parker and Charles Tunnicliffe has deterred a generation of young artists from its exacting practice. James Osborne used wood engraving for some of his printmaking. An engraving exhibited at the Royal Academy in 1947 has three grasshoppers among the seed-heads of grasses, and demonstrates how good he was compared with some better known, but less skilful, artists. In another he shows Lapwings and Fieldfares in characteristic postures in a winter field.

Colin See-Paynton (b. 1946) does not like to be described as a wildlife artist. He works in wood engraving, linocut and watercolour; but his skill in a single colour medium, through the delicate way in which he uses tonal effect, creates an impression of colour. It is difficult not to compare See-Paynton's work with Miller Parker's and Tunnicliffe's, because his wood engravings include aquatic subjects such as otters as well as birds and fish. Although fish and birds are drawn (and engraved) figuratively, the patterns created by their movement through the water are treated in a way in which the tonal effects take on an abstract quality.

Born and trained in the East Midlands of England, See-Paynton now lives in a half-timbered hall near Welshpool on the border between England and Wales. He works with Susie See-Paynton, who prints many editions of his work on one of his two Albion platten presses, Victorian cast-iron versions of the wooden presses used by Gutenberg and Caxton. Most of his editions are of 75 copies. The papers he uses are carefully chosen to add to the tonal effects he is seeking. His prints vary in size. The smallest, a delicate print of a teal's feather on lemon wood, is 70mm x 100mm.[17] Most of the blocks See-Paynton uses are comparatively large (about 200mm x 250mm) but the largest block that he has engraved, of a group of Mallards springing from the water as a Pike cruises beneath the lilypads, measures 507mm x 153mm.[18] Such a large block has to be well made. See-Paynton, in the *catalogue raisonée* of his work,[19] pays tribute to the makers of the blocks that he uses and records the blockmakers, inks and paper used for each of the 157 wood-engravings he has made since he started wood engraving in 1980.

Wood engravings printed in more than one colour are unusual. However, coloured prints from wood engravings are the favoured medium of the Swiss artist Robert Hainard (b. 1906). He is a native of Geneva, where his father, also an artist and sculptor, taught at the School of Industrial Arts. His response to his subjects is emotional. Even his line drawings take a holistic approach in which the animal is not allowed to dominate the picture. In his introduction to *Mammifères Sauvages d'Europe* (1949-1951) he wrote:

> My sketches represent an entire, actual scene, as I have seen it in the exact relationship between the animal, the environment and the light. In this way I have avoided arbitrary compositions, which overloaded by precise details make a false, often contradictory ensemble.

No modern wildlife artist compares to Hainard in conveying a sense of place. But it is the quality of light in his work which does more than anything else to achieve this effect. Hainard does this through a

CHARLES TUNNICLIFFE (1901-1979).
Lone Swallows. c.1932.
Wood engraving. 150 x 102mm.
Tunnicliffe's jacket illustration for Williamson's *The Lone Swallows* demonstrates his ability as a graphic artist who could produce a strong composition that leads the reader's eye across the jacket towards opening the book.

combination of inks, paper and the tonal effects on the blocks. The prints are made on an Albion press using Japanese papers with a fluffy, almost flimsy softness that gives even greater subtlety to the tones.

Hainard's approach to his complex art form is as simple as possible. His reference is a single black drawing with notes about colours. Watercolour sketches, he feels, would complicate the process by adding an extra dimension. He traces the portion of the sketch for each colour on a block of pearwood. He then carves away the extraneous wood. His work is greatly influenced by Hiroshige and Hokusai, but it was Gauguin who taught him how to shade a block by paring it. He feels his passion for mammals is atavistic, and very much in the tradition of the anonymous artists of Lascaux.

Etching is one of the print-making techniques most favoured by wildlife artists. Etching has an immediacy that is not possible with the more laborious processes of engraving either on wood or metal. One surface of a prepared copperplate is covered with a mixture of beeswax, bitumen and resin. The lines are drawn with a steel etching needle that penetrates the ground to the metal so that when the plate is immersed in a bath of acid the lines are cut into the plate. By 'stopping out' (or painting over with varnish) portions of the design the lines can be cut to varying depths to give tones to the plate. The printing is by the intaglio method, where the ink is rubbed into the incised lines and wiped off the surface of the plate. A sheet of damp paper is then laid on the plate and covered by several thicknesses of felt blanket. Plate, paper and blanket are run through the rollers of a copperplate press which squeezes the paper into the ink-filled lines and leaves an impression of the whole plate. A prepared etching plate can be taken into the field and drawings made on the spot. The final printed sheet has a softness and delicacy of line that gives a very different effect from wood engraving. The tones can be enhanced aquatint, an etching process that creates a similar effect to a wash drawing. Aquatint and etching are sometimes combined.

Many of Charles Tunnicliffe's early prints were etchings, but the subjects were mainly farming scenes. Winifred Austen (1876-1964), who was twenty-five years older than Tunnicliffe, also produced etchings of birds and other animals. Between 1908, when she printed her first etching of a dormouse, and her death in her 89th year in 1964 she produced over 200 etchings, several of which were hung at the Royal Academy. She was a skilful etcher, but as in her watercolours there is a hint of the anthropomorphic romanticism of the Victorians. Comparison between her work and Tunnicliffe's is interesting in this respect.

Despite etching being the most portable of all the printing media it has not attracted very much attention among wildlife artists. Two contemporary etchers are Andrew Stock (b.1960) and Robert Greenhalf (b.1960). Stock is primarily a painter in watercolour and oil and has never had formal training, but he has experimented with other media including etching. Places are as important as animals in Stock's work and his etchings, like his paintings, feature recognisable landscapes. Greenhalf learned printmaking under Graham Clarke at Maidstone School of Art. In the 1980s he spent much of his time etching, sometimes printing in as many as eight colours from one plate, stopping off all the areas he did not need in each colour printing. His scenes of Kent and Sussex featuring a variety of animals have a unique quality. Greenhalf also paints in watercolour and makes sketch-prints and drypoints using plastic sheets as the base and then colouring them by hand to produce atmospheric coloured editions of his watercolours. As a student Greenhalf worked in both linocut and silkscreen printing (seriography). Drypoint is the chosen medium of Katrina Cook (b. 1965), who obtained a master's degree in Natural History Illustration at the Royal College of Art. She works on a large scale on copperplates. Her subjects are usually seabirds and her prints have an interestingly dark quality to them.

Silkscreen printing is admirably suited to the reproduction of animals' colours. Anne Senechal Faust (b. 1936), who studied at Boston University and the University of Hartford, Connecticut, now lives in Baton Rouge, Louisiana. She specialises in silkscreen prints, using the cut-screen method in which she reduces the number of stencils without losing the essential details of a three-dimensional image. Her animals are part of the landscape, which contrasts with John Paige's silkscreen prints in which he concentrates on individual animals or groups of animals in action. His fox moves with a combination of caution and boldness and his male Smew perform their exaggerated displays in prints in which he uses no more than four printings.

ROBERT HAINARD (b. 1906).
Brown Bear. 1972.
Wood engraving.
Coloured wood engravings are rare, but Robert Hainard may cut up to eight blocks for each of his prints. Using hand-made Japanese paper he produces prints which are notable for their subtlety of line and colour.

WINIFRED AUSTEN (1876-1964).
Swallows on the Line. 1948.
Etching.
The Suffolk artist, Winifred Austen, was a
prolific etcher and exhibited her etchings at the
Royal Academy and The Society of Painter-
Engravers.

186

ROBERT GREENHALF (b. 1950).
Swallows. c.1976.
Etching. 283 x 305mm.
Relatively few wildlife artists produce etchings, but this is a process that works well with Greenhalf's pictures of animals in a landscape, because its abstract elements allow the viewers to use their imaginations.

187

KATRINA COOK (b. 1965).
Fraser's Hill. 1995.
Drypoint and aquatint on copper. 500 x 590mm.
The contrast between the darkness of the forest
and the brightness of the sky above it is high-
lighted by the sun shining through the tail
feathers of the hornbill.

ANDREW STOCK (b. 1960).
Barn Owl. 1998.
Etching. 76 x 178mm.
This small etching shows a Barn Owl in the porch of the old church in the hamlet of Pescadoires in south-west France with the village of Lagardelle in the background.

ROBERT GREENHALF (b. 1950).
Godwits Feeding. Undated.
Hand-coloured drypoint. 80 x 150mm.
Although now primarily a watercolourist
Greenhalf has worked in several media and has
created prints with drypoint, etching and silk-
screen.

ANNE SENECHAL FAUST (b. 1936).
South from Ulan Ude (Demoiselle Cranes). 1995.
Silkscreen. 407 x 635mm.
The flatness of colour in silkscreen printing
provides the artist with a challenge. Faust has
chosen grey and black birds here and used the
bulk of the tree and horizonal lines to empha-
sise the birds' elegance.

CHARLES HARPER (b. 1922).
Prickly Pair. Undated.
Silkscreen. 190 x 190mm.
Harper's geometrical interpretations of animals almost always capture the creature's character and often ask questions or even make statements about its status.

CHARLES HARPER (b. 1922).
The Last Aphid. Undated.
Silkscreen. 190 x 190mm.
The charm of Harper's work is the unusual angles from which he views the world of nature. By using technical drawing instruments he produces shapes that tend towards the abstract, but whose recognisable characteristics provoke thought. By choosing silkscreen printing as his medium he is able to make the most of the shapes through the flatness of the colour.

193

KIM ATKINSON (b. 1962).
Tigers with Chital Buck. 1998.
Monotype. 843 x 1140mm.
A female tiger throttles a deer. Her almost fully
grown cubs ineffectually try to join in. In the
background are elephants bearing unseen spec-
tators. By using a monotype print Atkinson has
captured the excitement of the drama in front
of her and the turbulence of the action, which
would have been lost in a more naturalistic
treatment.

LARS JONSSON (b. 1952).
Goshawk. Undated.
Lithograph.
Lithography became a popular medium during the nineteenth century, especially for the production of high quality books with short production runs. Jonsson used the medium for this print with the soft colours that reflect the light of a Swedish forest.

JOHN PAIGE (b. 1927).
Red Fox. 1975.
Silkscreen print. 381 x 533mm.
Silkscreen printing can give soft lines that add
to the stealth of this Red Fox. Using three
screens Paige has created the impression of
solidity in the animal's body.

GREG POOLE (b. 1960).
Gannets. 1996.
Collage. 370 x 750mm.
The busy, noisy atmosphere of a gannetry lends itself to the technique of torn paper collage, reducing the colours used to concentrate on the movement of the birds.

GREG POOLE (b. 1960).
Red Fox. 1997.
Silkscreen print. 153 x 665mm.
Strong, thick lines in black with a flat second
colour give a series of simple images of a hunt-
ing fox.

GREG POOLE (b. 1960).
Red Kite. 1997.
Monoprint. 480 x 420mm.
Poole uses the technique of monoprinting to enhance the primitive feeling of his basic design.

A completely contrasting style is found in the work of Charley Harper (b. 1922). Although he started in watercolour, he now works exclusively in acrylic and silkscreen. The sense of design in his prints is powerful, especially as the lines are mathematically precise, drawn with compasses and rulers. Nevertheless they retain the essence of the animals. Each print is given a title that will appeal to the pun-lover. Even the title of the book of his works, *Beguiled by the Wild*,[20] is a play on words.

Harper has the ability to reach the essentials of an animal. Roger Caras summed up the essential Harper:

> You would think that if you stripped away fur, scale and feather you lose a sense of the animal. That is not what happens at all. When you remove the *noodling* aspect of wildlife you gain perspective. You see the beast. You understand it better because you have uncluttered it and brought its style and place down to simple lines – stripped of its more or less fancy covering. All of a sudden, everything seems clear, as if you had never really seen the beast before. "Yes, that is what a jay looks like! And there, those are giraffes! That is the geometry of their life and niche. And here, this is the real essence of owl."[21]

Silkscreen printing is a medium used by Greg Poole (b. 1960). He uses a number of techniques, printing with wood, lino, polystyrene and cardboard, often combining several of these. Kim Atkinson (b. 1962), like Poole, is an experimenter who works in several media. A technique that she frequently uses is monoprint, in which images are painted in oil colours on a piece of perspex and paper is then pressed onto the plate so that the image adheres to the paper. She uses this technique to capture the atmosphere of confusion that surrounds the final moments of the killing of a chital buck by a tiger.

These art prints are still relatively inexpensive and so, even if they are not quite as accessible to the poor as John Ruskin would have wished, they do provide a chance for people who might not otherwise do so to buy original art. And that has to be preferable to buying mechanical reproduced four-colour prints, whose price is inflated just because they contain the autograph of the artist.

NOTES AND REFERENCES

[1] Ruskin, J. (1996) *Lectures on Art*. Allworth Press, New York, p.54.

[2] Andrea Rich *in litt.*

[3] Garrett, A. (1978) *A History of British Wood Engraving*. Midas, Tunbridge Wells, p.230.

[4] Hodnett, E., (1988) *Five Centuries of Book Illustration*. Scolar Press, Aldershot.

[5] Daglish, E. F. (1929) *Animals in Black and White, Volume 1: The Larger Beasts*. J. M. Dent, London, p.??.

[6] Elton, C. (1933) *Exploring the Animal World*. Allen & Unwin, London.

[7] Kieran, J. (1947) *Footnotes on Nature*. Doubleday, New York.

[8] Horne, A. (1994) *The Dictionary of 20th Century British Book Illustrators*. Antique Collectors' Club, Woodbridge, p.425.

[9] Horne (1994) p.343.

[10] Bates, H. E. (1936) *Through the Woods* Victor Gollancz, London.

[11] Bates, H. E. (1937) *Down the River*. Victor Gollancz, London.

[12] Bates (1937) p.127.

[13] Williamson, H. (1932) *Tarka the Otter*. Puttnam, London.

[14] Niall, I. (1980) *Portrait of a Country Artist: Charles Tunnicliffe R.A. 1901-1979*. Victor Gollancz, London, pp.60-61.

[15] Niall (1980) p.73.

[16] *Birds* May/June 1967.

[17] See-Paynton, C. (1996) *The Incisive Eye: Wood Engravings 1980-1996*. Scolar Press/Glynn Vivian Art Gallery, Aldershot, p.89.

[18] See-Paynton (1996) p.91.

[19] See-Paynton (1996) p.16.

[20] Harper, C. (1994) *Beguiled by the Wild*. Flower Valley Press, Gaithersburg, Maryland.

[21] Harper (1994) p.5.

PAINTING WITH A SENSE OF PLACE

While I'm painting, scents and sounds waft in through the open windows of my studio.
Even though I'm also surrounded by modern gadgets
– phone, computer and fax machine – that defy geography,
this proximity to the world as it was before technology and progress became our gods
is my constant reminder of something deeper –
of just how great a responsibility we have to achieve
a state of peaceful coexistence between the human and the wild.

Robert Bateman[1]

Painting that concentrates on the details of an individual animal helps us to identify the animal but tells us little about the artist's experience of seeing it in its environment. The compulsive ticker may require nothing more than an animal's portrait with every detail of feather, fur, fin and scale in place. But for other lovers of nature the excitement of wildlife art goes beyond the identification of animals to experiencing the place where they live. Because the major threat to so many animals today is the loss and transformation of their habitats, this dimension is highly relevant and important.

By the beginning of the twentieth century landscape had become increasingly important in wildlife painting. Portraits of animals developed from the vignetted plates of the Gould School to the 'full-bled' paintings of Wolf and Liljefors. Thorburn followed on the tradition of Landseer and Millais; his grouse and Red Deer became part of the landscape in which they live, but the landscape rarely gains as much attention as the animals. The landscapes of Liljefors on the other hand partake of the impressionist *plein air* style of painting. Liljefors's time in the field taught him that animals were inseparable from their environment. Their protective colouring made them invisible until they moved. The German Kuhnert also shared this insight. In Britain, Peter Scott, possibly following Frank Southgate, a wildfowling painter killed in the First World War, brought together landscape and birds in exciting combination.

In the nineteenth century the German Romantic Albert Bierstadt (1830-1902) first visited the Rockies and was enthralled by their drama. Carl Rungius, another German, also showed in his paintings his great love of the North American wilderness. Francis Lee Jaques, who was raised in rural Illinois and Minnesota, celebrated the places where the animals lived as much as the animals themselves. He found the birdwatchers' obsessive quest to identify species sometimes tedious. After a day's birdwatching on the Hudson river, as recalled by Don Eckelberry,[2] he remarked that the difference between warblers and no warblers was very small. The problems posed in painting small birds in a natural environment may have given rise to this remark, and it is true that large animals give greater opportunity for larger landscapes; but some artists have triumphed over the problems of giving a sense of place to paintings of smaller animals. Among them are Liljefors, Bateman, Busby and Jonsson.

In the second part of the century wildlife artists have paid more attention to painting landscapes with animals rather than portraying animals in a more or less formal landscape. The criterion of their success must be the ability to capture the atmosphere of the place and its subjects. The quality of light is of supreme importance and it is, therefore, not surprising that so many of them cite French impressionists, either individually or severally, as influences on their own work. The photorealist wildlife painting is often let down by poor lighting. Sometimes its practitioner does not even omit the reflection of twin flash lamps from the eyes of his subject. More importantly, photoflash obliterates the subtleties of colour and shadow that are the essence of the animal's lifestyle. Ray Harris-Ching's understanding of the effects of light and his drawing skills put his work in a different category from other artists, who in an attempt to achieve total realism put technique above emotional involvement. Chris Bacon (b. 1960) from Ontario combines his realism with an enigmatic quality that makes the viewer think more deeply about the painting's

subject. His painting of a Sandhill Crane is a fine example of this and is still more of an enigma for being untitled.

Liljefors captures the mysterious twilight of the Swedish forest; Scott the vast evening skies lighting the flat landscapes of the East Anglian Wash; Rungius the sharp, bright contrasts of the Rockies; and Jaques the wintry snows of Minnesota.

Travel broadens the palette perhaps as much as it broadens the mind. There have long been travellers among wildlife artists (and wildlife artists among travellers), but today more artists are travelling further. In recreating their experiences of new places they must take into account the variable qualities of light in different parts of the world. The smaller the animal portrayed, the more important becomes this dimension. An artist good at interpreting the effects of light on the colours of animals in the absence of information about habitat can give clues about where a painting is made. In this respect John Busby and Lars Jonsson are particularly successful.

Busby is excellent at depicting the effects of local colour and local light. The plumage patterns of the Stone Curlews flying above the limestone cliffs at Cala Algar in an illustration from his *Birds in Mallorca* reflect the light and colours of the Mediterranean.[3] The same species painted in Norfolk by the same artist would appear very different. Jonsson has a similar talent. His painting of a Red-backed Shrike in *En Tag i Maj*[4] is unmistakably Swedish because of the colours created by northern sunlight in May.

A sense of place may also be captured by putting the animals in the same context as human beings or their artefacts. Since the nineteenth century, artists have avoided painting human beings and animals together. Sometimes this is because the artist is not good at drawing people or even objects that are man-made. Highlander Peter Munro (b. 1954) has no inhibitions about the juxtaposition of artefact and animal. Many of his paintings show the way in which animals will react to man-made objects with an apparent unconcern at their link with human beings. Munro often chooses a relatively close view of an animal, but creates a sense of place by portraying man-made objects. The hard surfaces and regular angles of these contrast with the textures of his animals. His work often recalls Edward Hopper's paintings.

RICHARD TALBOT KELLY
(1896-1971).
Hooded Crows. Undated.
Oil.
Talbot Kelly rarely included much landscape in his paintings, but he often included enough suggestions to identify the place where the action was happening.

ROBERT BATEMAN (b. 1930).
Everglades. 1979.
Acrylic. 1778 x 2273mm.
The reflections of these egrets in the still water
of the Everglades produce series of shapes that
add to the feeling of place that the painting
gives.

ROBERT BATEMAN (b. 1930).
Gentoo Penguins and Whalebones. 1979.
Acrylic. 762 x 1219mm.
Port Lockroy is an old whaling station in Antarctica. The discarded whalebones are a poignant reminder of the destruction of wildlife. The bones nevertheless create wonderful abstract shapes and beyond is sufficient landscape to put them into context. The penguins have the dejected appearance of moulting birds.

RICHARD SLOAN (b. 1935).
Triple Threat. 1992.
Acrylic on composition board. 1016 x 762mm.
This study of Hyacinth Macaws captures the
strong contrast between light and shade in the
forest of the Neotropics.

DONALD WATSON (b. 1918).
Hen Harriers. Undated.
Watercolour and bodycolour.
The evening light catches the backs of the male
Hen Harriers quartering the valley among the
Ayrshire hills.

CINDY HOUSE (b. 1952).
Shrike in Late Winter. 1996.
Pastel. 229 x 406mm.
The winter snows have melted, but the spring
is still no more than a promise. The smart
plumage of the Northern Shrike stands out
against the brown landscape of Vermont at this
time of year.

ALBERT EARL GILBERT (b. 1939).
White-tailed deer, Connecticut. 1997.
Acrylic.
The quality of light in the Connecticut fall
enhances the colours of the leaves and grasses
and brightens the outlines of the deer as they
cross the meadow.

KEITH SHACKLETON (b. 1924).
Off Cumberland Bay, South Georgia. 1994.
Oil.
The huge seas, glaciers and snow of Antarctica
are frequently painted by Shackleton and give
his paintings a definite sense of place.

PETER MUNRO (b. 1954).
The Victorian Railing. 1997.
Acrylic. 432 x 653mm.
Man's creation of a place and wildlife's use of his artefacts is a recurring theme of Munro's painting. Here he has painted a Barn Owl on a railing in a churchyard in the Scottish Highlands.

FRANCIS LEE JAQUES (1887-1969).
Egret in Florida Pond. c.1935.
Oil on canvas. 610 x 711mm.
Jaques, who painted a number of backgrounds
for museum dioramas, had the ability to create
a strong sense of place. The elegance of the
Great White Heron is refelected in the shape
of the trees.

BRUCE PEARSON (b. 1950).
The Old Cortina. 1990.
Oil on canvas.
A car dumped in a gravel pit provides shelter for a shoal of perch, while a Great Crested Grebe dives. The sunlight casting shadows on the old car and showing through the vegetation is vital to give the impression of water and the bird's movement through it.

Travel means that an artist has to come to terms swiftly with new unfamiliar landscapes, unfamiliar animals and unfamiliar light effects. Having accompanied two Artists for Nature Foundation expeditions, I have had the chance to watch artists adjust to unfamiliar surroundings. The ANF organises trips by groups of artists to places of great scientific importance and natural beauty that are under threat. Spanish artists were included on the expedition to Extremadura, the purpose of which was to draw attention to cranes. Although none of them was from that province, they were more familiar than the other artists with the colours, light, atmosphere, landscape and, of course, wildlife. However, the Spaniards did not produce work that *demanded* the viewer's attention by saying, 'Look at this! It's really interesting/ atmospheric/beautiful!' By contrast, it was the foreign artists' work that drew attention to how exciting the place and its wildlife were. Because they had a short time to adjust to the area and its wildlife, their response had to be more immediate and emotional. Drawing beside a dry stone wall in the traditional forest-pasture known as *dehesa*, Kim Atkinson, who then lived on a small windswept island off the coast of North Wales, gave her reactions:

> The single aspect of the landscape which particularly impresses me is its vastness. Huge distant horizons. Not used to this. But in combination with the *dehesa*, with the round trees whose pattern of oval shadows gives away the undulations of the ground beneath. The pattern is so regular that it looks like park planting on a huge scale.[5]

Denis Clavreul's problem on his visit to Poland was not only that the wildlife was unfamiliar, but also other aspects of the countryside. Hundreds of years of traditional farming have produced a harmony between the people and their environment. The shapes of the haystacks, cattle, hens, the people working the land became as important to the artist as the White Storks, the Great Snipe or the Golden Orioles. Robin D'Arcy Shillcock painted a watercolour of a birch-fringed meadow and managed to convey its sounds, *Corncrakes All Around*: there was not a Corncrake to be seen in the painting.[6]

Whether Vadim Gorbatov is painting in the snowy forests of Russian Karelia, a Polish river valley, the gentle countryside of the eastern Netherlands, southern Spain or a dry forest in India, he develops a sense of the place and its light. Gorbatov, like the animals he paints, becomes part of the landscape. He tucks himself into cover and waits for the animals to come to him. His paintings have a typically Russian narrative thread, so that when he sketches in pencil he constructs a composition as he goes. I watched him drawing a Sambar and its fawn on the edge of a stand of sal in the forest at Bandavgarh. As he sketched the scene he altered the positions of the deer in relation to each other to improve the composition.

Gorbatov will also draw scenes by composing a picture with elements from more than one source. One evening in Bandavgarh he and Lars Jonsson watched a male Tiger make its way down from a plateau on which were the remains of a fort and a temple. Later we found the tracks of the Tiger leading through the ruins of the fort. Gorbatov sat in the fort and painted it with a Tiger in the shadows of a wall. Although the scene was imaginary, he knew the Tiger had been there and he based his drawing on the animal he had seen a few days before, almost certainly the same individual that had made the tracks through the fort. That the painting was painted in India is shown by its warm light, which is very different from the cold light of Gorbatov's Polish paintings or the hot Mediterranean sun of his Spanish paintings.

The major threat to animals remains the destruction of their habitat. We have recognised that it is not enough to preserve individual species while ignoring their biotopes, and thus landscape has achieved greater prominence in wildlife paintings. Without doubt artists have played their part in conservation. They have done it in two ways. They have produced work that has fired the imagination of their audience and sparked off their interest and sympathy, and the sale of their work has produced funds.

The change in attitude towards otters in Britain over the last hundred years owes as much to the illustrations of Tunnicliffe as to the writing of Henry Williamson. Tunnicliffe's work created huge interest and, from the Christmas cards he illustrated, it also produced income for the RSPB.

The interest in birds stimulated by the Peterson field guides induced the spread of yardbird feeding stations and consequently the spread northwards through North America of Ruby-throated Hummingbirds.

ROBIN D'ARCY SHILLCOCK (b. 1953).
White Wagtail, Sweden. c.1995.
Oil. 180 x 240mm.
The light and the position of the bird in this painting add to the impression of the landscape already formed by the stone and the meadow plants.

VADIM GORBATOV (b. 1940).
Bandavgarh Fort with Tiger. 1997.
Watercolour.
Gorbatov had watched a tiger descending the hillside on which this fort stands and had then seen pug-marks in the sand in the gateway to the ruin. The painting was completed at the fort with the artist using his sketches of the tiger as a reference.

ARTHUR SINGER (1917-1990).
Caroni Swamp at Sundown. 1981.
Oil on canvas. 623 x 774mm.
The striking contrasting colours of Scarlet Ibises and Great White Egrets is echoed more subtly in the sky in this evocation of one of the most spectacular wildlife sights with these beautiful birds returning to roost on the island of Trinidad.

217

DYLAN LEWIS (b. 1964).
Wildebeeste. 1991.
Oil on canvasboard. 300 x 600mm.
In a hot country animals seek whatever shade
they can find. These wildebeeste in South Africa
have lined up in the shade of a solitary tree.
The effect is a painting that works as an abstract
pattern and as a naturalistic painting which has
a strong sense of place.

218

PETER SCOTT (1909-1989).
Pink-footed Geese at Moonrise. 1933.
Oil on Canvas. 508 x 762mm.
Moonlight can be as effective as sunlight in creating a sense of place. Early Scott paintings are as much about places as they are about his beloved wildfowl.

GUNNAR BRUSEWITZ (b. 1924).
Brent Geese: Baltic Sea. 1989.
Watercolour. 750 x 570mm.
The watercolor washes of Brusewitz's landscapes
with animals in them create a remarkable sense
of sharing with the painter the essence of place,
as well as of the animals themslves.

BOB KUHN (b. 1920).
The Heat of the Day. 1989.
Acrylic. 610 x 914mm.
One of the most powerful of the North American painters of wildlife is Bob Kuhn. His draughtsmanship and ability to create the effects of light on the animals and their landscape give the viewer the feeling that here is an artist who created a painting from personal experience.

221

Peterson was employed for a period by the National Audubon Society, whose education programmes for many years led the world. Don Eckelberry was also employed by Audubon, and many other artists have worked on museum and zoo exhibits and publications for conservation organisations.

Had Peter Scott concentrated solely on painting, he might have been an even greater painter, but he would not have played such an effective role in nature conservation. Undoubtedly Scott's reputation aided enormously its cause and it could be argued that this was more important than his paintings ever could have been.

Once Peterson had published *A Field Guide to the Birds* his development as an artist was inhibited by the pressure of illustrative, editorial and educational work. Robert Bateman has continued to focus on his painting, but his skills as a writer and lecturer have been used effectively on behalf of the environment. His outspoken approach has probably not enhanced his reputation with the Canadian art establishment. In Bateman's case critical animosity may be more to do with his output of reproduction prints. In 1992 he told a forum, 'I have been called, on television, a sort of public enemy number one to the art world – "I've set Canadian art back twenty years" by doing these horrible, hideous, nefarious, so-called signed and numbered limited-edition prints. I've been embroiled in this in the Globe and Mail and elsewhere for quite a number of years now…'[8] The popularity of reproduction prints in large limited editions may be critically deprecated, but they (and few are as of high quality as Bateman's) do promote an interest in wildlife and, by extension, in its conservation. It is a pity that much of the limited edition market involves a view of wildlife as artificial as that shown in Walt Disney True Life documentaries.

Since Thorburn donated his Christmas card artwork to the RSPB, artists have given their work to raise funds for conservation. Notable among these artists has been David Shepherd, who, through his work, has raised seven-figure sums for his conservation charity. When Congress passed the Migratory Bird Conservation Act in 1929, one of the conservationists pressing for annual funds to maintain the wetlands so important for migrating wildfowl was the cartoonist on the Des Moines Register, Ding Darling. In 1934 he was named head of the US Bureau of Biological Survey, which was charged with overseeing and regulating the hunting of wildfowl across the country. One of his first acts was to design a stamp to be stuck onto duck-hunting licences. The stamps sold at a dollar each and raised $635,000. The stamp featured a pair of mallards and started an annual pattern that has resulted in the acquisition of huge areas of wildfowl habitat. It also led to an annual competition, the beginnings of the American limited edition print market and the collecting of the stamps and associated artwork. Competent as some of the art has been, this ground-breaking conservation scheme has not yet produced any great art. Fundraising, because it relies on the popular appeal of the artwork, does not induce innovation. Look through the advertising pages of *Wildlife Art* or the catalogues of Christie's South Kensington Wildlife Art Auctions. The paintings (or reproductions) that command the best prices are not necessarily the best when judged by artistic or even scientific criteria. For those innovative wildlife artists who do not achieve financial success their satisfaction may come from the knowledge that their interpretation of the wild and its creatures has led or will lead to a deeper appreciation of a wild time and place.

CHRIS BACON (b. 1960).
Untitled – Sandhill Crane. 1996.
Watercolour and Prismacolour pencil on ragboard. 508 x 431mm. Although Bacon's painting is realistic, it has an enigmatic quality that stems from the artist's deep thoughts about his life as an artist. This painting is about Bacon's desire to separate himself and his art from outside influence. The crane represents the artist, centrally located in his own space, and it is concentrating on an egg-shaped pebble which the artist sees as a symbol of life, specifically his own life.

NOTES AND REFERENCES

[1] Bateman, R. (1996) *Natural Worlds*. Swan Hill Press, Shrewsbury, p.20.

[2] Hammond, N. (1986) *Twentieth Century Wildlife Artists*. Croom Helm, London, p.105.

[3] Busby, J. (1988) *Birds in Mallorca*. Christopher Helm, London, p.99.

[4] Jonsson, L. (1990) *En Dag i Maj*. Atlantis, Stockholm, p.61.

[5] Hammond, N. (1995) *Artists for Nature in Extremadura*. Inmerc/Wildlife Art Gallery, Wormer, p.35.

[6] Shillcock, R. D'A. (1993) *Portrait of a Living Marsh*. Inmerc, Wormer, p.139.

[7] Mealy, W. V. and Friederici, P. (1992) *Value in American Wildlife Art: Proceedings of the 1992 Forum*. Roger Tory Peterson Institute of Natural History, Jamestown, NY, p.139.

ARTISTS' BIOGRAPHIES

The following biographies are of artists who have specialised to a greater or lesser extent in the depiction of wildlife. Most have been mentioned in the previous pages. It is not pretended that coverage is comprehensive and the author's personal choice (and some artists' failure to respond to his requests for information) must be blamed for any omissions of artists.

Information given includes dates of birth (and death), present domicile, artistic training and qualifications, media used, major influences, participation in Artists for Nature (ANF) projects, and membership of organisations.

Abbreviations used

AMNH	American Museum of Natural History	RI	Royal Institution of Painters in Watercolour
ANF	Artists for Nature Foundation	RMS	Royal Miniaturists Society
ARCA	Associate of the Royal Cambrian Society	RSMA	Royal Society of Marine Artists
ARE	Associate of the Royal Society of Painter-Etchers and Engravers	RSPB	Royal Society for the Protection of Birds
ARSA	Associate of the Royal Scottish Society of Arts	RSW	Royal Scottish Society of Painters in Water-colours
BBC	British Broadcasting Corporation	RWS	Royal Watercolour Society
BOU	British Ornithologists' Union	SAA	Society of Animal Artists
BTO	British Trust for Ornithology	SOC	Scottish Ornithologists' Club
FZS	Fellow of the Zoological Society of London	SPNR	Society for the Promotion of Nature Reserves (now Royal Society for Nature Conservation/The Wildlife Trusts)
ICBP	International Council for Bird Preservation (now BirdLife International)	SWA	Society of Women Artists
IUCN	International Union for Conservation of Nature and Natural Resources	SWAN	Society of Wildlife Art for the Nations
		SWE	Society of Wood Engravers
NAS	National Audubon Society	SWLA	Society of Wildlife Artists
PSA	Pastel Society of America	WWF	World Wide Fund for Nature
RA	Royal Academy	ZSL	Zoological Society of London
RCA	Royal College of Art		
RE	Royal Society of Painter-Etchers and Engravers		

Kim Atkinson

Born 26 April 1962, Bath, Somerset. Lives in Gwynedd, North Wales. Falmouth School of Art, Cheltenham School of Art and Royal College of Art (MA in Natural History Illustration). Works *plein air* in charcoal, water-colour and pencil and in the studio in printmaking, media including woodcut, card printing, monoprinting and combinations of monoprint, collage and other media. Interested in the Expressionist way of working; Van Gogh, Cezanne, Gauguin, Bonnard and Picasso have all influenced her, but "it doesn't really show in my work". ANF Poland, Extremadura and Loire projects. SWLA.

Winifred Austen

Born 1876, Ramsgate, Kent. Lived in Suffolk from 1926 until her death in 1964. She was taught art privately and became a painter, etcher and drypoint engraver. Illus-trated books, magazines and postcards. SWA (1905); ARE (1907); RE (1922); RI (1925). Died 1964.

Chris Bacon

Born 14 November 1960, Watford, UK. Lives in Ontario, Canada. Self-taught, he has painted full-time since 1980. Paints with transparent watercolour and alkyd, but also makes lithographs and etchings. Tries not to be influenc-ed by other artists in order to maintain own individuality and personal artistic vision. Has travelled extensively including Ascension, Fiji and Bermuda. ANF Extrema-dura Project. SAA.

Priscilla Barrett

Born 4 May 1944, Cape Town, South Africa. Lives in Cambridge. Studied languages and trained as teacher. Her study of animal behaviour included several years of research which led in 1976 to a full-time career as an illustrator. Inspired by Edmund Caldwell as a child and Maurice Wilson as a teenager, but later it was ideas rather artists that inspired her. Works in watercolour, pastels, pencils and ink. SWLA.

Robert Bateman

Born 24 May 1930, Toronto, Canada. Lives on Gulf Islands, British Columbia. University of Toronto (Geo-graphy). Teacher for 20 years including two years in Nigeria. Began painting with a representational style, moving through Impressionism and Cubism to Abstract Expressionism and back to realism in his early 30s. Influenced by Terence Shortt, chief illustrator at the Royal Ontario Museum, and inspired by illustrations of Fuertes and Allan Brooks. Moved through the modern to the *avant garde* with Monet, Degas, Van Gogh, Gauguin, Rockwell Kent and Charles Burchfield as influences. Style changed after seeing an exhibition of Andrew Wyeth. Works in acrylic and oils. Has used art to raise huge sums for conservation and is an eloquent spokesman on behalf of the environment. Subject of several television films. ANF Poland, Extremadura and Alaska projects. SAA.

David Bennett

Born 11 December 1969, Doncaster, South Yorkshire. Lives in South Yorkshire. Doncaster College of Art, Leeds Polytechnic and Royal College of Art (MA in Natural History Illustration). Freelance artist since 1995. Works in oils, watercolours and pastel. Paints in the field. Inspired by Cezanne, Munnings, Liljefors and Crawhall to paint movement and light in the field. Busby, Greenhalf and Jonsson are contemporary influences. ANF Extremadura, Wexford and Alaska projects. SWLA.

Keith Brockie

Born 5 October 1955, Haddington, East Lothian, Scot-land. Lives in Perthshire. Duncan Jordanstone College of Art, Dundee (Illustration and Printmaking). Illustrator at Dundee Museum and Art Galleries. Full-time freelance artist since 1979. Works mainly in pencil and watercolour, but increasingly using oils. Early influences were Thorburn, Ennion and Tunnicliffe, then John Busby and Lars Jonsson. Keen bird ringer. ANF Poland, Schier-monnikoog and Alaska projects. SWLA.

Gunnar Brusewitz

Born 7 October 1924, Stockholm. Lives in Lisinge, Sweden. Lena Börjesson's School for Sculptors, Signé Barth's School of Painting, School of Book Art and Royal Academy of Art, Stockholm. Self-educated as a wildlife painter. Works mainly in watercolour, but occasionally in oil. Has studio on shore of Lake Sparren. Influences include fellow Swedes, Harald Wiberg, Arvid Knöppel and "inescapably" Liljefors, and Fuertes, Eckelberry, Johannes Larsen, Leo-Paul Robert, Hainard, Tunnicliffe and Paul Barruel, but he gives prominence to Peter Scott. Over 250 books illustrated and many awards won for his work.

John Busby

Born 2 February 1928, Bradford, Yorkshire. Lives in East Lothian, Scotland. Leeds and Edinburgh Colleges of Art. Taught painting and drawing at Edinburgh College of Art (1956-88). Bird paintings influenced by Talbot Kelly and Ennion. Other influences were W. G. Gillies, former principal of the Edinburgh College of Art, Norman Adams, Derek Hyatt, Cezanne, Piero della Francesca and Paul Nash. Paints from life and has been influential on many younger European wildlife artists. ANF projects since 1990. His work has graced the pages of many books. Founder member of SWLA. President Scottish Society of Artists (1976-79). External assessor Royal College of Art Natural History Illustration Course 1989-92. RSW (1982). ARSA (1987).

Ken Carlson

Born 12 August 1937, Morton, Minnesota. Lives in Kerrville, Texas. Tutored by wildlife artist, Walter J. Wil-werding. Minneapolis School of Art. Commercial and children's book illustration until becoming full-time painter for exhibition in 1970. Influenced by work of Wilwerding, Rungius, Kuhn and Kuhnert. Paints in oils on board. Subjects are larger animals of North America. Travels annually to Alaska, Canada and Wyoming.

Jean Chevallier

Born 7 July 1961, Bologna-Billancourt, Paris. Lives in Fresnes, France. Studied biology. Self-taught as an artist. Full-time illustrator since 1985. Has taught etching, carving, drawing and oil painting. Influences include Robert Hainard, Gunnar Brusewitz, Leopold Robert, Serge Nicolle and Lars Jonsson. Influenced by working closely with other artists involved in ANF projects, particularly by Atkinson, Gorbatov, Greenhalf, Pearson and Poole. Works principally in watercolour with pencil or charcoal and has begun to use pastel. Occasionally produces lithographs and linocut prints. ANF Poland, Extremadura and Loire projects.

Denis Clavreul

Born 20 March 1955, Saint-Poix, France. Lives in Nantes. Rennes University (Biology). Doctorate in ecology. Self-taught as a painter. Hainard is the main influence on his natural history paintings, but he has also been influenced by prehistoric paintings and many artists from Courbet to Picasso including Monet, Gauguin, van Gogh and Degas. Works in pencil, watercolour, oil and pastel. Each experience in the field gives him new ideas and inspires new projects. Board member ANF. ANF Poland, Extremadura and Loire projects.

James Coe

Born 5 March 1957, New York City. Lives in Hudson Valley, New York. Harvard University (Biology), Parson's School of Design, New York (Master's in Fine Art). Works in watercolour and gouache, drawing from personal experience, photographs and specimens. As a teenager he used to visit Don Eckelberry in his studio and considers him to be his most formative influence. Guy Tudor is both a friend and important mentor, and he continues to study the "remarkable work" of Louis Fuertes whom he describes as "the father of us all here in the States". Publications include identification guides to both Eastern and Western North American birds.

Guy Coheleach

Born 20 February 1933, New York. Lives Bernardsville, New Jersey. Cooper Union, New York. Ten years as commercial illustrator before becoming a full-time painter of animal subjects. Has worked in a variety of media, but now prefers oils for paintings and acrylics for the originals of print editions. Eckelberry, Liljefors, Kuhnert and Rungius are his main influences. SAA.

Katrina Cook

Born 13 October 1965. Lives in Rutland. Exeter College College of Art and Design (Fine Art) and Royal College of Art (MA in Natural History Illustration). Her prints are mainly drypoint, but also works in aquatint, mezzotint and photo-etching. Draws in graphite pencil for detailed anatomical drawings with watercolour for field sketches. Although inspired by several artists, it was Audubon's hard work and single-minded determination that changed her. Inspired by seabird colonies in UK and abroad, visited on ringing expeditions.

John Cox

Born 9 April 1967, Romford, Essex. Lives near Preston, Lancashire. Largely self-taught, becoming a full-time wildlife illustrator after winning the British Birds 'Bird Illustrator of the Year' award in 1989. Works mainly on illustration work for books, magazines and calendars, but would prefer to spend time splashing paint onto big canvases. Field work is very important and his sketch-books are the work he likes best. Influences include past masters such as Rungius and Liljefors, and inspirational modern painters such as Lars Jonsson, Bruce Pearson and Kim Atkinson. SWLA.

Joseph Crawhall

Born 20 August 1861, Morpeth, Northumberland. Died 24 May 1913. Enrolled at Aimé Morot's atelier in Paris in 1882. Influenced by Bewick and later by contemporary artists of the Barbizon and Hague schools. Member of Glasgow Boys group of painters. Moved from oils to watercolour in 1890s. His paintings of animals have been influential on several modern wildlife painters.

Eric Fitch Daglish

Born 29 August 1894 in London. Died 1966. London and Bonn Universities (Science). Served in World War I in France and as army education officer from 1918 to 1922. Professional naturalist, lecturing, writing, engraving, painting and broadcasting on BBC Radio. Served in RAF 1940-1948. His illustrations were wood engravings and occasionally pen and ink. SWE. FZS.

David Daly

Born 22 March 1956, Westmeath, Ireland. Lives Wexford, Ireland. Self-taught artist working mostly in pencil and watercolour. Works from life in the field and has been influenced by Busby, Ennion, Jonsson, Measures, Mc-Queen, Greenhalf, van Dusen and Rees. Teaches courses at Wexford Wildfowl Reserve. Illustrator of books, magazines and exhibitions. ANF Poland, Extremadura, Wexford projects.

Don Eckelberry

Born 1921, Sebring, Ohio. Cleveland Institute, Ohio (Art). After working as foreman in a Hollywood optical factory, he was employed by the National Audubon Society, as a layout artist and illustrator on *Audubon*. Became full-time freelance artist in 1940s to concentrate on illustrating the *Audubon Bird Guide*. Great encourager of young talent and influential on many younger wildlife artists in the USA.

Basil Ede

Born 12 February 1931, Fetcham, Surrey. Lives in East Sussex. Kingston Art School, Surrey. After army service he joined Orient Steam Navigation Company as a purser. Began seriously to paint birds when working for Cunard Line in London. Became full-time painter in 1964. Worked in watercolour until 1989 when a stroke disabled his right hand, causing him to learn to paint with his left

hand, but in oils. Greatly influenced by Thorburn before developing his own style.

Eric Ennion

Born 7 June 1900, Kersingham, Norfolk. Cambridge and St Mary's Hospital, London (Medicine). Practised in Burwell, Cambridgeshire. No formal art education. Gave up medicine in 1945 to become first warden of Flatford Mill Field Study Centre in Suffolk. Ran his own field centre at Monk's House, Seahouses, Northumberland from 1951 to 1961, when he moved to Shalbourne, Wiltshire, where he died in 1981. Inspirational teacher of drawing, both writing and broadcasting about wildlife. Influenced many British wildlife artists. He wrote or illustrated a number of books and his distinctive style became widely known. Founder member of SWLA. Served on councils of BOU, BTO and RSPB.

Anne Senechal Faust

Born 11 March 1936, New Britain, Connecticut. Lives in Baton Rouge, Louisiana. Boston University (BFA) and University of Hartford (Masters in Art Education). Worked as draughtsman for 10 years before becoming art teacher. Full-time printmaker since 1979. Specialises in silkscreen printing, continually trying to reduce the number of stencils used in a piece of work without losing a three-dimensional realistic image.

Louis Agassiz Fuertes

Born on 7 February 1874, Ithaca, New York, where he lived until his death on a railroad crossing at Unadilla, New York on 22 August 1927. First illustration commissions came while a student at Cornell. Taught painting by Abbot Thayer. As well as prolific book illustration he undertook many museum dioramas. Appointed 'resident lecturer' at Cornell in 1922. He was perhaps the most influential North American wildlife artist of the twentieth century.

Albert Earl Gilbert

Born 22 August 1939 at Chicago, Illinois. No formal art training, but he drew in zoos and museums with individual influences, such as Doc Sutton, Don Eckelberry and James Perry Wilson, whom he watched at work in Chicago Museum. Influences among his friends Guy Tudor, Bob Kuhn, Robert Verity Clem, Ray Harris Ching and Walter A. Weber. Also credits effects of working alongside great naturalists such as Dean Amadon, Leslie Brown, John Williams, Jean Delacour and Paul Schwartz. Work also includes commercial work and product design of plush toy animals as well as book and scientfic illustration and gallery paintings. Works mainly in watercolour, but also uses pastels, oils and acrylics. Vice-president SAA, 1974-7, President, SAA 1977-84.

Robert Gillmor

Born 6 July 1936, Reading, Berkshire. Lives Cley, Norfolk. Reading University (Fine Art). Taught art at Leighton Park School from 1959-65, when he became full-time illustrator. Influences were his grandfather, Seaby, Ennion, Hainard and Tunnicliffe. Paints in watercolour, but has drawn many pen and ink illustrations. His distinctive linocut designs have been used for magazine covers and book jackets. Has served on the councils of BTO, BOU and RSPB. Co-founder of SWLA and mentor to many promising younger artists. Has illustrated many articles, books and Christmas cards for BTO and RSPB. Art editor of *The Birds of the Western Palearctic*. Has designed covers of New Naturalist Series for HarperCollins since 1988. President Reading Art Guild (1969-86). SWLA, Hon Secretary 1964-74, Chairman 1974-84, President 1984-94, Vice-President since 1994.

Vadim Gorbatov

Born 1940, Moscow. Lives in Moscow. Academy of Art, Industrial Design and Applied Art in Moscow. Illustrator for Soviet Television, becoming Head of Graphics and Illustration and later Head of Nature, making wildlife films. Full-time freelance artist since mid 1980s. Has travelled widely in Russia and ex-Soviet republics as well as to Europe and USA. Works principally in watercolour. His paintings have a romantic, narrative quality, which is rare in watercolour paintings. ANF Poland, Extremadura, Alaska and India projects. SWLA.

Robert Greenhalf

Born 28 June 1950, Haywards Heath. Lives in East Sussex. Eastbourne School of Art and Maidstone School of Art (Fine Art and Graphics). Full-time freelance artist, working in several print media including linocuts, screenprints, monoprints, batik, etching, hand-coloured drypoints, woodcuts, watercolours and most recently oils. Busby has been a major influence through example and encouragement. Other admired artists include Tunnicliffe, Ennion, Liljefors, Jonsson, Samuel Palmer, Cotman, Impressionists, Crawhall, Japanese woodcuts, Piper and Seago. He places great importance on drawing and painting directly from life and in the composition of his pictures. ANF Poland, Extremadura and Wexford projects. SWLA.

Robert Hainard

Born 1906, Switzerland. Lives in Berne, Switzerland. Expert naturalist with a particular interest in mammals. School of Industrial Arts in Geneva where he studied sculpture in wood and stone before moving to wood engraving. Produced an average of 15 wood engravings a year from 1929 for over seven decades. Colour engravings are printed in as many as 20 colours on fine Japanese paper. He cites as influences Cro-Magnon cave painters, the great Japanese print-makers, Hiroshige and Hokusai, and Gauguin from whose woodcuts he learned how to alter the shading of a single colour by paring the block. Widely travelled in Europe and Africa.

Charles Harper

Born 4 August 1922, Frenchton, West Virginia. Cincinnati Art Academy and Art Students League, New York. First nature illustration was for *Ford Times* in 1950s, followed by illustrations in *Audubon*, *National Wildlife* and *Ranger Rick*. Has designed posters for National Park Service,

Cincinnati Zoo, Michigan Audubon Society and Hawk Mountain Sanctuary, and trailside displays for Everglades National Park. Early work was in watercolour, but now works in acrylic and silkscreen prints. Influences include Nicolaides, Gwathmey, Klee, Miro, Picasso, Mondrian, African sculpture and all primitive art.

Alan Harris

Born 10 April 1957, Epping, Essex. Lives in Essex. BA (Hons) in Graphic Design. Freelance illustrator since 1980. Influences include Tunnicliffe, Gillmor, Hayman, Reid-Henry, Bateman and Jonsson. Admires the work of David Quinn. Works in watercolour and gouache for illustrations and acrylic for picture-making. Active ringer since 1973. Joint art consultant fot *British Birds* since 1980. SWLA.

John Cyril Harrison

Born 1898 in Wiltshire. From 1912 he lived in British Columbia until he joined the Army in World War I. Lived most of his life in Norfolk where died in 1985. Studied at the Slade School of Art in London and in the studio of Thorburn. Travelled regularly to Scotland, Iceland and East Africa.

Andrew Haslen

Born 25 December 1953, Coggeshall, Essex. Lives in Suffolk. Works mostly in watercolour, but also paints in oil and produces linocuts and sculpture. Partner in The Wildlife Art Gallery, Lavenham, Suffolk. Major influences have been Talbot Kelly, Seaby, Ennion, Watson, Hainard, Jonsson, Liljefors and Rungius as well as French and British Impressionists. ANF Poland project. SWLA.

Peter Hayman

Born 17 February 1930, Uxbridge, Middlesex. Lives in Bury St Edmunds, Suffolk. Trained as an architect, becoming a full time illustrator in 1970. Works in watercolour and gouache, and is particularly interested in birds in flight. Specialised in landscapes from 1989-1995, but mainly works as a bird book illustrator. Early influences include Thorburn and Keulemans; more recently the measured drawings of Tunnicliffe were a major inspiration. Founder member SWLA.

Matthew Hillier

Born 7 May 1958, Buckinghamshire, UK. Lives in West Sussex. Dyfed College of Art (Wildlife Illustration). Has worked an illustrator, but now paints for exhibitions and fine art publishing in acrylic, gouache and pastel with watercolour. Influences include Maurice Wilson, Bateman, Tunnicliffe, Alfred Munnings and Andrew Wyeth. SWLA.

Gary Hodges

Born 11 November 1954, Carshalton, Surrey. Lives in Wiltshire. No formal training. Full-time artist since 1989. Works in graphite pencils, ranging from 9H to 6B, and drawing on Fabriano 5. Admires several artists, but does not claim any as an influence, being inspired more by the beauty of nature. Much of his work is sold in aid of conservation charities and his work also appears as commercial prints. SWLA.

Cindy House

Born 1952, Rhode Island. Lives in Vermont. University of Maine (Wildlife Biology). Has moved away from watercolour bird illustrations to working in pastel on landscapes with animals in them. Initially influenced by Fuertes, Sutton, Eckelberry, Landsdowne and Singer, but later by Harris-Ching, Group of Seven, Bateman, Tunnicliffe, Jonsson and Liljefors. After seeing William Merritt Chase exhibition came under influence of American and French Impressionists. PSA. SAA.

Francis Lee Jaques

Born 28 September 1887, Genesco, Illinois. Retired to Minnesota in 1941. Died 24 July 1969, Minnesota. Self-taught. Painted in oils. Had drawings published in *Field and Stream* and worked as a taxidermist in Aitkin for nine winters, before getting a job with the Duluth Power Company. Drafted into the Army and served in France in 1918. After working in shipyards he became a commercial artist and received valuable tuition from Clarence C. Rosenkranz. From 1924 worked as an artist at AMNH, New York, under Fuertes' mentor, Frank Chapman. Several expeditions to Central America, the Bahamas, the Arctic, UK, Canada and Switzerland in order to draw material for dioramas at the museum.

Lars Jonsson

Born 22 October 1952, Stockholm. Lives on Gotland, Sweden. First exhibition at Stockholm's Natural History Museum in 1968. His first book was a five-volume series published from 1976 to 1980, which was revised and published in 1992 as *The Birds of Europe*. Works in watercolour, oil, lithography and pencil. Cites Liljefors, Fuertes, Robert and Levitan as influences. Also paints landscapes and portraits. Has travelled extensively in Europe, North America, India and South-East Asia, including ANF projects in Spain, Alaska and India. SWLA.

Richard Talbot Kelly

Born 20 August 1896, Birkenhead, Cheshire. Died in Warwickshire 30 March 1971. Served in Royal Artillery 1915-1929. Painted throughout army career, exhibiting regularly at RWS. Director of Art at Rugby School 1929-1966. Chief instructor in camouflage, Royal Artillery 1939-45. Made models of birds in paper and designed material for exhibitions for RSPB. Design consultant for the Pavilion of Natural Science at the Festival of Britain in 1951. Influenced by Egyptian and Chinese art and Crawhall. His own work has been very influential among European wildlife artists. RWS. RI. Founder member SWLA.

Kees de Kiefte

Born 1 March 1935, Zutphen, Netherlands. Lives Arnhem, Netherlands. Academie voor Beeldende Kunsten. Artistic heroes of his youth were Sikker Hansen and Sjoerd Kuperus, but he came to admire prehistoric paintings and Liljefors' rough sketches in oil, Vere Temple and more recently work the of Busby, Ennion, Charles Donker, Jonsson and Freek van Binsbergen. ANF Extremadura project.

Bob Kuhn
Born 28 January 1920, Buffalo, New York. Lives in Connecticut and Arizona. Pratt Institute, Brooklyn, N.Y. Illustrator on *Reader's Digest, True, Argosy, Outdoor Life* and *Field and Stream* until 1970, when he became an easel painter. Works in both opaque and clear acrylic. Influenced as illustrator by the work of Paul Bransom and as painter by Liljefors, Rungius, Kuhnert, Degas and Winslow Homer. Expeditions include 12 trips of up to two months to Africa, six trips to Alaska as well as numerous trips to Canada and the American West. Trustee, Genesee Country Museum. Emeritus member, Boone and Crockett Club. SAA.

Wilhelm Kuhnert
Born 28 September 1865, Oppeln, Germany. Died 11 February 1926, Flims, Switzerland. Apprenticed to a machine-tool maker at 14, but moved to Berlin in 1882 to work as a calligrapher. Studied at Königliche Akademische Hochschule für die Bildenden Kunste under Paul Meyerheim amd Ferdinand Bellerman. First went to German East Africa in 1891, visiting Africa again in 1905 and moved on to Ceylon and India, returning to Germany in 1908. Final African expedition was in 1912. In 1916 he visited Bialowiesa Forest in German-occupied Poland. There were over 500 lions in his output of 3,500 oil paintings, of which the whereabouts of only about 1,000 are known, as many were destroyed (or looted) in World War II.

James Fenwick Landsdowne
Born 8 August, 1937, Hong Kong. Lives in Victoria, British Columbia. Has painted birds since childhood, but no formal art training. Early influences were Allan Brooks, Fuertes and then Thorburn and later Audubon. Worked in gouache for many years, but increasingly using pure watercolour and graphic pencil.

Ian Lewington
Born 3 December 1964, Oxford. Lives in Didcot, Oxfordshire. No formal art training. Influenced by his brother, Richard, and Lars Jonsson, Ray Harris-Ching, Allen Seaby and Josef Wolf. Freelance bird illustrator since 1985, working almost entirely in gouache and ink with ink-wash. Has illustrated several books and identification plates in *Dutch Birding, Birding World* and *Limicola*. SWLA.

Richard Lewington
Born 8 October 1951, Taplow, Buckinghamshire. Lives in Oxfordshire. Berkshire College of Art and Design. Freelance biological illustrator since 1971. Works in designer's gouache, pencil and line drawing. Major influences include Arthur Smith and Terzi, both illustrators at the Natural History Museum in London. Has illustrated many insect books including field guides to butterflies and dragonflies.

Dylan Lewis
Born 7 July 1964, Johannesburg, South Africa. Lives Stellenbosch, Cape Province. Cape Technicon Art School and Ruth Prowse School of Art, Cape Town. Taxidermist/display artist at Rondervliet Nature Reserve near Cape Town. Full-time painter and sculptor since 1991. Paints in pencil, watercolour and oil. Sculpts in bronze. Influenced as painter by Liljefors, Monet, Modigliani and Wyeth and as sculptor by Rodin, Rembrandt, Bugatti and Giacomo Manzu. Works in the field, taking a 'portable studio' on his back. ANF Alaska project.

Bruno Liljefors
Born 14 May 1860, Uppsala, Sweden. Died 18 December 1939. Lived in Kvambo near Uppsala (1884-94), island of Ïdo (1895-6), island of Mörkö (1896-8 and 1901-3), Ingarö on Stockholm peninsula (1898-1901), in a house called "Wigwam", Ytter-Järna (1905-17), Österby Manor in Dannemora (1917-30) and Stockholm (1930-9). Studied under K. G. Holmgren at Uppsala and at Royal Academy of Art, Stockholm. Tutored in animal painting by C. F. Dieker in Düsseldorf. During 1880s visited various European countries including France spending time with Carl Larsson at Grèz-sur-Loing near Paris. A hunter/painter he painted oils of animals on a large scale and has been an inspiration to other wildlife artists throughout the century. During the latter part of his life he was recognised as a major Swedish artist together with Carl Larsson and Anders Zorn. Elected Berlin Academy of Art 1906; Royal Academy of Art, Stockhom 1920.

George E. Lodge
Born 3 December 1860, Scrivelsby, Lincolnshire. Lived in Camberley, Surrey. Died 5 February 1954. Apprenticed at 14 to a wood-engraver. Influenced by Joseph Wolf (1820-1899) and in turn influenced Rickman and Harrison. Media used included wood engraving, etching, drawing in pencil and crayon, watercolour, oil. Prolific illustrator of bird books including great handbooks by Lilford and Bannerman. Travelled in Sweden, West Indies, Norway, Ceylon, Singapore, Hong Kong, Japan, Canada and USA. Vice-President BOU 1947. Council member, SPNR and ICBP.

George McLean
Born 18 September 1939, Toronto, Ontario. Lives in a fieldstone building in the countryside near Bognor, Ontario. Became illustrator on leaving school, illustrating books and magazines in North America. Now paints for exhibitions and commissions. Works in casein on masonite panels prepared with gesso. Bob Kuhn, Liljefors and Rungius are all influences.

Rodger McPhail
Born 10 May 1953, Lancashire. Lives in Lancashire. Liverpool College of Art. Freelance artist/illustrator since college. Works in oils and watercolour. Many of his paintings are of gamebirds and fish, but also draws cartoons, illustrations and paints portraits. Has been influenced by several artists, especially the Dutch artist, Rien Poortvliet. Numerous books illustrated.

Lawrence B. McQueen
Born 28 May 1936, Danville, Pennsylvania. Lives in Eugene, Oregon. University of Oregon (Art), Bucknell University and Idaho State University (Biology and Conservation). Full-time artist since 1978. Works in oil, gouache and transparent watercolour. Influences include Audubon, Fuertes, Ennion, Liljefors, Eckelberry, Jonsson, and Pearson, and among non-bird artists Homer, Sargent, Bellows, Hopper and Burchfield. ANF Poland project. Numerous magazine illustrations and products such as posters, flash cards and calendars.

David Measures
Born 22 November 1937, Warwick. Lives in Nottinghamshire. Mid-Warwickshire School of Art, Bournemouth College of Art and Slade School of Fine Art (Illustration, Painting and Printmaking). Art college lecturer until retirement. Numerous natural history influences include Stubbs, Bewick, Sowerby, Curtis, Gosse, Ruskin, Frohawk, Ennion, Edmund Wilson and BB. Also influenced by cave paintings, Egyptian art and the art of Greece and Rome, and Bomberg, Bonard, Cezanne, Picasso, Matisse and American abstract painters. Works in the field in watercolour, and occasionally oils, colour crayon, colour biro, marker pens and pencil. ANF Extremadura project.

James Morgan
Born 7 August 1947, Paysan, Utah. Lives Mendon, Utah. Utah State University (Fine Arts). Worked for eight years for Wurlitzer Piano Company. Now full-time painter. Works in oil, watercolour and drawing media. His influences are Sargent, Zorn, Rungius, Kuhn, G. Carlson, Liljefors and Bugatti. Has a simple goal of enjoying the process of painting and seeing in the hope of gaining "an emotional participation from the people who view the painting and to bring an awareness to others of the often overlooked intimate aspects of nature". Intrigued by the patterns and shapes of nature, he concentrates on the effects of light on them. National Academy of Western Art. Northwest Rendezvous Group. SAA.

Peter Munro
Born 10 August 1954, Dingwall, Scotland. Lives in Ross-shire. North Staffs Polytechnic and Chelsea School of Art, London. Worked in family forestry business before becoming a full-time artist in 1987. Paints in oil, acrylic, watercolour and egg tempera. His subjects are based on local landscapes and wildlife. Major influences are Andrew Wyeth and the Glasgow Boys, especially Joseph Crawhall. SAA.

John P. O'Neill
Born 12 April 1942, Houston, Texas. Lives in Baton Rouge, Louisiana. University of Oklahoma (B.S. in Zoology), Lousiana State University, Baton Rouge (M.S. and Ph.D). LSU Museum of Zoology since 1965 and became director in 1978. Moved to part-time post to allow time to paint, becoming a full-time professional painter in 1987. Continues ecological and ornithological research in South America, and in Peru recently discovered his 13th species new to science. Numerous illustrations for books, magazines and journals.

John Paige
Born 3 October 1927, Lymm, Cheshire. Lives in Northamptonshire. Read law at Cambridge. Worked as army officer, warden in Ugandan National Park and trainee corn merchant before studying graphic design at Birmingham College of Art. Freelance artist, graphic designer and teacher of fine art, running a teaching studio with Jane Leycester Paige. Works in a variety of media including watercolour, oil, acrylic, pastel, screen and lino printing, monoprinting, drawing, collage. Influenced by Denys Watkins-Pitchford (BB), art master at Rugby School, Talbot-Kelly, Ennion, early Scott, Crawhall and Tunnicliffe. SWLA.

Agnes Miller Parker
Born 25 March 1895, Irvine, Ayrshire. Died 1980. Glasgow School of Art. Studied wood engraving under Gertrude Hermes and Blair Hughes-Stanton. Taught art in schools and wood engraving at Gregynog Press, Montgomeryshire. Moved to Glasgow and subsequently to the Isle of Arran. Primarily an illustrator using wood engraving. SWA. ARE.

Peter Partington
Born 29 September 1941, Cambridge, UK. Lives in Suffolk. Bournemouth Art College and Hornsey College of Art. Art lecturer for 20 years. Full-time painter since mid-1980s. Having "explored all the 'isms' at college", Partington lists Talbot Kelly, Ennion, Bateman (for composition), Liljefors, Monet, Sargent, Wilson Steer and Sickert as influences. Works principally in watercolour, but also includes oils, etching and working in clay. ANF Poland and Extremadura projects. Writes regularly for *The Artist*. SWLA.

Bruce Pearson
Born 20 September 1950, Suffolk. Lives in Cambridgeshire. Great Yarmouth College of Art and Design and Leicester School of Art (BA in Fine Art). After working for the RSPB Film Unit and British Antarctic Survey, began a career as freelance artist and broadcaster. Works in oils, watercolour and mixed media, painting both *plein air* and in the studio. Strongest influence has been Ennion, followed by Tunnicliffe, Seago and the Impressionists, but working alongside fellow artists such as Jim Morrison, Greg Poole and John Busby has altered his ideas and stimulated him to try new directions. ANF Poland, Extremadura, and Alaska projects. SWLA. President SWLA since 1994.

Roger Tory Peterson
Born 28 August 1908, Jamestown, New York. Died 28 July 1996, Old Lyme, Connecticut. Worked decorating lacquer furniture. Went to Art Students League in New York City, studying drawing under Kimon Nicolaides in 1925,

231

followed by three years at National Academy of Design. Taught in Boston before becoming staff artist/designer at National Audubon Society and then director of education. His enormous contribution to wildlife was through his *Field Guide to the Birds* in 1934, the first of 16 field guides he wrote or edited. Travelled widely throughout the world, lecturing and writing up to his death. First-class photographer. Many awards and honorary degrees. Served on numerous councils and committees including the boards of WWF, NAS, ICBP American section and UN Earth Care Conference 1975. SAA. Vice-President SWLA.

Greg Poole
Born 26 September 1960, Bristol, UK. Lives in Bristol. University College, Cardiff (Zoology) and Manchester (Art Foundation). Worked in conservation and at bird observatories. Present work includes field sketches in charcoal, crayon, gouache and watercolour; collage, relief printmaking using wood, lino, cardboard and polystyrene, silkscreen printing (including photo-screening) and monoprinting. Influences include the illustrator Laurel Tucker, Kim Atkinson, textile artist Nicola Henley and John Paige. ANF Loire, Alaska and India projects. SWLA.

Darren Rees
Born 15 March 1961, Hampshire. Lives in Scotland. University of Southampton (Mathematics). Taught for a short period before becoming a full-time painter. Self-taught as a painter and influenced by Jonsson, Tunnicliffe, Busby, John Singer Sargent, Wyeth and Gunnar Brusewitz. He works in watercolour, acrylic, oils and pastel. Lectures on wildlife painting courses. ANF Schiermonnikoog and Poland projects. SWLA.

Andrea Rich
Born 31 October 1954, Racine, Wisconsin. Lives in Santa Cruz, California. University of Wisconsin (Art Education). Involved in wildlife rehabilitation and gives talks to children as part of Santa Cruz Natural History Museum education programmes. Has worked as a graphic designer and illustrator. Specialises in woodcuts printed in several colours. ANF Loire and Alaska projects.

Richard Richardson
Born 1922 in Blackheath, London. Died 1977 at Cley, Norfolk, where he had lived from the late 1940s. Entirely self-taught as an artist. Expert in field identification and able to make drawings and paintings without field sketches. Founded and ran the Cley Bird Observatory. Travelled to the Camargue, Norway and Fair Isle in search of birds. *British Birds* commemorated him in the Richard Richardson Award for young artists.

Philip Rickman
Born 1891, Sussex. Died 1982 in Sussex. Studied painting in Paris and taught by George Lodge and Thorburn, who were both major influences. Painted landscapes in Sussex and the Highlands. Often used watercolour in the field.

Chris Rose
Born 27 August 1959, Kilembe, Uganda. Lives in Melrose, Scotland. Biology degree. Spent a year as an illustrator for the Dorset Heritage Coast Project before becoming a freelance illustrator and painter. Works in acrylic, oil, watercolour, pastel, pencil, pen and ink, scraperboard. Influences include Harris-Ching, Bateman, Shackleton, Ennion, Lars Jonsson, Busby and Gillmor. ANF Poland and Extremadura projects. SWLA.

Carl Rungius
Born 18 August 1869, Rixdorf, Germany. Died 1959 in New York City. House painter's apprentice. Attended Berlin Art School in winter. Later attended Academy of Art, where he was a contemporary of Kuhnert. Visited uncle in New York City in 1894 where his work was spotted by William Hornaday, a leading conservationist, who introduced him to the editors of *Forest and Stream* and of *Recreation*. Illustration commissions and an expedition to the Yukon followed. Theodore Roosevelt was among those who bought Rungius' work. Worked in oil. Typical hunter/painter, who spent many weeks in the field and understood his subjects.

Christopher Schmidt
Born 25 December 1965, Wuppertal, Germany. Lives Lebrade, Germany. Bielefeld University (Biology and English). Self-taught as artist. Full-time freelance artist and illustrator. Works mainly in watercolour and gouache, and occasionally in oil. Main influences are Swedish, especially Lars Jonsson, Brusewitz and Anders Zorn. ANF Extremadura project.

Peter Scott
Born 14 September 1909, London. Lived at Slimbridge, Gloucestershire from 1949 until his death on 29 August 1989. Trinity College, Cambridge (Natural Sciences and Art and Architecture), Munich State Academy (Animal Painting) and Royal Academy Schools, London. Earned a living from painting in 1930s. After distinguished naval war service, he founded The Severn Wildfowl Trust (now The Wildfowl and Wetlands Trust) and began career in broadcasting, presenting BBC Television's *Look* (1955-72). Founder and first chairman of WWF. Chairman, IUCN Survival Service Commission (1962-81). Co-founder of Falklands Foundation. Scott's contribution to wildlife conservation was unrivalled.

Allen William Seaby
Born 26 May 1867, London. Died 28 July 1953 at Reading. Borough Road Teacher Training College, Isleworth, Middlesex. Taught in Reading, then attended the School of Art, joining the staff in 1899. Head of art school (1910-33) and Professor of Fine Art (1920-33). Professor Emeritus, Reading University (1926). Worked in oil, watercolour (on paper and linen), pen and ink, pencil and pastel linocut and colour wood block printing. Influenced by Japanese colour prints and work of Crawhall and Edwin Alexander. Grandfather of Robert Gillmor.

Society of Animal Painters. Founder member Graver-Printers in Colour and Colour Print Society. Founder and first President of Reading Guild of Artists, 1930.

Colin See-Paynton
Born 8 July 1946, Bedford, England. Lives in mid-Wales. Northampton School of Art. Specialises in wood engraving, linocuts and watercolours. Many of his wood engravings are inspired by his enthusiasm for birds and fishes. Influences include Eric Ravilious, Gertude Hermes, Charles Tunnicliffe and William Blake. Has illustrated several books for Gregynog and Gruffyground Presses in Wales and Barbarian Press in Canada. Elected ARCA, ARE, SWE, RE. ANF Alaska project.

Keith Shackleton
Born 16 January 1923, Weybridge, Surrey. Lives in Kingsbridge, Devon. Lived in Australia as a child, returning to school in England. Painted war scenes with Army and Naval Coastal Forces during RAF war service. Became full-time painter after 15 years as salesman and pilot in family aviation business. Edward Seago, Scott and Tunnicliffe are the artists who have most influenced his work. Has presented wildlife programmes for BBC and Survival Anglia. Past President Royal Society of Marine Artists, Past President and founder member of SWLA, Past Chairman of Artists' League of Great Britain.

J. A. Shepherd
Born 29 November 1867, London. Died 1946, Charlwood, Surrey. Described by Horne as a "comic animal draughtsman". No formal training, but worked with Alfred Bryan, cartoonist of *The Moonshine*. His humorous drawings of animals were anthropomorphic, but his illustrations for *The Bodley Head Natural History* were among the first wildlife drawings to attempt to capture the 'jizz' of the animals. He contributed to numerous popular magazines including *Punch* from 1893.

Raymond Sheppard
Born on 3 March 1913 in London. Died 21 August 1958. Studied at London College of Printing and Graphic Arts. Became a freelance illustrator in 1934, illustrating books on natural history. He taught for three years at the London College of Printing for three years. His illustrations appeared in several magazines, including *Boys' Own Paper* and *Lilliput*. His three instructional books were popular with would-be wildlife artists in the years after World War II, during which he served with the RAF Photographic Section. FZS. SGA. Pastel Society. RI.

Robin D'Arcy Shillcock
Born 28 September 1953 in The Netherlands of Australian parents. Lives in Groningen, The Netherlands. Educated in India, Guatemala, Australia and The Netherlands. Groningen Academy of Fine Arts. Professional artist since 1980. Staff of ANF 1992-5. Writes and teaches wildlife and art. Draws in pencil, conté, ink and brush. Paints in the field and in the studio mainly in oils but also in other media including lithography. Influenced

principally by Evert Musch, teacher at Groningen, and by Zorn, Monet, Liljefors, Johannes Larsen, and Andrew Wyeth. ANF Schiermonnikoog and Poland projects.

Arthur Singer
Born 1917, New York City. Died 1990. Lived in Jericho, NY. Cooper Union Art School. Worked in advertising as illustrator. Became full-time illustrator/artist in 1955. Used either gouache or oils. Influences were Rungius, Fuertes and Kuhnert. With his artist-son, Alan, designed 50 postage stamps for US Postal Service, featuring flowers and birds of each State. Travelled widely including expeditions to American tropics.

Richard Sloan
Born 11 December 1935, Chicago, Illinois. Lives in Florida. American Academy of Art, Chicago. Worked in advertising illustration and as staff artist at Lincoln Park Zoo. Full-time painter since 1966. Works in acrylic and pencil. Lists Dean Cornwell, Bob Kuhn and Arthur Singer as influences. Although he spends much of his time painting tropical forest subjects, he is a diver and plans several coral reef paintings.

Eileen Soper
Born 26 March 1905, Enfield, Middlesex. Lived from the age of three until her death in March 1990 in Hertfordshire. Taught to paint by her artist father, George Soper. Her father had created a wildlife sanctuary in the grounds of their home and she drew the animals she saw there. She was also an illustrator of children's books including *The Famous Five* series by Enid Blyton. Founder member of SWLA. RMS.

Andrew Stock
Born 25 March 1960, Rinteln, Germany. Lives in Dorset. No formal art training, but has been working as an artist since leaving school, where he was inspired by meeting Peter Scott. Works in watercolour and oils with some etchings and occasional sculpture. Influenced by watercolourists of the Norwich School, Tunnicliffe and Bateman, but later by the Impressionists and Andrew Wyeth. SWLA.

George Miksch Sutton
Born 16 May 1898, Bethany, Nebraska. Died 1982. Bethany College, West Virginia, and Cornell University (Ph.D). Worked for Carnegie Museum, Pittsburgh; for Pennsylvania Board of Game Commissioners; Curator of Birds, Cornell University; University of Michigan; Professor of Zoology and Curator of Stovall Collection, University of Oklahoma. Learned painting from Fuertes, with whom he corresponded between 1915 and 1927. Took part in several expeditions from arctic North America to Mexico. Encouraged and taught many younger artists. His work has illustrated numerous books.

Archibald Thorburn
Born 31 May 1860, Lasswade near Edinburgh. Taught by his father, Robert, a miniaturist, and at art school in St John's Wood. In 1887 he was commissioned to paint 268

plates for Lord Lilford's *Coloured Figures of the Birds of the British Isles*. Influential on Harrison, Rickman and Lodge, and even a century after his first work for Lilford he has many imitators. Worked mainly in watercolour. Sketched in the field in the Highlands, particularly Gaick in Inverness-shire. In 1902 he moved to Hascombe in Surrey, where he lived until his death in 1935. His painting of Common Terns was the first Christmas card published by the RSPB, in 1889, and he continued to paint cards for the Society until 1934. His work has illustrated numerous books.

Guy A. Tudor III

Born 28 September 1934, New York City. Lives in Forest Hills, NY. Princeton University, Yale School of Fine Arts and Skowhegan Painting School. Considers himself self-taught as a wildlife artist. Freelance illustrator for 40 years. Works in watercolour/gouache. Lists as important mentors Eugene Eisenmann, ornithologist at the American Museum of Natural History and Rudy Freund, a major wildlife illustrator for *Life* magazine. Influential artists include Fuertes, Sutton, Eckelberry, Jacques and Walter Weber. Has travelled widely and has an extensive reference collection of over 6,000 photographs of birds. Recently became interested in butterflies and founded The Butterfly Club with Jeff Glassberg.

Charles Frederick Tunnicliffe

Born 1 December 1901, Langley, Cheshire. Lived in London, Cheshire and Anglesey. Died 7 February 1979. Macclesfield Art School, Manchester School of Art and Royal College of Art. Initially concentrated on printmaking. After part-time teaching he worked as a commercial artist, illustrator and engraver. Made reputation as an illustrator with wood engravings for Henry Williamson's *Tarka the Otter*. Illustrated another five Williamson books as well as three for H. E. Bates, five for R. M. Lockley, six for N. F. Ellison ("Nomad") and 18 for Alison Uttley. Moved to Anglesey in 1947. From 1950 to 1966 produced all the covers for the RSPB magazine, *Bird Notes*, and all the Society's Christmas cards. His work was based on sketches made in the field and his meticulous measured drawings of dead specimens. He was one of the most prolific and influential British artists of the century. ARE, RE, and RA. Vice-president, SWLA.

Barry van Dusen

Born 23 November 1954, Portland, Maine. Lives in Massachusetts. Southeastern Massachusetts University (Visual Design). 12 years as a graphic designer/illustrator. Freelance painter and illustrator since 1985. Works primarily in watercolour and oils. Early influences were Fuertes and Eckelberry, but more recent involvement with fieldwork was inspired by Ennion, Busby, Jonsson and McQueen. ANF Extremadura and Wexford projects. SWLA.

Michael Warren

Born 26 October 1938, Wolverhampton, United King-dom. Lives in Nottinghamshire. Wolverhampton College of Art. Full-time painter since 1972. Paints in acrylic or watercolour on rag paper. Has studied birds in Europe, USA, the Pacific and Africa. His work includes designs for postage stamps for UK (1980) and the Marshall Islands (1990-2); conservation stamps for NAS (1984-97) and UK Wildlife Habitat (1996-7); paintings of birds of 50 states of USA for Unicover Corporation (1985-7) and of ducks of 50 states (1990-2). ANF projects in Schiermonnikoog, Poland, Extremadura and Wexford. SWLA. Founder member of SWAN.

Keith Waterfield

Born 7 November 1927, Watford. Lives in Hampshire. Watford School of Art and King Alfred's College, Winchester (Teacher Training). Worked as a graphic artist for the publisher, Hutchinson, and after Army service worked in the Department of Agriculture in Nyasaland until 1960. Schoolmaster until 1972. Now full-time painter. Works in oils and acrylics. Artists who have influenced his work are Cezanne, Braque, Gauguin, Nicholas de Stael, Audubon and Paul Nash among others. Having set out to become "a descriptive painter of a traditional English bent" he began to paint in a more imaginative way. SWLA.

Donald Watson

Born 28 June 1918 at Cranleigh, Surrey. Oxford University (Modern History, specialising in Italian Renaissance). After wartime Army service in India and Burma he became a full-time artist. Works in a variety of media including watercolour and gouache, oil, scraperboard, and pen and ink. Influences include Liljefors, Edwin Alexander, Fuertes, French Impressionists, landscape painters (especially Corot), Tunnicliffe, Crawhall and Ennion. Received personal help from Frank Wallace, Stanley Cursitor and Thorburn. Has lived most of his life in Scotland and is a painter of Scottish landscapes and birds. Council member BTO; President SOC; Founder member SWLA.

Wolfgang Weber

Born 11 March 1936 in Koblenz, Germany. Lives in Frankfurt-am-Main. Studied at Art School, Mainz, and Schule des Sehens, Salzburg under Kokoschka. Freelance artist and illustrator. Works in oil, watercolours, woodcuts, etchings, bronze (sculpture) and draws in ink and pencil. Influences have been prehistoric cave paintings, Delacroix, Rodin, Emil Nolde, Oskar Kokoshcka and Kuhnert. Draws in the field, trying to approach animals as closely as possible. Has painted wildlife throughout the world. Work includes calendars, limited edition prints of watercolours for Rosenstiel's, London, postage stamps and logos for conservation societies. ANF India project.

Maurice Wilson

Born 15 March 1914 in London. Lived in Kent and died in 1988. Studied at Hastings School of Art and the RA Schools. Taught at Bromley College of Art and worked

with Rowland Hilder on the 'Shell Nature Studies'. Worked in watercolour, acrylic and oil, and in ink with pen and brush. Although specialising in animals, he painted seascapes and portraits and had a period during which he produced exquisite reconstructions of prehistoric humans and other animals. RI. SWLA.

Martin Woodcock

Born 14 January 1935, Sidcup, Kent. Lives in Kent. Freelance artist/author since 1983. Largely self-taught, he was given great help by Richard Richardson, R. B. Talbot Kelly and Chloe Talbot Kelly. Admires Thorburn and Lodge. Works in watercolour, gouache and oil. Has painted over 550 colour plates depicting over 3,000 species, including most of the plates for *The Birds of Africa*. President, African Bird Club. SWLA.

Julie Zickefoose

Born 24 July 1958, Sioux Falls, South Dakota. Lives in Ohio. Harvard University (Natural Sciences). Has painted birds since childhood when she was enchanted by Fuertes' illustrations. Bob Clem encouraged her to draw from life. Cites Lars Jonsson as a recent influence. Has painted birds across North America and in the Neotropics. As an illustrator she has contributed to several magazines including *The New Yorker*, *Birding*, *American Birds* and the *Living Bird*. Contributing editor to *Bird Watcher's Digest*. Lectures on wildlife.

INDEX

Acknowledgements

AMERICAN MUSEUM OF NATURAL HISTORY, NEW YORK
p69, p70

ARTISTS FOR NATURE FOUNDATION
p119, p133, p140, p171, p216

THE BURRELL COLLECTION, GLASGOW MUSEUM
p111

CHRIS BEETLES LTD
p128 (The Estate and Copyright is run by Chris Beetles Ltd, 8 Ryder Street, London SW1Y 6QB)

CHRISTIE'S IMAGES, LONDON
p10, p23, p43, p47, p57, p101, p100, p102, p105

THE EWELL SALE STEWART LIBRARY, ACADEMY OF NATURAL SCIENCES, PHILADELPHIA
p25, p71, p72, p75, p77

GLENBOW COLLECTION, CALGARY, CANADA
p45

GOTHENBERG ART MUSEUM
p34

HARPERCOLLINS, LONDON
p150

HOUGHTON MIFFLIN COMPANY, NEW YORK
p28, p148, p149

JAMES FORD BELL MUSEUM OF NATURAL HISTORY, UNIVERSITY OF MINNESOTA, MINNEAPOLIS
p50, p212

LEIGH YAWKEY WOODSON ART MUSEUM
p63, p65 with funds provided by John and Alice Woodson Forester and Lyman and Nancy Woodson Spire,
p63 gift of Ray and Marie Goldbach Foundation,
p78, p84 with funds provided by John and Alice Woodson Forester,
p81 gift of the artist,
p222 with funds provided by John E. Forester,
p206, p207

NATIONAL MUSEUM, STOCKHOLM
p33

ORIEL YNYS-MÔN
p136, p137, p138

OXFORD UNIVERSITY PRESS
p161

RIJKSMUSEUM DE TWENTHE, ENSCHEDE
p11, p13

THE ROYAL SOCIETY FOR THE PROTECTION OF BIRDS, BEDFORDSHIRE
p27

LADY SCOTT
p17, p54, p219

SOTHEBY'S TRANSPARENCY LIBRARY, LONDON
p36, p37, p90, p94, p98, p103

THIEL GALLERY, STOCKHOLM
p35, p39

TRYON AND SWANN GALLERY, LONDON
p90, p92, p94, p98, p99, p100, p102, p103, p105, p176, p183

THE WILDLIFE ART GALLERY, LAVENHAM
p17, p54, p61, p112, p113, p115, p123, p124, p127, p130, p170, p173, p 185, p186, p195, p202, p207, p219